THE ART OF LASSEN

THE LASS

A collection of works from

ART OF
SEN

Christian Riese Lassen

PROJECT COORDINATORS: CHRISTIAN RIESE LASSEN, JEFFREY GIRARD

TEXT: DREW KAMPION

EDITING: BOB HAYES, MICHAEL BESSON

ART DIRECTION: JEFFREY GIRARD

EXECUTIVE PUBLISHER: JONÁ-MARIE PRICE

TECHNICAL CONSULTANT: MARCIA A. CRAWFORD

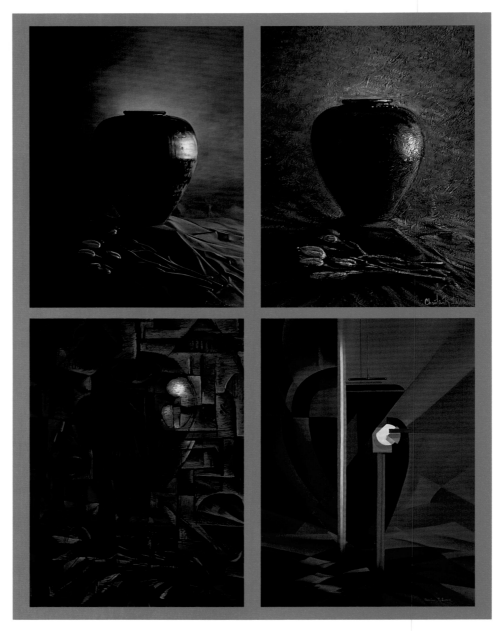

QUATEC

1986. Oil on panel. Four 12" x 16" (30cm x 41cm) panels

I've always been interested in challenging myself with different styles and wanting to learn as much as I could about each [historic] period in art. This painting illustrates the different styles that I was experimenting with at the time. It goes from realism to impressionism to cubism to abstraction. The Quatec illustrates the different styles I've experimented with and used to round out my knowledge of art. I think that each of them is successful; each achieves what I set out to accomplish.

Acknowledgements

To Carol Lassen, Walter Lassen, Dolores Lassen, the Reverend Dianne Winter, Ron Lassen, Joná-Marie Price, Nicky Price, John Price, Erik Aeder, Dan Merkel, Sonny Miller, Tomas DeSoto, Leonard Brady, Ricardo Iaconetti, Mark Foo, the staff of Lassen Publishing and Galerie Lassen, Jeff Divine, Shintaro Shigemori, Naoya Hayashida, Masaki Saito, Cathy, Sarah, and Trevor Girard, Connie Poole, Susan Kampion, and all my fans around the world who made this book possible.

ISBN 1-879529-00-9
First Hardcover Edition, June 1993

© 1993, Christian Riese Lassen

Published by

LASSEN PUBLISHING
P.O. Box 10309 • Lahaina, Maui, Hawaii, 96761
(800) 827-0723 • (808) 667-2606 • Fax (808) 667-9230

Printed in Japan

PAGE 4

OUR EARTH is in a constant state of change. Its inexplicable beauty belies a complex nurturing organism that mankind has taken for granted. Man has exploited and destroyed global resources for power and profit with wanton disregard for future generations.

However, there has also been a creative and caring segment of the population, crying out for awareness and change. Artists have taught, counselled, and protested—on cave walls and canvas — since the stone age. Native Americans documented the disappearance of the buffalo; political satirists in the late 1700's called attention to corrupt and immoral politicians; sensational personalities explored and explained a changing consciousness in the sixties, then anguished through the seventies. The eighties brought a calm, soothing art that attempted to heal the great wounds of man, and allowed new venues, new styles, and new hope to flourish.

Today's artists use emotion, fantasy, and our world's natural beauty to communicate with the soul. There is a school of thought that hopes man, once exposed to the beauty he does not encounter in his daily existence in the concrete jungle will rally to save what is left of a dying planet. He will then turn his energies from consuming to sharing...to communing with Mother Earth and his higher self.

At the forefront of this concerned generation stands Christian Riese Lassen whose talent for molding pigment, light, and movement, along with his compassion for the harmony of life on Earth, has allowed him to touch the hearts of virtually millions of people.

Viewing a work of art by Lassen is not merely the passage of time, but an experience of nature, captured in the scene by its exquisite detail. Wondering at the life and experiences of a man who can create such images, one magically loses himself in the encounter enjoying it on an unexplainable level.

What makes each canvas so unique is the longing it leaves behind. One yearns to do something to preserve the delicate balance still present on this Earth.

Christian's popularity is due to his uncanny ability to awaken in each of us a positive awareness of ourselves, and to restore the hope that we can indeed contribute to the healing of our home.

Christian Riese Lassen is a young artist in years, but his experiences allow him immense creativity. So seldom can a self-taught artist master so many techniques. One painting, *Quatec*, exhibits Christian's proficiency in not one, but four classical styles. Most artists spend a lifetime achieving such mastery in only one style.

His skill allows him to vary his technique, creating a multitude of new images. His style changes according to what he is communicating, yet each canvas is unmistakably a Lassen.

With the great gift given to Christian he endures an equal responsibility. He must communicate a vital and regenerative vision. Christian opens doors in both our hearts and minds, while awakening in us our inner light. The impact this experience brings to each man's spirit can only be measured by the vision that is carried on to the next generation.

A LIFE OF VISION

Surrendering at last

to its own

first dream,

the spirit of Maui

shrugs off the sleep

of man

and breathes a sigh

of return

to life.

Surrendering at last

to its own

first dream,

the spirit of Maui

shrugs off the sleep

of man

and breathes a sigh

of return

to life.

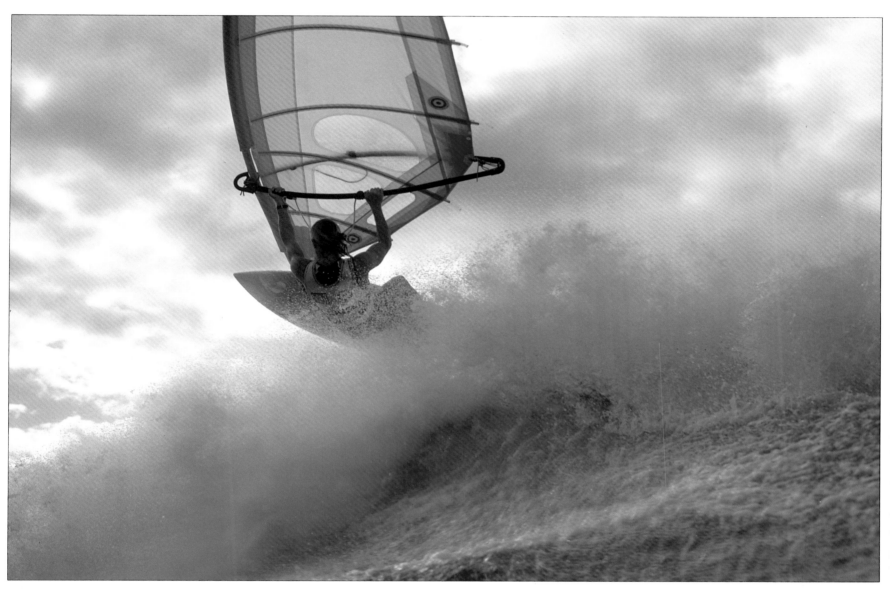

Christian Riese Lassen vaults over the wind-blown curls off Maui's Ho'okipa Beach. Photo by Erik Aeder.

No setting could be more perfect to stimulate an artist's senses. As the sun sets over the Au'au Channel, the haze of volcanic ash from the Big Island of Hawaii captures the last rays of the descending sun, setting the sky ablaze with the fires of paradise. Beneath the golden-orange surface of the channel waters, giants stir, moving gracefully north or south, or simply remaining to calve before migrating. The whales—humpback, sperm, and pilot—take to these warm currents with collective memory pulsing familiarly through their consciousness.

Beneath warm tropical waters, the mosaic of reef has attracted an intricate world of plants and animals. Coral, sea grass, anemone, eel, urchin, and porpoise, coexist with an endless rainbow of reef fish.

Ashore, the extravagant beauty abounds with food for all the senses. The old whaling village radiates charm, its historic landscape maintained over generations.

Of course, there are the waves: Clean swells surge down and break in such perfection that surfers recognize this island as a wave riding mecca. Add Maui's tradewinds, rushing to funnel through the island's center, and you'll find beaches windsurfers long for, travelling from all parts of the world to sample Maui breezes.

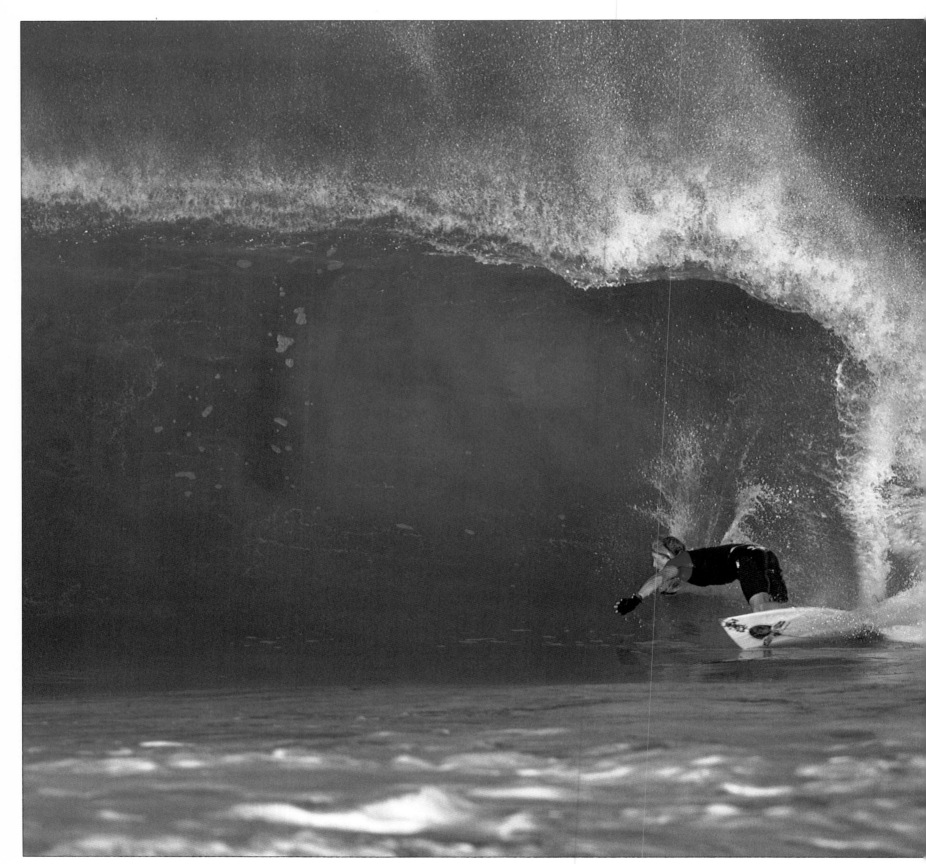

The artist carving a hard turn in extremely shallow water at the bottom of a very hollow wave at Puerto Escondido, Mexico.

All this has become a part of Lassen's art and life. He rises early to check the waves; he calls the North Shore for a forecast on the wind. On a typical morning, he'll surf or sail, depending on conditions. If the waves are small, and the winds calm, he'll take out his boat and free-dive off the reef. This daily ritual of contact with the ocean and other elements is vital to Christian's creative process. Energized by these experiences, he

LIGHT AND ENERGY

CHRISTIAN RIESE LASSEN was born near the sea in Mendocino, California, on March 11, 1956. His mother, Carol, was a talented artist, both in spirit and practice. She created an aura of love and support around Christian and his older brother and sister, Ron and Dianne. A touch of the miraculous surrounded Christian from the beginning. Carol contracted polio after Ron's birth, and for a time received treatment in an iron lung. Her doctors told her she would be unable to have more children, but she would not accept their negative prophecy. "I wanted desperately for Ron to have a brother to play with—because I was restricted in some ways. I prayed for another son and promised that I would name him Christian and bring him up in a God-like fashion."

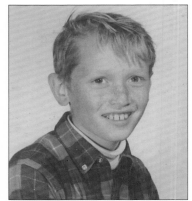

Christian Riese Lassen, age 10.

To the Lassens, Christian's birth (and his mother's surviving it) was nothing short of a miracle. She raised the boy according to her promises and was not surprised by the ethereal quality that began to emerge in his art. "Imagine," she marvels, "if I had listened to the doctors he would never have been born."

Christian Riese Lassen's first home was the redwood coast of Fort Bragg, California. The family lived in a rustic log home in a residential park, built by his father and grandfather. Deer and raccoons thrived in the neighboring forests of redwood trees. The surge of the nearby ocean's rhythms, and the drama of the seasons at this spectacular land's end illuminated the boy's soul with vivid impressions of our natural world in cyclic harmony.

Christian's father, a masonry contractor, built the infrastructures of new communities and industries around Northern California. With a thriving business, the family owned a second home in nearby Ukiah for a time. Nature was always present there, as well.

THE GIFT

Christian's artistic gift made itself known as soon as he was able to use pencil and pen. "My God," says Carol, still astonished after many years, "his drawings looked like illustrations from an encyclopedia!" The boy loved the forests, fields, and shores. He'd return home with a shoebox filled with treasures—toads, spiders, insects, lizards, and any other wonder he could find—and escape to his room for hours of drawing. "He was so quiet," muses Carol, "we wondered what would become of him."

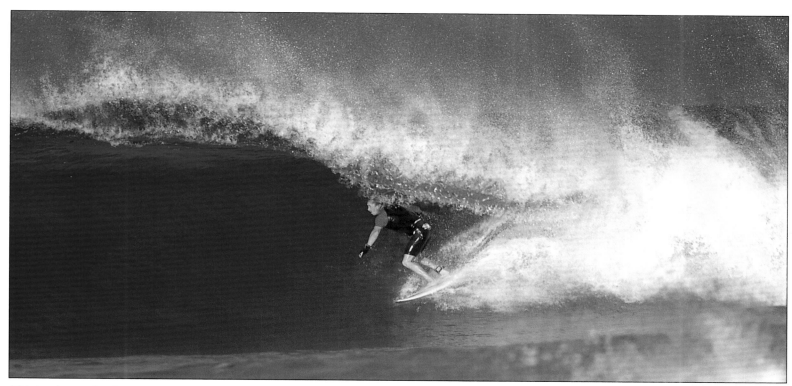

This is what surfers live for — crouching low under the powerful lip of a curling wall of moving water. Puerto Escondido, Mexico. Photo by Dan Merkel.

After breaking an arm at age seven, Christian was required to wear a cast for several months. Any drawing would now have to be done with his left hand. "Having always been able to draw and color really well, all of a sudden, I couldn't do it anymore," recalls Lassen. "For a year, the fear my precious talent was gone consumed me. I'll never forget discovering I could use my right hand again, and almost immediately everything was okay."

In school, he was scolded by teachers for drawing on his homework, but he persisted. He experimented with oil for the first time at the age of nine, painting a picture of a house surrounded by a picket fence.

"If you have artistic talent," says Walter Lassen, "it's going to come out. This is certainly true of Christian. No matter where he was born, or where he was raised, it would have still come out. It's not a chance thing. He would still have known how to put the colors together to create a feeling. It's almost a spiritual thing. You can't teach someone to be an artist."

A Mendocino County native during World War II, Walter visited Hawaii as a crewman on the *USS Missouri* on her maiden voyage. In charge of the 40mm anti-aircraft batteries, he was still aboard for the 1945 surrender ceremonies. In 1967, he and Carol decided to move the family to the Hawaiian Islands.

They packed up what they needed, sold the rest, and were off. After a brief look at the islands of Oahu, Maui, and the Big Island of Hawaii, the Lassens settled on Maui. It appeared to Walter that the island was on the verge of major development. How right he was.

THE RYTHYM OF THE WAVES

Christian caught the first wave of his life during his second day on Maui. He learned to surf on the little reef waves that peeled off from the harbor's breakwater. Although years of practice in challenging surf would evolve him into a world-class surfer and one of the island's most respected athletes, that first wave will always stand alone in Christian's memory.

"I think every surfer remembers the first time he stood up on a wave and rode it to shore. It's such an unusual experience—standing on top of the water and having the water move you along, while riding the swell. I was hooked from that first wave. This was something I was going to pursue for the rest of my life. I was passionately and completely hooked."

Maui was a new world to the young Lassen brothers. Blue-eyed and blonde, they experienced the culture shock of being a minority. They were "haoles" in a small Hawaiian community, but the boys were both friendly and confident. Christian's creative gift meshed well with the artistic nature of the Polynesians. His meticulous work was fascinating to his classmates and new-found friends. "I got a lot of encouragement from the locals," he remembers. "They gave me emotional support right from the beginning."

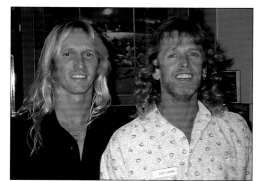

Christian and brother Ron in Lahaina, 1992. Photo by Natasha King.

Young Christian attended Kamehameha III Elementary School, a small public facility. Although the campus was no more than a few nondescript buildings, it sat gloriously on Lahaina's shoreline. The boys would dream as they watched perfect little waves break just a hundred yards away. The morning bus ride was a lopsided affair, as Christian and the other surfers crowded the ocean-view seats to inspect the swells. Most mornings there was time for him to grab his board (so secure was village life in those days that he left it on the breakwater overnight) and surf a few waves before the first period bell. He was not alone. He recalls, "During the Pledge of Allegiance, you could always tell who'd been surfing by the puddles of water under them." At the end of the school day, he'd make a beeline back to the breakers.

Christian with his father, Walter, and stepmother Dolores Lassen, at the United Nations in 1992. Photo by Peter Benoit.

In the eighth grade, his parents were called to the school for a conference. It was Christian's last year at Kamehameha, and the principal, vice-principal, and faculty expressed concern for the boy's future. They announced they were even considering expelling him. His crimes? Too much drawing and not enough interest in other studies.

"They told me all he ever did was doodle," Carol remembers. "I said, so what? He'll be a great artist some day. They disagreed, saying he'd never amount to anything because all he wanted to do was surf and draw."

But the young artist had already achieved his first commercial success, selling a T-shirt design of several dolphin to a local gift shop for fifty dollars. It was tremendously exciting and gratifying for Christian to see one of his drawings move into the public domain. By this time he had become the school's "artist-in-residence"; he was called on to submit drawings for the school newspaper, posters, and announcements on a regular basis.

So it was not surprising that pressure from teachers and administrators had little effect on his passion for art. He admits to working somewhat harder on his academic load for a while, but what he really wanted to do was draw, paint, and surf. The following year, as a freshman at Lahainaluna High School, Christian experimented with a more rebellious approach, cutting classes to surf, and often ignoring his studies. But eventually, he admits, "I just sort of wised up and figured, when in Rome, do as the Romans do, and things'll be a lot easier. I did that, and I began earning some respect from my teachers and the administrators, which in turn allowed me more time to develop my art."

Christian's teachers and administrators had become customers. Sketches of the campus' historic buildings—which include Hawaii's first print shop—and other Lahaina landmarks were especially popular. He also began to paint and sell seascapes—dramatic paintings of waves and Maui's beaches. This watery world was where he lived; where his experiences were concentrated, where he drew his energy.

FREE REIGN

Christian's art and his surfing developed at a similar pace. His paintings were selling at Bob Kelsey's art shop on Front Street for $25. He was committed to living life at its fullest, according to his own heart and conscience.

His teachers had accepted the inevitable. In his final semester at Lahainaluna, he carried one course of algebra and six art classes. "My teachers pretty much put me out to pasture. Essentially, they told me to go ahead and do my thing. So, on a typical day, I'd just go to the art room, painting and drawing all morning until the afternoon bell rang. Then I'd take my paintings down to the gallery and sell them."

He credits one of his art teachers, Robert Schumann, with helping to expand his basic drawing skills and techniques. The well stocked art room provided an ideal studio for the young artist to experiment and develop techniques for painting and drawing. Schumann allowed him free reign with the school's supplies, nurturing and encouraging him along the way. It was the ideal laboratory for Christian, enabling him to master perspective and other laws for making an object appear three-dimensional.

Left free to explore, expand his interests, and above all, master a style and technique that would effectively communicate his perceptions of the world, Christian worked extensively in watercolor, concentrating on views of different areas in Lahaina. This was his world, but increasingly, visitors from other places were coming here to see paradise. Many of them wanted to take a piece of that experience home. Christian's paintings captured the essence of that memory.

One of Lahaina's big attractions has always been the annual migration of humpback whales through the Pailolo Channel. Christian had already begun to focus his creative gift on the sea life around him.

"It was a natural progression for my art," he explains. "Every artist draws from what he's experienced, and I

WIND AND WAVES

While the Mala Wharf house was great for Christian as an artist, it was even better for him as a surfer. By 1981, a number of his friends were learning the newest sport on the island— windsurfing. While watching Maui's pioneer wave-sailors venture out into the surf at Ho'okipa Beach, he quickly saw the potential. Maui's waves are beautiful, but seasonal and inconsistent. More reliable are the winds that funnel through the low isthmus between East and West Maui, making Ho'okipa and the northern shore one of the world's best windsurfing arenas.

"Suddenly I was passionately drawn to the wind as I had always been to the surf," Christian admits. "Before I knew it, I was completely absorbed in this new sport that perfectly complemented my art and my surfing." Soon he was spending day after day on the island's north shore, at Kanaha, Spreckelsville, and Ho'okipa. The winds were stronger and steadier there than at Lahaina, the waves larger and more consistent.

As with surfing, Christian approached the sport of boardsailing as another art form. A difficult and challenging sport, mentally and physically, he studied, practiced, and persevered in the face of adversity. Soon, he was rivaling the best. By 1985 Christian had become one of the top boardsailors on the island,

pushing his limits with maneuvers like the now famous 360 degree 'helicopter' loop, performing the first such feat recorded on film. Christian found he was commuting so much, a home on the north shore was inevitable. He chose Spreckelsville, a small beach community tucked away between the Kanaha Ponds and the quaint, old village of Paia.

Spreckelsville was close to the wind and wave action, and an ideal place to paint. The challenge was finding a balance between the athlete and the artist. This was especially trying since both windsurfing and surfing are art forms in themselves, demanding huge amounts of time, energy, and strength to achieve a satisfying level of performance.

Ironically, Christian would first gain international recognition not for his artwork, but for his athletic ability. By the mid-eighties, he was exploding into aerial loops in dramatic television commercials for everything from Swatch watches to Quasar televisions, as well as being featured on billboards across Europe. He was a star surfer in magazines, movies, and advertisements. His many guest appearances on television included shows like *PM Magazine* and *The Extremists*. By 1992 he had graced over forty magazine covers, been the topic of thirty magazine articles, and appeared in eight films.

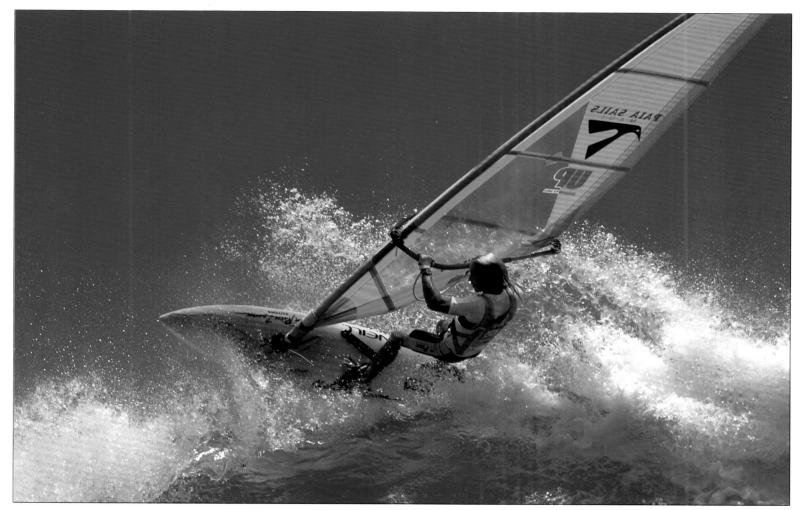

Leaping into the tropical skies off Maui's north shore. Ho'okipa Beach, 1988. Photo by Erik Aeder.

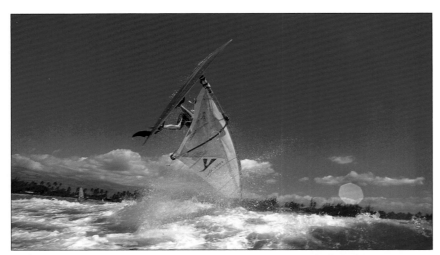

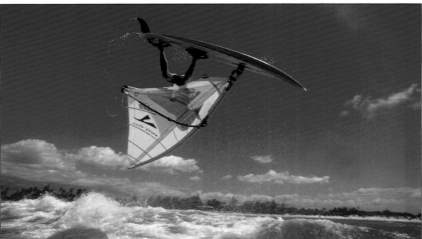

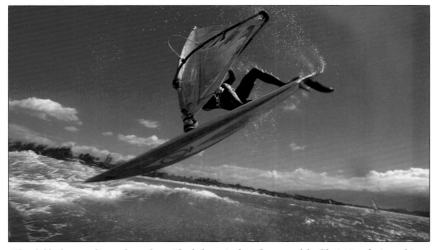

The 360-degree loop that electrified the windsurfing world: Christian brings his rig full circle off Spreckelsville on Maui's north shore, 1990. Photo by Erik Aeder.

THE BALANCE POINT

Maintaining excellence in so many arenas took a considerable force of will, but Christian found that one pursuit seemed to complement the other. Just as he was pushing the limits of physical performance in the sea, his paintings were becoming more refined and exploratory, requiring ever greater concentration.

"It took a great deal of discipline to focus," he says, "and to sustain growth in three areas. But I was so completely caught up in each that there was no letting go or slacking off. About this time, I was taking oils to a level I had never previously achieved. It was very

difficult because there are a limited number of hours in a day, and I have an absolute passion to do things well."

Already well known to Maui collectors and Hawaiian galleries as a seascape artist, Christian began to actively explore new styles and subjects. He did a series of impressionistic studies of the Kanaha ponds, near Spreckelsville [SEE PLATE 75] that led him to experiment with abstract, abstract-impressionism, pop, kineticism, and other avant-garde styles. Discovering his ability to communicate fluently through these varied approaches, Christian embarked on a path of diversity few artists can achieve.

The galleries that featured his works were not giving him the placement or compensation he deserved. He wanted to break free of the traditional artist/gallery relationship...to control his own destiny.

His mother remembers that time well: "It was when he painted the *Impressionistic Self-Portrait* in 1985 [PLATE 70]. I believe that was the turning point in his life. The day he finished, he was at his lowest point. He was so disappointed after learning he just couldn't rely on other people. They simply didn't believe in him as much as he believed in himself. 'Mom,' he told me, 'I'll do it myself.' From that day on, he took control of his life, realizing that only he was in control of his destiny."

Christian began to direct all his business activities personally. He was extremely interested in the popularization of his work, not for commercial gain, but to share his vital message of harmonious natural order. He launched his own publishing venture, Lassen Art Publications, in May of 1985. One year later he met Joná-Marie Price and immediately recognized her gift for the art of business.

"The moment I met Christian and saw his work, I thought, 'This is a man who can really make a difference in our environment!'" Ms. Price recalls. "And this was before environmentalism was politically correct or fashionable."

If there was such a thing as a natural-born entrepreneur, it was Joná-Marie Price. Her father, John Price, was a successful businessman and one-time Mayor of Park City, Utah, who actively encouraged independence, practicality, and self-reliance in his daughter. "He is still my role model, my pillar of strength, my idol," says Ms. Price, proudly. She acquired her first business license at age ten, for a flower stand. "I learned early on how to set up and service accounts, what side of the street to sit on, even what dress to wear."

By the time she and Christian met, all she needed to do was learn the business of art. "Christian spent a lot

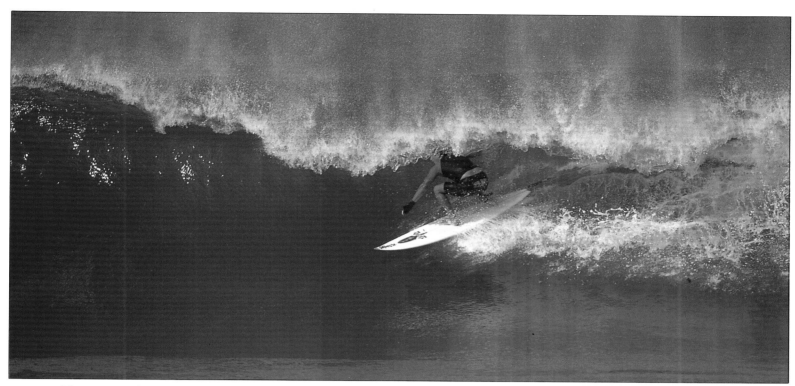

Time spent surfing is not subtracted from one's life. Christian going right at Puerto Escondido, Mexico, 1992. Photo by Dan Merkel.

of time with me," she recalls. "Hundreds, thousands of hours, teaching me everything I needed to know."

It was a perfect partnership: Christian, the detail person, the aesthetic eye, the creative visionary, the conjurer of meaningful illusion and Ms. Price, the savvy marketing mind, able organizer, and the true believer in the artist's vision. With Price to organize the business and implement his ideas, Christian could at last look forward to creating a momentum that would make his vision a global reality.

Even he was not prepared for the overwhelming success of his limited edition program. Beginning with his first series of images in 1985—*Our World* [PLATE 35], *Diamond Head Dawn* [PLATE 29], *Jewels of Maui* [PLATES 36 & 37], *Maui Colors* [PLATE 76], *Timeless Dance* [PLATE 99], *Bella Rosa* [PLATE 100], and *Maui Daybreak* [PLATE 2]—demand far outweighed supply, and prices were driven higher. Hand-signed and remarqued editions met with astounding success. To meet the demand for his work, a second series of limited edition graphics was released in 1986, followed by a third.

In Japan, where his ethereal visions were immediately perceived as windows into a more harmonious reality, demand could not be met. A virtual

Joná-Marie Price, much like the captain of a ship, navigates the future of Christian's work with a passion for excellence rarely found, 1990. Photo: Steve Brinkman

buying frenzy resulted, and in three short years, Christian became the best-selling artist in that country. One Japanese gallery spent millions of dollars to advertise a major showing of Lassen's works, then quickly realized a tenfold return in sales.

"The growth was astronomical from the beginning," relates Ms. Price, who has not been surprised by Christian's meteoric success. "He has brilliant marketing ideas, which is very unusual for an artist. Christian doesn't get lost in his emotional world, but actually uses those emotions to communicate. He's as creative with his marketing as he is with his painting. Here is a man who thinks like he paints—with no boundaries."

While hitting Japan like a tsunami, and sweeping the art community there off its feet, Lassen's work began to fly off the walls in Hawaii and the rest of the United States. The super-realistic and idealized worlds he portrays harken back to fundamental human values that recall Earth's intrinsic beauty and harmony.

In Japan, as in other parts of the world, wherever Christian's work was hung, it created a window to a better world. The pristine vision of nature in absolute clarity was more than a casual reminder of the damage wrought by human history. It was a vital mirror held up to the global insanity of our tampering with the very foundations of all life on this planet.

This vision is all the more powerful because it is positive. It gives identity, voice, and compelling hope to the possibility of realizing an achievable harmony and true peace on our planet.

NEXUS

An expression of the nexus between surfing, boardsailing, and painting, the central focus of Christian's work continued to be the sea and its ecosystem. As early as 1981 he began to experiment with the split-image view of the marine environment. This style allows the viewer to experience not only the fiery sunset and emerald mountains that are visible above the surface, but also the antics of a playful dolphin swimming through a world filled with color and grace below. Lassen's brilliant palette, masterful technique, and experiential authority quickly established him as the consummate marine artist in Hawaii and the world.

Driven to expand his personal understanding of psychology in the higher aquatic mammals, Christian arranged to spend private pool time with dolphin at Sea Life Park on Oahu, as well as at the Hyatt Regency Waikoloa on the Big Island of Hawaii. "I felt that I needed contact with these extremely intelligent creatures; to study their anatomy, certainly, but also to achieve a clear feeling for their unique senses. There was a genuine communion with the dolphin, and I've had ample opportunity to experience their unique presence. So now, when I'm painting them, I have a clearer understanding of what I'm trying to communicate; there is a self-awareness I'm trying to document, because it's really there."

The days spent swimming and diving with the dolphin have had a great effect on his work. "I've never seen an animal so in tune with its environment; the dolphin has reached a level of environmental harmony that greatly exceeds ours. I do a lot of dolphin paintings now—they're among my favorite subjects —because I feel I have an understanding of them. I've cradled them in my arms and been towed through the water, and made extended eye-to-eye contact with them. These are perhaps the most extraordinary creatures on the planet; they have much to teach us."

Maui's magnificent whales have been another favorite subject for Christian's brush. Frequently, he has seen them spouting nearby as he windsurfed near the coast. On one occasion, he was boardsailing through a large pod of whales when a breaching humpback exploded out of the water right next to him. When the whale plunged back into the surf just a few feet away, Christian was thrown from his sailboard.

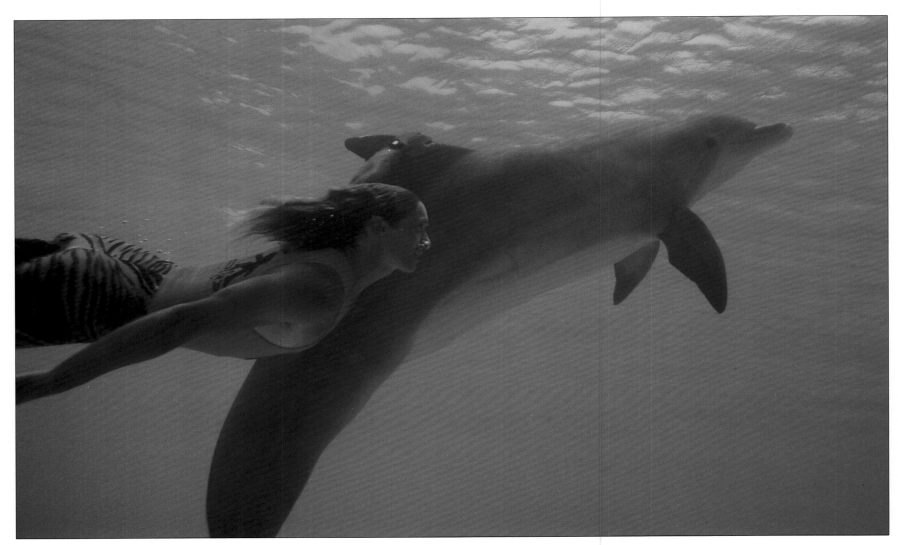

Long hours swimming and playing with captive dolphins has led Christian to a new level of understanding for the complex intelligence of these amazing creatures.
Sea Life Park, Oahu, 1989. Photo by Sun Star.

"My friends on the beach thought it had landed on me. It was heart-stopping—the enormity of it! The velocity and force of the water was incredible!"

The plight of these endangered giants—and of the dolphin—has become a deep concern for Christian. "The ocean was alive with whale songs for millennia," he states, "and now there is a very real danger that the oceans will be silenced due to man's interference. We must stop killing these highly evolved creatures. It is my avowed passion to use my art to influence governments not to allow the slaughter of these intelligent beings for food."

It is a sad irony that while the Japanese buy more of Christian's work than any other nation, they continue their damaging whaling practices. "The young people are aware of the problem and support change," Christian believes, "but the traditional business mind in Japan is still set on whaling. Hopefully my art will put pressure on their government to stop the hunting and killing of whales and dolphin. Because even today, after all the slaughter, these creatures remain our friends."

As the eighties progressed, Christian began to realize his growing compulsion to prevent the destruction of the sea and its creatures. His mission became increasingly clear. While he had long known his destiny as an artist, the next plateau of his personal evolution was clear: making the commitment to accept the responsibility his vision demanded of him. He plunged ahead, joining an international vanguard of conscience, calling for an immediate response to the worsening environmental crisis.

In 1990, driven by his personal conviction to do everything possible to preserve the ocean he loved and its creatures, Christian created the SeaVision Foundation, a non-profit organization dedicated to supporting environmental causes [see sidebar]. "The ocean has given so much to me,' the artist said in his founding comments, "I feel it is my obligation to give something back."

With the opening of Galerie Lassen on Lahaina's Front Street on July 14, 1991, the artist had created yet another vehicle for his message. The opening was a stunning development—one that had great impact on the art community in the Pacific Basin. Executed on a grand scale, the presentation of Lassen's art in this formal, yet highly-interactive environment was a multi-million dollar endeavor. The gallery exudes the same warmth and richness that is intrinsic to the images it presents. Its success was so phenomenal that it warranted the opening of a sister gallery at the opposite end of Front Street in 1992.

Christian with Japanese student leaders at a conference in Tokyo, 1991.

THE SEAVISION FOUNDATION

Inspired by the ocean and the aquatic creatures he loves, Christian Riese Lassen founded the SeaVision Foundation in 1990. His expressed intention: to support efforts to restore the quality of the Earth's waters and preserve the diverse species that inhabit the undersea realms.

"Through SeaVision," Christians states, "we're going to have a major, major impact." SeaVision's initial endeavors involved both charitable contributions and the production of environmentally-oriented television commercials featuring the artist's marine paintings.

Ten percent of Galerie Lassen's profits are donated to environmental groups—most prominently the Pacific Whale Foundation—who provide research and data for groups lobbying for legislative changes. To further those causes closest to his heart, Christian formed a partnership with that organization in 1991; the information it provides is a very powerful tool for restricting destructive fishing practices and pollution.

It is Christian's hope that eventually large corporations will join with SeaVision to enhance their environmental image, and thereby be won over to an alternate perspective. "Large corporations have enormous power, They can make a difference. Rather than create polarity between environmentalists and big business, I see us working together. We can do it."

SeaVision, Christian says, is a positive organization. "It's not a foundation that's out there brutalizing people with images of destroyed environments and animals. I want it to have a positive message—that the whale population has increased 35% over the last ten years, and so on. I want people to know that some things are changing; some things are getting better.

Eventually, Christian wants SeaVision to have its own team of environmentalists operating its own research vessels. They would be dispatched to critical areas around the world as needed, to provide research or other forms of assistance.

Ultimately, the foundation could have an even broader purpose. "This is not just to save the whales," comments Joná-Marie Price. "We've got situations all over the world that demand attention, though right now the ocean is the forefront of our efforts."

A further purpose of SeaVision, Christian acknowledges, is his own development as an artist. "Through them [the researchers he supports], I can do my part to help the creatures I'm painting, and I care very much about that. I can also learn more about them and further educate myself so I can educate others. In this way, my painting is helping to heal the Earth's environment."

The Christian Riese Lassen Aloha Foundation was created in 1991 to distribute funds for basic humanitarian aid to individuals in need. Directed by Carol Lassen, the foundation supports homeless shelters, aids pediatric homes, and provides beds and televisions for prison inmates.

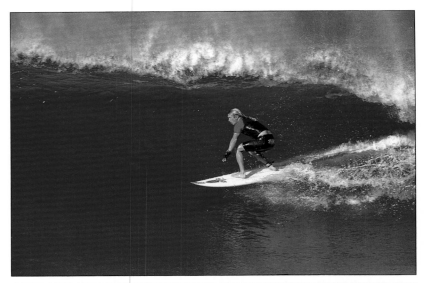

The Christian Riese Lassen Aloha Foundation was created in 1991 to distribute funds for basic humanitarian aid to individuals in need. Directed by Carol Lassen, the foundation supports homeless shelters, aids pediatric homes, and provides beds and televisions for prison inmates. Furthermore, the regular Friday evening gallery showings (Lahaina Town sponsors a 'Friday Night is Art Night' celebration on Front Street) serve as benefits for the SeaVision Foundation. The public has been enthusiastic in its support for this ongoing tradition.

The popularity of Christian's work attests to the magnetic draw of both his vision and power as an artist. All gallery collections are prodigiously successful, but they require the attention of the artist himself. With almost 100 employees (including his brother Ron, one of the gallery's top art consultants), Christian is often busy with the responsibilities of communicating his plans and decisions. When he is not painting or surfing, he is in almost constant contact with Ms. Price and other business associates. His is a relentless pace that requires tireless effort.

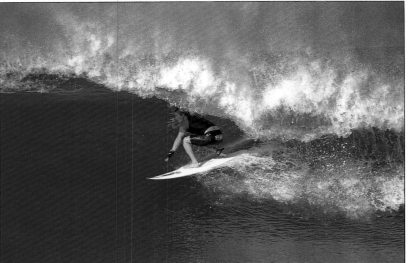

"As far as I'm concerned," states Ms. Price, "Christian and I work together 24 hours a day. He calls me at any hour of the night. We talk to each other at least twenty times a day regarding the conduct of business, the presentation of his work in the galleries, every minute detail that catches his attention."

INFLUENCE

It is a marvel that having assumed so much personal responsibility, Christian Riese Lassen has continued to generate and painstakingly create masterwork after masterwork. Extremely self-disciplined by nature, as interest in his work has escalated, Christian has organized his life to meet all responsibilities while still finding time to surf, sail, and enjoy life. Fortunately, painting is still the function he enjoys most.

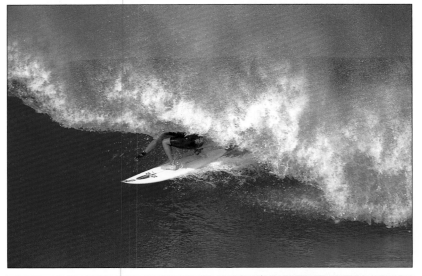

"My hope is to integrate my painting with the many activities, interests, and commitments that are vitally important to me." About doing so many things well without losing his artistic focus, Christian says, "It's an ongoing process. I'm continuously learning, pushing myself to find better and better ways to do things, improving my methods and techniques. I'm always sampling new concepts and technologies; experimentation is a major thread that runs through my work." And, he might add, his life. For Lassen is continually blending everything he learns into an accumulated body of experience which, in turn, becomes a fuller expression of who he is.

Direct personal experience is the engine that drives Christian's life and art. As his creative vision has expanded, so has his appetite for new impressions. In the eighties, he increasingly augmented his time on

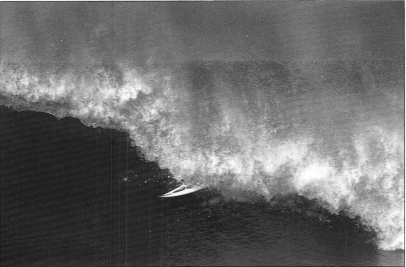

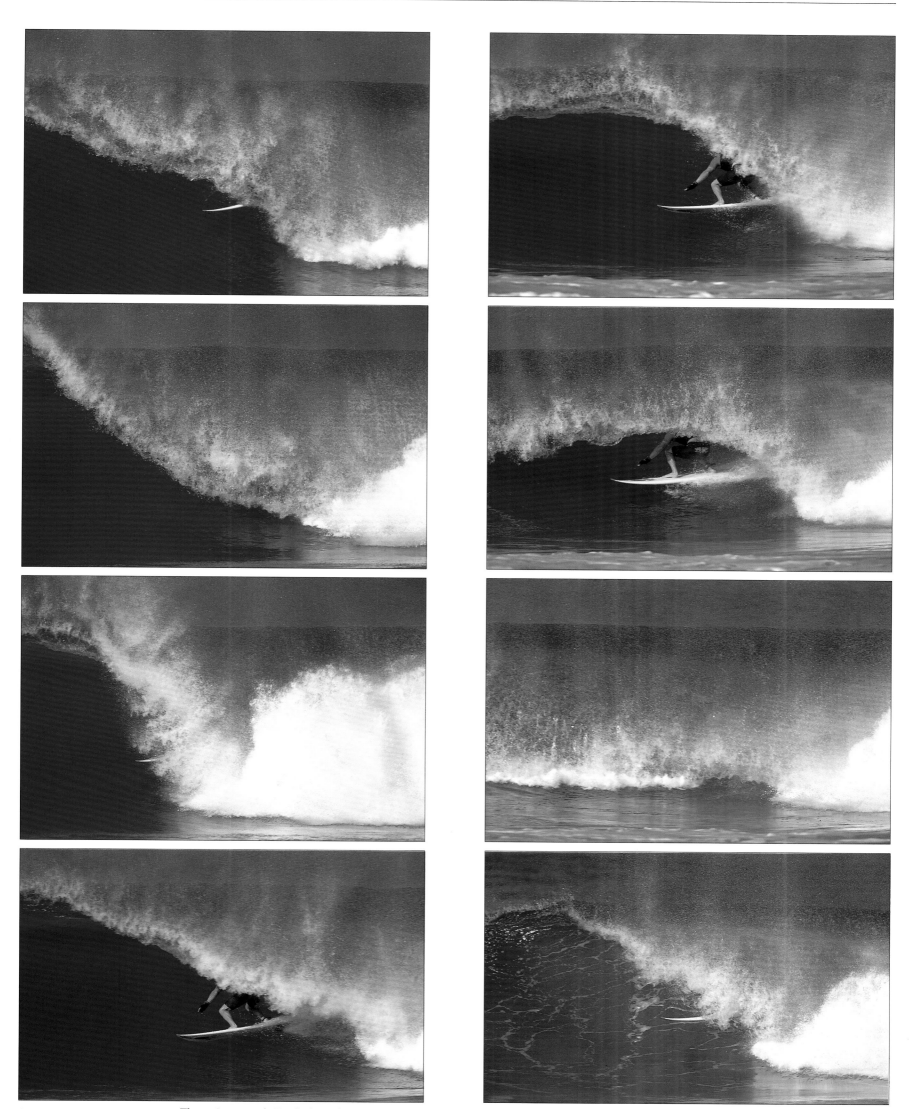

(sequence top to bottom, left to right) The artist at work "in the barrel" at Puerto Escondido, Mexico, 1992, proves that persistence and confidence pay off. Photos by Dan Merkel.

Galerie Lassen on Front Street is the jewel of Lahaina's galleries. The unique architecture and warm presentation complement the colorful and dynamic works on display.
Photo by Tomas DeSoto.

Maui with travels to other parts of the world—Australia, Tahiti, Fiji, Japan, Europe—often simply to surf and explore; often with canvas and palette in tow. In experiencing these stimulating new environments, he could absorb new information—new colors, textures, and understanding. His creative consciousness could be continually expanded. Each new experience added to his artistic vocabulary, giving him more to draw from, and allowing him to diversify his subjects, motifs, and styles.

When a trip to Europe at last brought Christian face to face with the original paintings of the European Masters displayed at the Louvre in Paris, the effect was seminal. Already attracted to the strong works of Monet, he was struck by the power of Vincent Van Gogh. "The color combinations were astounding," he recalls. "Van Gogh's paintings were so drenched in human emotions and suffering that they were like... raw feelings on canvas. Initially, I was very much taken aback by his work. I was also impressed by the technical expertise of Degas. In my opinion, he is unequalled in history for his ability to render nuance."

"Seeing the works of these masters brought on a whole new wave of painting for me. I felt deeply drawn to impressionism; devout study and practice taught me a whole new vocabulary of color. With impressionism, you're painting the essence of life. You capture your subject with fragments of pure color, catching reflections and weaving them together in a tapestry of light, form, and texture." The fever of inspiration that followed this first European journey is best represented in the painting *Maui Colors* [PLATE 76].

Although greatly inspired by the Old Masters, Christian has continued on the course that seemed a part of him from the very beginning. "There are really no outside influences driving me or my art," he states. "I feel self-propelled. There is this desire inside me to create, and I know that I was born to paint. What propels me as an artist is the desire to better express my feelings and perfect my skills."

He is remarkably confident in the fulfillment of his destiny as an artist, and not at all reluctant to make great efforts to bring his dream to fruition. "I've

always had a vision of where I want to be. I knew it was going to take a lot of hard work, effort, and perseverance to get there, but I was willing to make that sacrifice. People often told me it would be impossible—that I could never be a great artist—but my mother had instilled enough confidence in me that I wasn't affected by anyone's comments or their rejection. Nothing was going to stand in the way of achieving my goal, and I still feel that way today. I'm still jumping hurdles, striving to improve my art and become more successful."

Christian's goal as an artist is clear: to be a master; to achieve the levels of creativity attained by Cezanne, Van Gogh, and Monet. "I believe it will happen, eventually; I feel my art is evolving all the time. I've reached a level of worldwide recognition, but it's nowhere near where I want to be in the final analysis. On the other hand, I want to make an artistic contribution that has a significant and lasting impact, but that's not even in my mind when I paint. What drives me is a hunger to improve, learn new techniques, better express my emotions and feelings, and better translate these things into my work."

If the great artists have had an impact on Christian, it has been to stimulate the process of discovery and translation. "I paint in many different styles. Some approaches are very representational, others very non-representational. I think the representational images are more graphic, or illustrative; they don't convey emotion as much as document a specific reality. The non-representational works, the abstract and surreal, really convey my feelings. So I approach art on many different levels. I don't approach it simply as a recorder, although sometimes I am documenting what is in nature; at other times I'm translating my emotions onto canvas. I'm able to switch from one mode to the other depending on what I want to achieve at a particular time in my life."

THE MESSAGE AND THE MESSENGER

Today, Christian Riese Lassen is not only recognized as the world's premier marine painter, but also as an artist who has broken new ground in both traditional and avant-garde styles. He is the best-selling artist in Japan, and an icon of the Hawaiian Islands. Christian's kinetic work, Impact II [plate 83], was selected as the backdrop for the 1990 Doobie Brothers benefit for the Vietnam Veteran's Association at the Waikiki Shell. He was commissioned to create the art for the Honolulu Marathon poster in 1990. And, in a most significant honor, was selected to create an above-and-below marine painting, Sanctuary [plate 66], for the 1992 United Nations First Day Cover commemorating "ocean preservation".

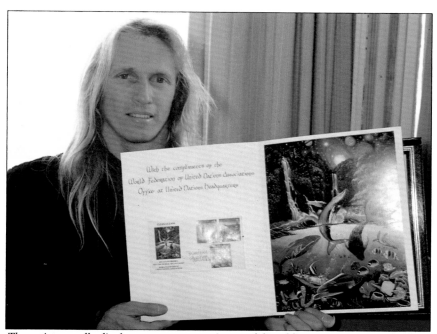

The artist proudly displays a commemorative portfolio of Sanctuary, *presented to him by the United Nations. The painting was created in 1992 for the UN's commemorative stamp calling for the preservation of the world's oceans. Photo by Peter Benoit.*

In Japan, Christian's influence is no longer confined to the art world. He has spoken to millions there about the need to preserve the ocean and its inhabitants. As a special speaker to an environmental convention at the Tokyo Dome in 1992, he addressed a crowd of over 40,000 people on the state of the oceans, and the environmental dangers of such practices as whaling, gill-netting, and industrial pollution. Countless magazines and television programs in Japan have interviewed him, and his message is always the same: "We have one world, and it shares a global economy. Japan has the unique opportunity to set a good environmental example for the rest of the world." Christian feels he is making a difference in that country: "The acceptance of my work proves

Christian, Joná and Weird Al Yankovich celebrating their thrill-seeking adventure —bungee jumping—in Daytona Beach, Florida, 1992.

Christian and rock superstar Michael Anthony of Van Halen, 1992. One of many celebrity collector's of Christian's work. Photo by Ron Lassen.

how interested these people are in salvaging our planet. The old mindset is changing."

Christian's hope—his mission—is to create change. "If I can affect people's thinking, or help fund some worthwhile environmental causes, that will be my greatest satisfaction at this time in my life. Years from now, my goals and desires might change. But right now I feel a responsibility, one that I'm blessed to be able to accomplish through my art. If my art helps to feed someone, or save a child's life—if it serves humanity and the environment—that's what I'm here to do."

Having trained himself diligently for over thirty years, Christian has created an ideal vehicle for his message. In this way he is unique among contemporary artists. "You can't generally characterize artists as messengers, because many of them aren't," Christian muses. "Artists have different personalities and consciences. Some of them don't care if there is a message in their work at all, which is fine. It's just another form of expression. I can only speak for myself. Given the attention my work is attracting around the world, I want to do something with it. I'm not saying every artist who reaches some level of notoriety should do that, but it's clearly something I need to do.

"I believe in my ability to do something through my art—act as a messenger—spreading the word about the destruction and deterioration of the global environment, and to help improve the way people view

each other and different cultures. I feel it is critically important to preserve the innumerable qualities of our Earth that are steadily being eroded away. This is my message."

Fortunately, that message is being heard. Lassen's works have moved to the forefront of collectibility. Celebrity purchasers inspired by Christian's vision and message include Robin Leach, who featured Christian on a Lifestyles of the Rich and Famous segment, David Rockefeller, Nikki Sixx of Motley Crüe, Steven Tyler of Aerosmith, Bon Jovi, Clint Black, Randy Travis, Ed McMahon, Robert Redford, Elton John, Chuck Norris, Donald Trump, and the Princess Dalal of Saudi Arabia. The 1992 triptych, *Ancient Rhythms* [PLATE 69], commissioned by Michael Anthony of Van Halen, has been heralded as Christian's finest marine work to date.

According to Ms. Price, the thousands of collectors who acquire Lassen's limited edition graphics don't buy them because they are in fashion: "I would say that 99% of these people don't buy the art for its collectibility. To them, I think, Christian's work represents fantasy...a magical escape."

Perhaps an aspect of the attraction is the magnetic ease of the artist himself—a calmness and clarity that resonates in his paintings. Christian Riese Lassen possesses a very balanced temperament that is truly rare in an artist. Perhaps it has something to do with the balance of his psychology—the left and right brain coordination—or possibly it is the underlying confidence in his own strength and validity as an artist. He's paid his dues; worked long and hard for

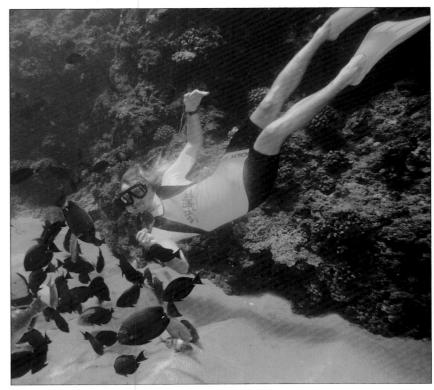

Snorkeling off the magnificent western shores of Maui, Christian is at one with the water and feels at home with his time spent there, 1992. Photo: Erik Aeder

many years developing his artistic skills and focusing that creative vision. But, inevitably, his is a confidence that comes from the power of his convictions.

"I believe it comes down to the fact that I care what's happening," he says. "The more I learn about the threats to the Earth's future, the more concerned I become; it drives me to do something about it. Our humanity is common to us all, so I believe that any individual expression one makes speaks to the mass of humanity. It is ironic that the more individu- alized the statement, the more people may be able to relate to it."

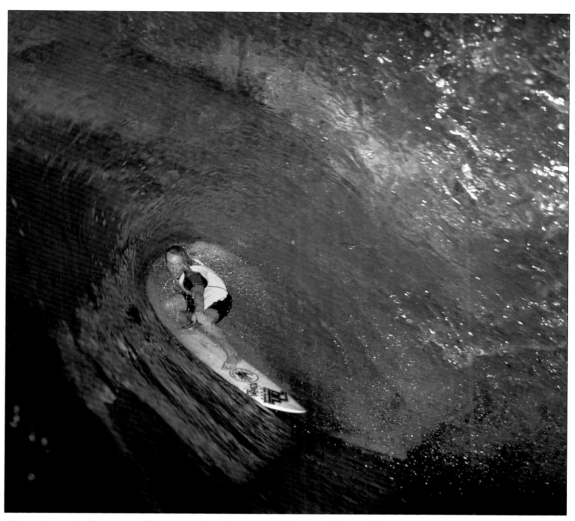

Commitment is the name of the game when it comes to doing anything well. "You must be willing to put yourself in situations that demand the best out of you." Christian puts it on the line, Tahiti, 1991. Photo by Sonny Miller.

A NIGHT IN THE LIFE

Lahaina has changed. It's no longer the small village it was in the sixties. "It's lost a lot of its local charm," Christian comments. "When I was growing up, Front Street was lined with grocery stores, hippie head-shops, surf shops, dive shops—'down-home' types of stores. This was once a quaint, rustic, charming town; it also had a pretty wild and woolly side to it. All that's gone now, but I still like Lahaina. There's still enough gravity to keep me here. I've been able to adapt to the changes, and I haven't lost hope for the future."

"Maui has become crowded, but it's the same all over the world. I think it is important that people get edu- cated about the environment, about taking personal responsibility, and learn how to create gardens in their backyards instead of dumps. I hope it's not too late to reverse the trends. I really, honestly, love peo- ple; the feedback I get just keeps me painting. I don't have any hard feelings about what's happening here. Maui is a beautiful place, and I can understand why people want to be a part of it."

Christian makes it a point to appear at the Friday evening shows in his galleries. He likes introducing his paintings to the crowds of collectors and admirers. They gather to watch his limousine pull up at the curb, hoping to catch a glimpse of the artist. The wind tussles his platinum-blonde hair as he steps out into the warm Lahaina night.

Adorned in black leather, Christian moves through the crowd, shaking hands and stopping to pose for photographs. This is clearly his element; talking with visitors and friends, sharing insights on the paintings, joking with the gallery staff. "It's very gratifying and exciting," he says, "to have this kind of following and interest in my work."

Christian seems a long way from where he started. But tomorrow he will surf the waves of Windmills or Honolua Bay that remain the center of his life—and a constant source of regeneration and affirmation.

Some may marvel at the good fortune, luck, and God- given gifts bestowed upon Christian Riese Lassen. They may be astonished by his sudden, meteoric rise to fame and success. Why, they may wonder, this particular artist?

The answer is evident in his paintings—those glori- ous images of light and energy. Here is an artist whose work lifts the veil of our negativity, allowing us to rediscover the natural, wondrous nature of life. Each painting is more than just a picture. As we view a canvas, we gaze upon the magical. The light of the artist's soul glimmers from each image, reflecting beauty, discipline, and consciousness. Here, we dis- cover the vision of Christian Riese Lassen.

EXPRESSION

"My career has been similar to Dali's... In that he started out with very traditional styles—very traditional subject matter and approaches to painting —but he became very individual and esoteric in his painting. I see that happening with my work."

— CHRISTIAN RIESE LASSEN

"My career has been
similar to Dali's...
In that he started out
with very traditional
styles—very traditional
subject matter and
approaches to painting
—but he became
very individual and
esoteric in his painting.
I see that happening
with my work."

— Christian Riese Lassen

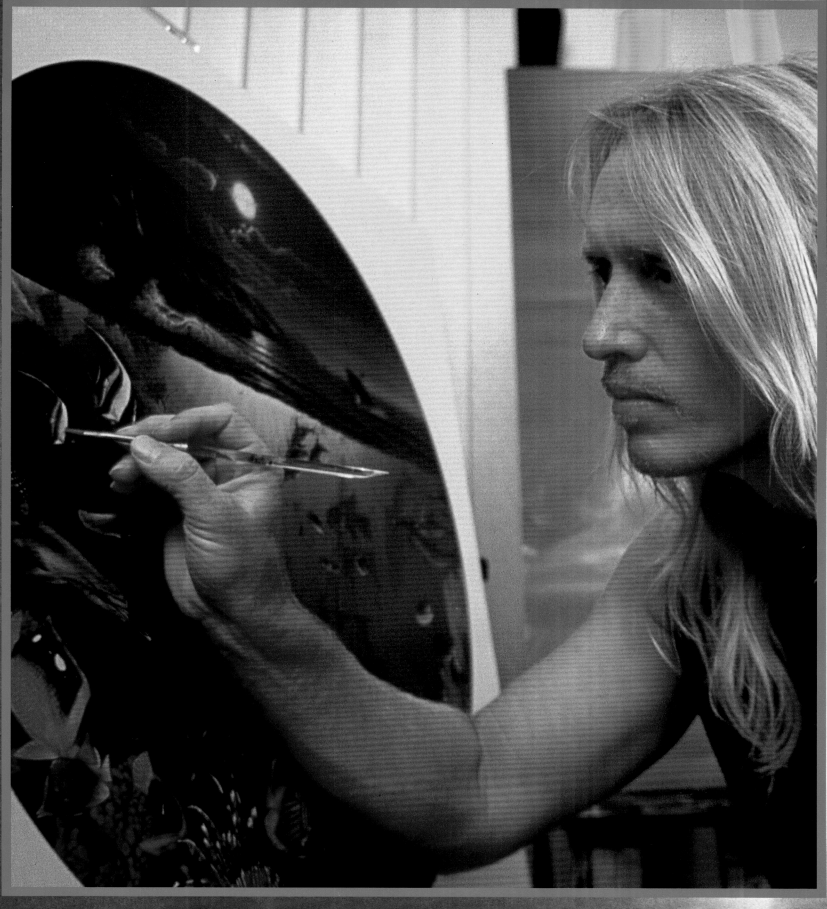

CRITIQUE

EXPRESSION

CHRISTIAN RIESE LASSEN'S reputation as the world's foremost marine and environmental artist is a topic few would debate. He has exhibited a mastery of these subjects that is recognizable to all; from the museum curator to the new collector. He is the creator of a collection of works so diverse, so exciting, that there is no single word capable of describing it. A clear case can be made for Christian's artistic brilliance without once referring to his paintings of the sea.

The artist's exploration of varied styles—abstract, pop, surrealism, kineticism, impressionism—has proven not only the flexibility of his skill, but also the fluidity of his vision. His uncanny grasp of both the structure and execution of a variety of techniques allows him to be as at home with a bold, 'kinetic' palette as he is with a softer, impressionistic approach.

Christian has demonstrated a remarkable ability to express himself in any medium or style. The traditional philosophy of viewing an artist's work chronologically to assess his development and track his career cannot be applied to the body of Christian's work. Throughout his life, he has been too much an individual to

'follow in the footsteps' of other artists. His approach has not been traditional, so how can a traditional measure be used? One must evaluate each painting for what it is: the artist's expression of a finite moment; the message he wanted to share in that one canvas and no other.

Lassen's earliest works were watercolors of Lahaina landmarks and realistic renderings of Maui seascapes. Some of his favorite subjects were found at his alma mater, historic Lahainaluna High School.

During the mid-'70s Christian was working primarily in acrylic, but by 1980, he was developing superb technique with other mediums, including oil, enamel, and gold leaf.

An excellent example of his ability with oil is the 1985 canvas, *Home Port II* [PLATE 4], his first painting of Lahaina Harbor. The scene is tranquil: in the lights of the little village one feels a sense of home. Over the harbor, moonbeams dance playfully atop the waters.

Christian can't remember a time when he wasn't fascinated by the dramatic lighting conditions found in nature, and he has continually strived to capture them in his marine works. An exception to this rule is the 1984 painting, *Spreckelsville* [PLATE 7], whose calm skies and softly rolling waves evoke a restful state in the viewer.

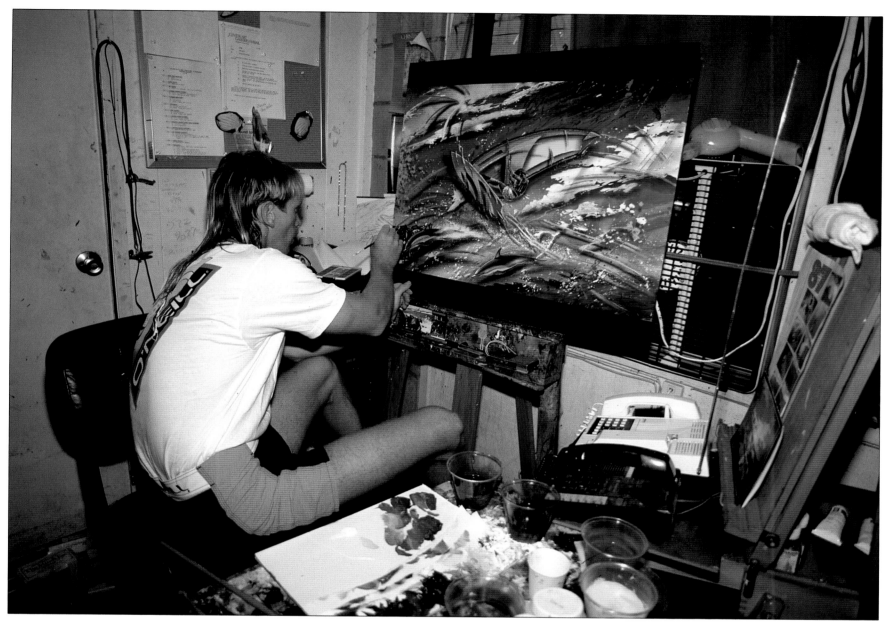

The artist in his Spreckelsville studio, circa 1986, putting the finishing touches on his kinetic work, Impact II. *Photo by Erik Aeder.*

Throughout the '70s, his paintings were sold either by the artist himself, or through the Bob Kelsey Gallery in Lahaina. Kelsey's customers were primarily tourists who wanted seascapes, images of Lahaina Town, and depictions of Hawaiian sea life. Christian used the standardized subjects as an opportunity, pushing himself to make each image better than the last.

During those years, Christian practiced and brought his layering technique to a high degree of perfection. "My first paintings were watercolors and acrylics," he says, "then I sort of graduated to oils. After a while, I was taking oils to a level where I was developing such involved techniques, it took me six or eight months to finish a painting. I did a lot of layering and glazing, refining techniques developed by the Old Masters."

Christian got so involved with intricacy and detail, he began to feel it was counter-productive: "I was working with such tiny brushes; it would take me three or four days to paint a single square inch of canvas."

He returned to acrylic in the mid-'80s, shifting his emphasis. "Instead of getting every possible aspect of an idea on canvas, I'd work to give the impression of that idea. The result had the same effect, but you couldn't look at it from three centimeters away and have it compare to what I was doing with the oils."

Christian stresses that communication is what he was after. If the impact of a painting becomes subordinate to the technique used to create it, the whole creative process is thrown out of balance. Returning to acrylic as a medium was liberating for him: "When you are expressing an idea, it really doesn't matter how detailed you get; being able to capture the effect or the concept is what's important."

Typically, Christian works in a series of increasingly intense stages. When an idea initially comes to mind, he will acknowledge it, but seldom take direct artistic action; more often he will let the idea develop subconsciously, returning to it again and again, over time. He may wait weeks, months, even years before he is

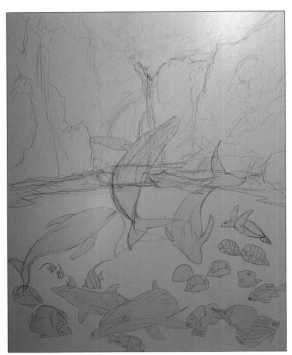

Preliminary sketches for the 1992 work, Sanctuary, *commissioned by the United Nations for a commemorative stamp calling for ocean preservation, already express the dynamic interplays of the final painting. Photo by Christian Riese Lassen.*

inspired to the next stage—a rough sketch. Once he's made that first sketch, he will usually begin the painting very soon thereafter: "Once I've sketched out a basic idea, it means I have a clear vision, and I'm pretty sure of what I'm going to paint."

Christian then selects the surface he will paint. He may choose the traditional canvas or panel, but he is also known to use Plexiglass. This relatively new medium is ideal for the artist's 'layered' paintings; its smoothness allows him to control the final texture of the painting. After preparing one of these mediums, Christian usually begins the process with an opaque base. He then applies increasingly transparent layers of paint. By using strong base colors—intense brights or moody darks—he is creating a platform for the work that follows.

"When you have a strong foundation of light and dark, you can build upon it with more translucent colors, and you have this powerful, structural foundation from which you can extract light or draw out darker tones."

For his marine works, Christian uses specific tools to get the look he wants. "I rarely use a palette knife; I've only done a couple of paintings with it. *Waikiki Nights* [PLATE 88] was done exclusively with the knife —it came out surprisingly well, but I just haven't felt the desire to spend a lot of time with the knife. Normally, I use brushes and airbrush. I like soft brushes; I don't use bristle brushes when I'm doing certain types of painting. With the idealistic or realistic images, I like to keep it really smooth, so I don't want a lot of tooth in the brush. For my impressionistic paintings, however, I'll use a bristle or stiffer brush so I can get a lot of texture in the paint."

To this day, Christian is still experimenting, and he frankly admits he has no idea what he'll be painting in six months. "My technique is changing and evolving all the time." Throughout the '70s and '80s, as his marine theme was developing, a casual visit to his studio would reveal several themes going at once. One might find an above-and-below triptych, an impressionistic work, a pop portrait, a kinetic sports

image, and perhaps another marine subject, all in various stages of completion.

Whatever theme or style he chooses, there is a marked continuity of quality, notably in the composition and technical execution. Christian has an innate capacity to capture the essential energy and force of a particular approach, conveying his vision masterfully. It is as if, when painting an impressionistic painting, he is exclusively an impressionistic painter. When working in the abstract, always an abstract painter. Each work possesses a clarity that is undisturbed by the peripheral activity in the artist's life. This kind of phenomenon is usually reserved for the artist who more clearly mixes media—the abstract painter who also creates metal sculpture, for example. To execute such distinctive expressions in the two- dimensional media of surface and pigment is most unique.

Christian generally paints every day, without regard for his moods, or the events in his life. "It doesn't matter what's going on, I just sit down and work. I've got a lot of discipline in that respect. In other areas, I am less disciplined. There are things that really appeal to me—I like surfing, windsurfing, painting, and spending time with a woman I really care about.

The evocative 1987 oil, *Blue Hana Moon* [PLATE 11], perhaps best reflects these interests. Balanced by the partially-silhouetted Polynesian woman and the brilliant full moon, the curling fan of wave is intricately rendered with a most articulate technique. The details of the wave face near the curl are especially exact and 'naturally' accurate. They belie the artist's intimate relationship with the waves.

In fact, the artist's dedicated involvement with the ocean is a continual source of energy and inspiration—one that has infused his God-given talents from an early age. So, while Christian has been broadly expressive, the clearest line of artistic evolution has been in his rendering of the ocean and its creatures.

OCEANIC VISIONS

He began with seascapes—secluded Hawaiian beaches with plunging surf and swaying palms *(see Maui Daybreak* [PLATE 2], *Purple Sunset* [PLATE 3], *Crimson Glow* [PLATE 6], *and Romance of the Sea* [PLATE 15]). These were the subjects through which he developed his command of the demanding 'glazing' technique of the Old Masters.

The early-'80s found Christian experimenting with above-and-below perspectives, an approach he had first seen in the paintings of Andrew Wyeth. This split-vision approach allowed the artist to make many of the emotional and conceptual connections he was striving to communicate.

Born in Paradise [PLATE 39], painted in 1986, illustrates the essential thrust of this new motif. The point of view of this circular oil is a reef off the West Maui Coast. A pod of whales frolicking in the afternoon sun share a spirit of intimacy while viewed from an unobtrusive distance. The lush coral reef sloping away in the foreground suggests the further depth and abundance of life in this world below.

Another 1986 oil, *Our World* [PLATE 25], creates an extraordinarily expansive feeling in an intensely-colored vertical format. A traditional seascape above contrasts with the bold and colorful marine life below. The underwater component, occupying almost two-thirds of the panel, conveys the artist's perspective that life in the sea is abundantly richer than life on the surface.

In 1987, Christian explored a unique circular approach to the above-and-below perspective with the two panel diptych, *Jewels of Maui* [PLATES 36 & 37], in which the airy above water view [I] contrasts strikingly with the scene below the surface [II]. The eloquent dolphin shapes link the two paintings into a complementary masterwork.

Maui Whale Symphony [PLATE 38], also completed in 1987, strikes a harmonious balance between migrating humpback whales and moonlit Lahaina Town. Rich purples create a poignant atmosphere that seems to complement the enveloping warmth of the sea and the cool night air. In this vertical work, the artist conveys an Eastern sense of divine clarity.

It is, perhaps, this sense of balance that emerges as the essence of Christian's above-and-below paintings. As viewers, we are suspended not only between two different worlds, but in that state of suspension, we are subliminally nourished by the artist's rich palette of form and color. Our consciousness is fed a lavish feast while our mind rests in harmonious balance. We sense an essence of greatness.

Christian considers the 1988 acrylic, *Circle of Life* [PLATE 62], one of his most successful marine-life paintings. Indeed, it is a gloriously colorful celebration of Earth's pristine natural state. Once again, the artist used the circular motif to emphasize his holistic vision of the planet's biosphere.

Another 1988 circular oil is *Maui Whale Song* [PLATE 28]. It is a tour de force in the 'glazing' technique that Christian has mastered so well. Intricate detail, complex layering, and an unusual interrelationship of perspective gives the work an intense dimensionality.

Eternal Rainbow Sea [PLATE 26] followed in 1989. The lush, tropical landscape was painted on the island of Kauai; the lower portion on Maui. It was the artist's first waterfall in an above-and-below painting, and very well received.

The wonderful horizontal acrylic, *Sea Vision* [PLATE 30], was painted that same year, and remains one of Christian's personal favorites. The overlay of the above-and-below views gives the piece an especially surreal appearance. Creating an effect similar to that of a photographic double-exposure, the artist's use of color is incredibly rich, and the details, impeccable.

In 1989, Christian Riese Lassen began to translate his increasingly cosmic and holistic world vision into his paintings. Initially, he did this by exaggerating the presence of stars, nebulae, planets, and other heavenly bodies in the sky (see *Lahaina Dreams* [PLATE 51] and *Genesis* [PLATE 54]), and by transporting the great sea creatures into an ocean of space *(Revelations* [PLATE 61]*)*.

By 1990, Christian was bringing the influence of planets and stars closer to the subjects of his paintings. In both *Dawn of the Dolphin* [PLATE 60] and *Mystic Places* [PLATE 68], the planets assume a disproportionate presence in the sky. This effect is even further

Working from found art, memory, and imagination, the artist employs a variety of tools (here it is the airbrush) to give birth to his vision of Sanctuary. *Photo by Drew Kampion.*

realized in the 1991 painting, *Eternity* [PLATE 64]. The celestial abstraction of the dolphin is born into glorious reality in the vertical acrylic, *Infinity* [PLATE 65].

Some time ago, Christian indicated that this would be his direction in the near future. The cosmological context of intelligence seemed like a logical direction in which to focus his talent.

"I'm getting more surrealistic, adding new dimensions to my work," he stated. "More cosmic and ethereal. I see my work moving toward a more spiritual plane. I think I've mastered the craft of painting to a level where I can accurately record something and make it look three-dimensional, make it look alive if it is a living thing, make a dolphin look like a dolphin, make a sunset look like a sunset...and give it intelligence and life. Now, the next level is to take that knowledge and go within, to conjure up more inspirational subjects, and for some reason that seems to be taking me into the heavens with my paintings."

"Dolphin floating in outer space tend to become more the essence of a dolphin. This is the message I see coming through my paintings—that my images are becoming the representations of spiritual ideas rather than simply a documentation of a particular animal or species. For instance, dolphin in space don't make any sense in physical terms but from a metaphysical standpoint; it's the idea that dolphin—like man—were born of spirit, of creation, of an inspiration, and having them in space seems to keep them eternally in that element, outside of time. In the eternal space of time, they become the very being of dolphin, the spiritual essence."

As an example, Christian cites the painting *Eternity*

The completed masterwork, Maui Gold, *integrates literal detail with fantastic imagery to evoke emotions of harmony and connectedness. Photo by Erik Aeder.*

[PLATE 64]. "To me, that painting represents the evolution of the spirit; of someone on the path to spiritual enlightenment; moving toward a seemingly distant horizon which may be only steps away, yet the traveler can't even see it.

This movement in Christian's artistic life —toward a deep and abiding reverence for the spirit in nature— seemed to culminate in the prolific outpouring of 1992. Literally dozens of paintings emerged from a thunderous creative cloud-

burst. Among them, *Children of the Stars* [PLATE 55], *Sanctuary* [PLATE 66], *In Another World* [PLATE 59], *Arctic Odyssey* [PLATE 58], and *Heaven* [PLATE 17]. These paintings are aglow with Christian's love of the Earth and its inhabitants.

A series of sea mammal portraits emerged along with these; *Family* [PLATE 50], *Friends* [PLATE 47], *Whale Song* [PLATE 44], and *Sea Flight* [PLATE 42]. The clear and profound evidence of sheer mastery is irrefutably presented in these works. Here, clearly, is a master at the peak of his powers. The voice is clear, resonant, vital, and even demanding—demanding that we see what is before our eyes...that which is reflected in the reality of the cosmic jewel: Earth.

LAST IMPRESSIONS

"He's an incredible impressionist," says Ric Iaconetti. "In fact, he's probably one of the best in the world. His impressionism is what appeals most to the serious art collector right now."

Painted in 1985, Christian's *Impressionistic Self-Portrait* [PLATE 70] boldly and honestly strips away the persona and allows the viewer to gaze directly upon the artist's soul. It is a powerful work that attests to Christian's fluency with the impressionistic vocabulary. Furthermore, its lack of restraint puts him at the fore of a small collection of artists who, over the last century, have had the courage to reveal themselves completely on canvas.

In general, Christian Riese Lassen is a profoundly evocative impressionist. His *Impressions of Maui* [PLATE 71], *Lin Wa* [PLATE 80], and *Maui Colors* [PLATE 76] render the traditional harborscape with superior veracity and intensity. *Koi Impressions* [PLATE 74], *Kanaha Pond* [PLATE 75], and *Maui Gardens* [PLATE 72] capture the essence, color, and fluidity of nature in three distinct, yet complementary, approaches.

Homage to Van Gogh [PLATE 73], is a wonderful image, and a compliment to the startling effect the work of the master had on Christian. The latter's comprehension of the energy of the former is most pronounced in this work.

The two 1987 oils—*Twin Falls* [PLATE 77] and *Hana Coast* [PLATE 78]—were an experiment in texture, yet they are so exceptionally effective, they stand alone as masterworks of a unique and exciting nature.

KINETIC DYNAMICS

In his 'kinetic' images, Christian vents the artistic energy and ferocity that are so restrained in his more formal paintings. The excitement and motion of *Impact II* [PLATE 83], are a complete departure from the euphoric calm of *Blue Hana Moon* [PLATE 11], yet

each draw on the artist's experiences and display facets of his personality.

Christian's ability to bring life to virtually any subject is evidenced in his kinetic works. In *Power Drive* [PLATE 85], *Triple Crown* [PLATE 82], and *Windward Passage* [PLATE 86], he deals with three different subjects in a theme—golf, surfing, and sailing. The use of bold, colorful strokes and three-dimensional accents that appear to float above the canvas create a medium of virtual space in which the protagonists execute their dramatic efforts in a manner that is individual and distinctive. The medium is the message.

POP ART

"The contemporary art movement is so fractured," Christian says. "There are so many facets, and no cohesive school that is dominating the artistic landscape. It changes month-to-month with each issue of *ArtNews*—there's a new direction in art, and it dilutes its central core. It's not as if we have any strong movement happening right now. No impressionistic movement, Renaissance movement, or even strong abstract-impressionism. I see it as very specialized; people are being very free with their expressions. The walls and barriers society once placed on artists have been broken down, and anything goes. Literally, anything can be labeled as art. The commercialization of the industry has made the artist focus more on the money he can make from his works, rather than in actually creating them in an environment free from that kind of outside influence."

In that sense, Christian's pop paintings are at once contemporary parodies of very glitzy, highly-saleable, trendy subjects, and extraordinary jewels of exquisite color and technical control. He mocks the saccharin by surpassing it.

His *Four Marilyns* [PLATE 89] resonates with energy and innuendo, speaking in tongues that echo—but never duplicate—themselves. *Charlie Chaplin x 2* [PLATE 96] uses color to draw us forward, then push us back. The poignant sense that humor and sorrow are just a breath apart is palpable. The result is dynamic.

MYTHICAL ABSTRACT

"The art world is in a state of flux and confusion," Ric Iaconetti points out. "What to collect? What is contemporary art? No one has really stepped forth to define a new movement, and I think Christian, given the right environment, will do that. I think he will be able to step forward and create a look that will, in time, lead him to historical significance. What sets him apart from other artists is his mastery of detail, use of color, and the luminescent

The artist regularly signs and remarques his limited edition fine-art prints at his galleries. The occasion here is a regular Friday evening signing benefit for the SeaVision Foundation in Lahaina, 1992. Photo by Drew Kampion.

quality of his paintings. All of his works reflect that. Every style he has mastered, and those he has created, will someday define the 'new look.' When he does, it will become 'Lassenism,' or whatever the historians call it. But he will define a period. It will come. It will happen. And, when it does, Christian will clearly emerge as the premier artist of his generation."

Certainly, there are many talented artists in the world today. Certainly, there are many creative souls tuned to the rhythms of time and place. But nowhere, it seems, is there another artist who has so precisely captured the psychic and spiritual needs of our planet.

Christian Riese Lassen is an artist for our times...one gifted in a variety of vocabularies, each tuned to a particular vibration; vital to the transmission of an entire message. And that message is about our world, the relationship between its creatures and ourselves, and the spiritual seed that lies within each one of us.

Ultimately, Lassenism—should such a thing come to pass—will be about life, hope, and a consciousness of where we are in the great scheme of things. Christian Riese Lassen's message of hope will continue to unfold as his extraordinary life plays on.

REVELATION

The art of Christian Riese Lassen is about lifting the veil of our negativity to reveal the natural glory of life and its infinite diversity of expression. The concentrated effort, discipline, and awareness in each painting comes from a clear and lifelong vision of a world that is at once before our eyes, yet mysteriously and tragically hidden.

The art of Christian Riese
Lassen is about lifting the veil
of our negativity to reveal the
natural glory of life and its
infinite diversity of expression.
The concentrated effort,
discipline, and awareness
in each painting comes
from a clear and lifelong
vision of a world that is
at once before our eyes,
yet mysteriously and
tragically hidden.

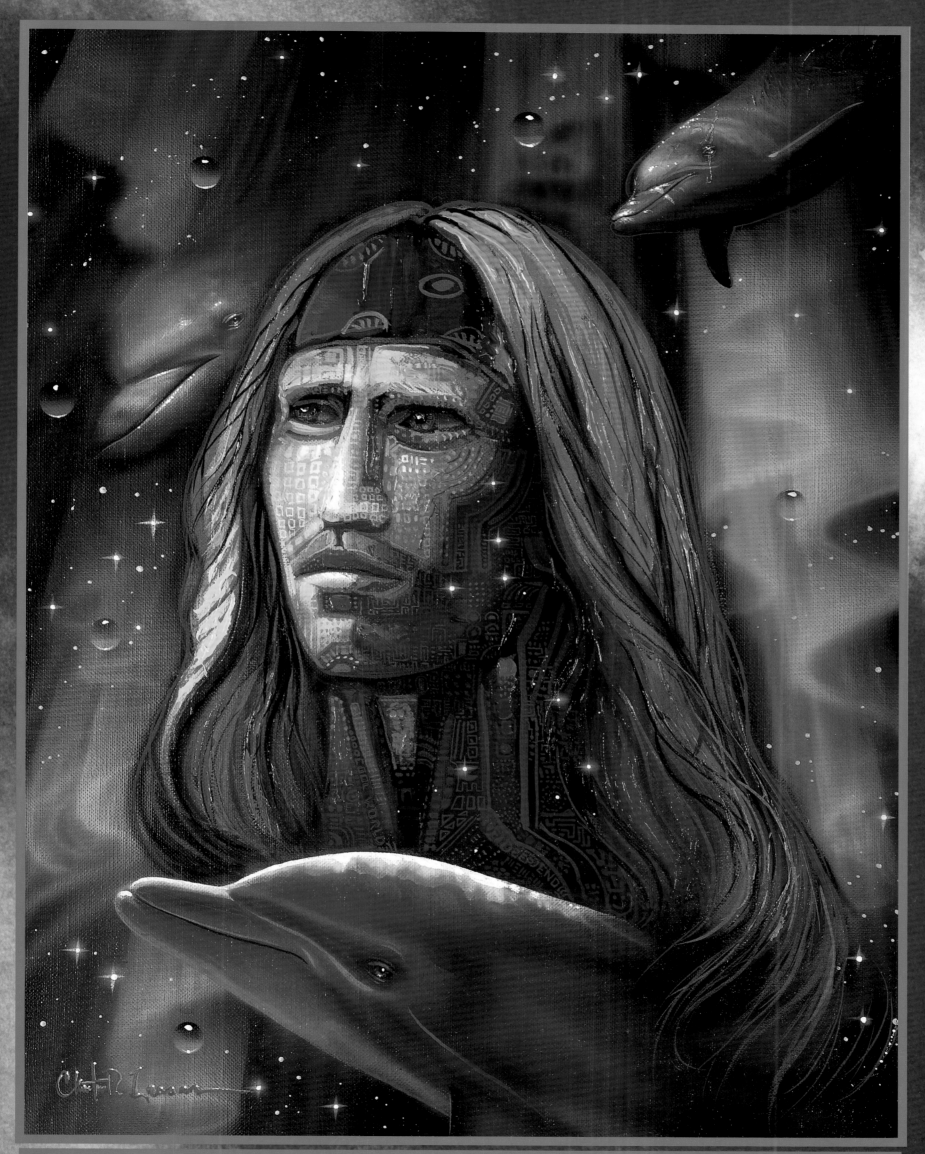

PLATE I • **SELF-PORTRAIT**

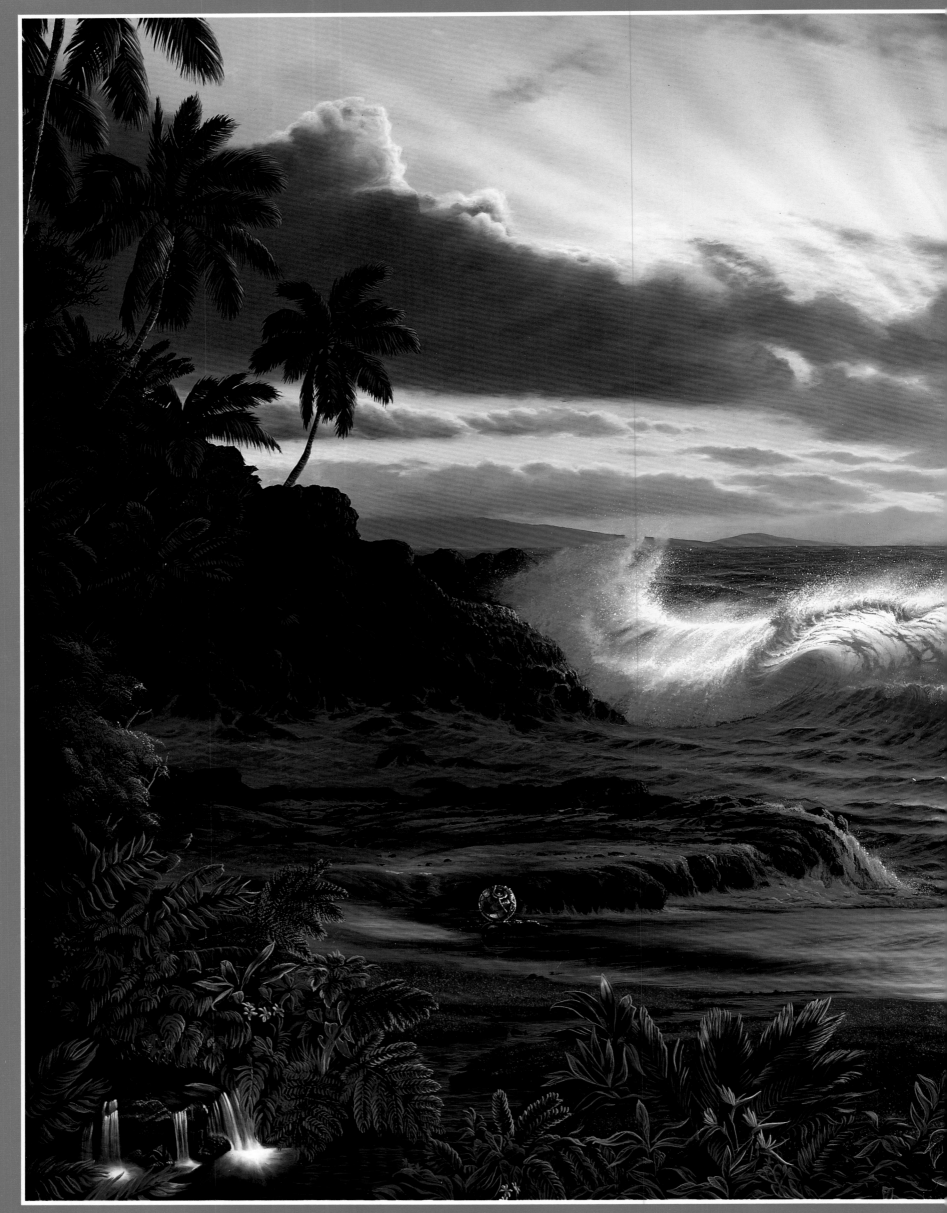

PLATE 2 ◆ MAUI DAYBREAK

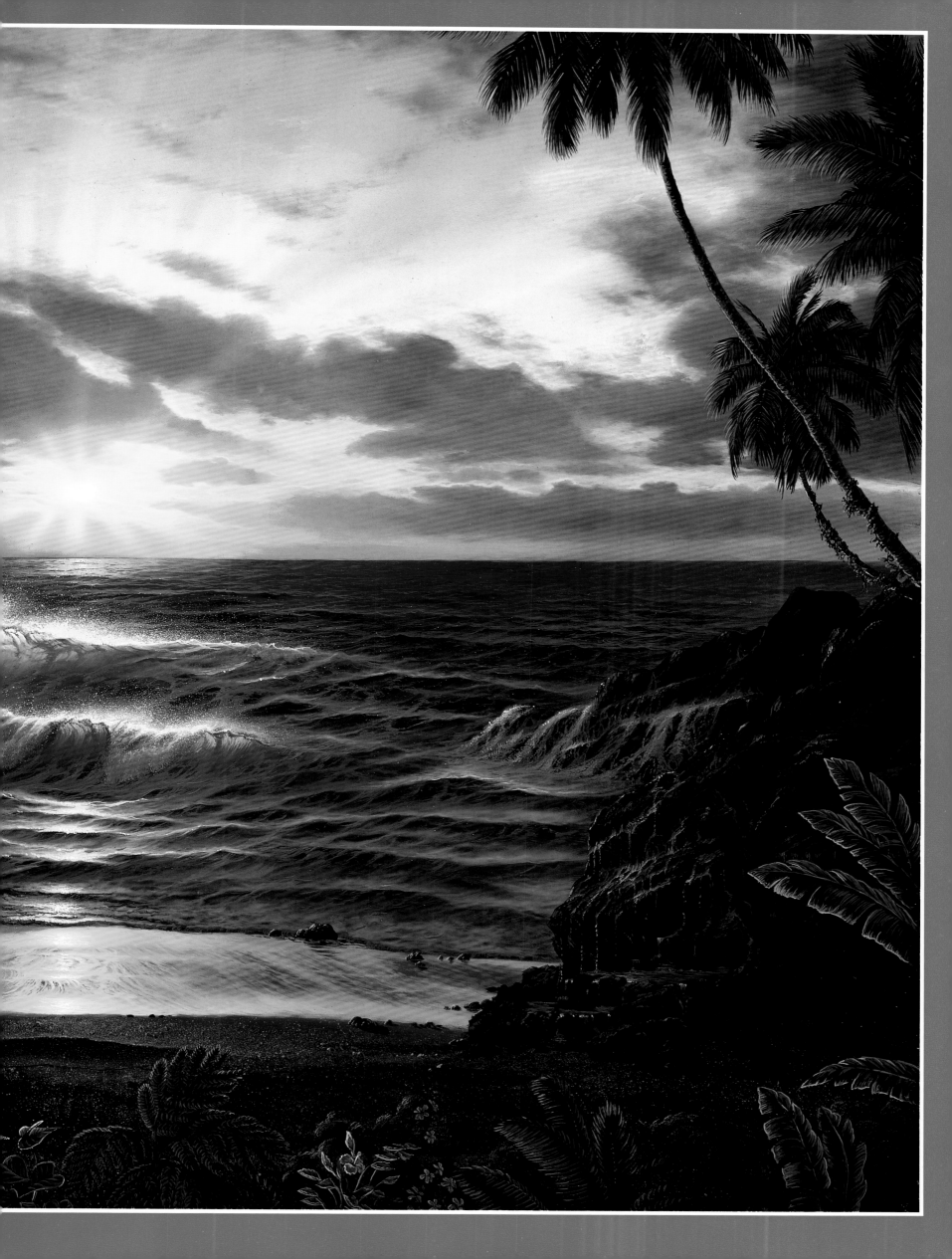

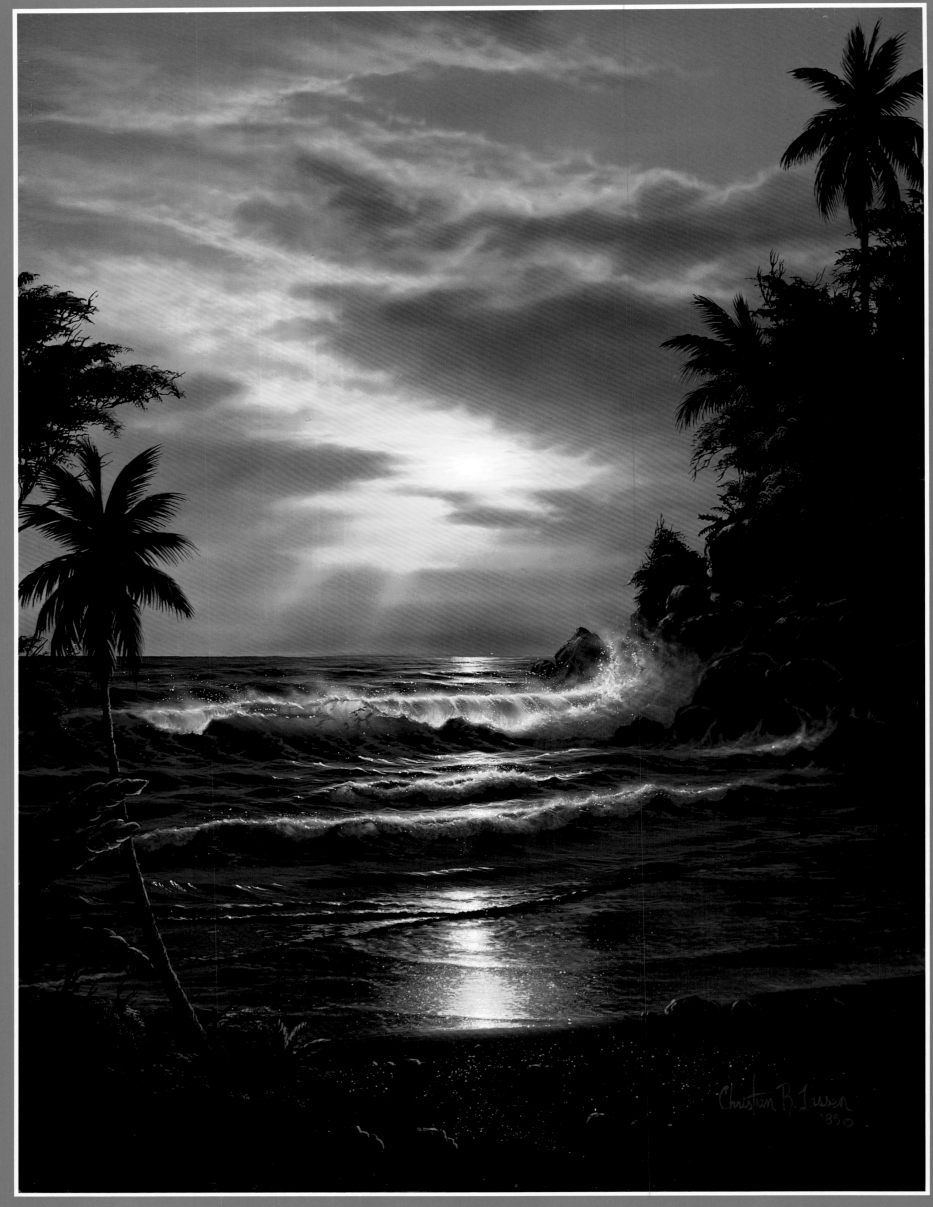

PLATE 3 • **PURPLE SUNSET**

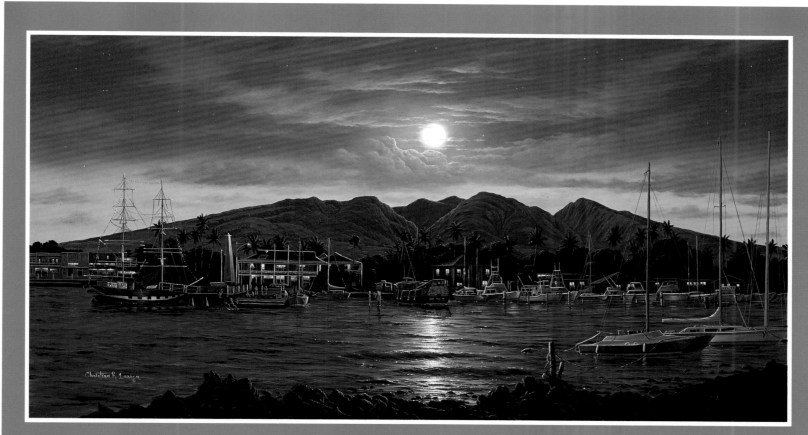

PLATE 4 • **HOME PORT II**

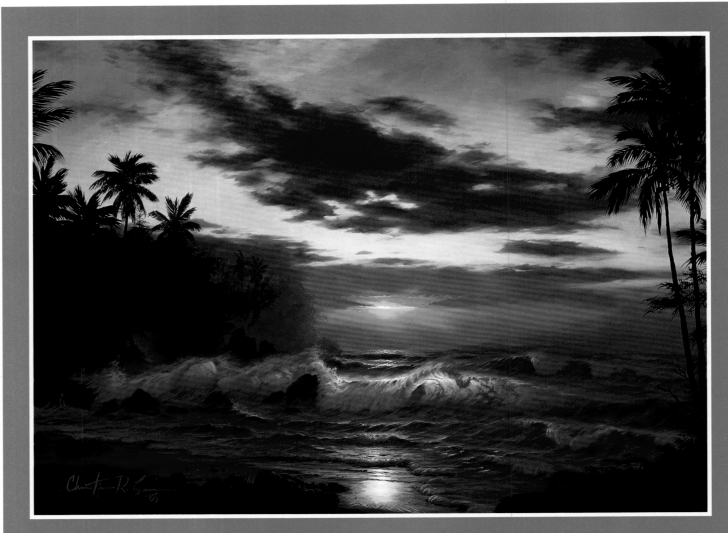

PLATE 5 ✦ **AFTER THE STORM**

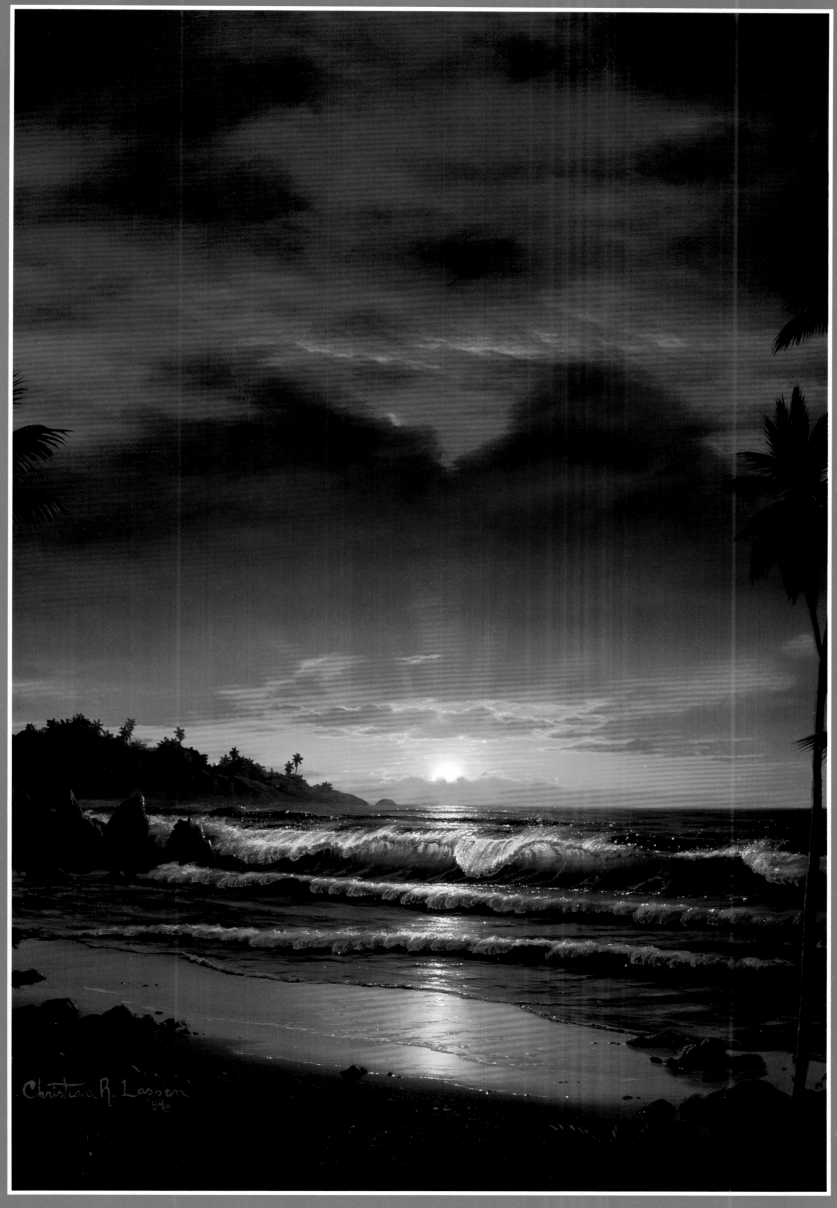

PLATE 6 ♦ **CRIMSON GLOW**

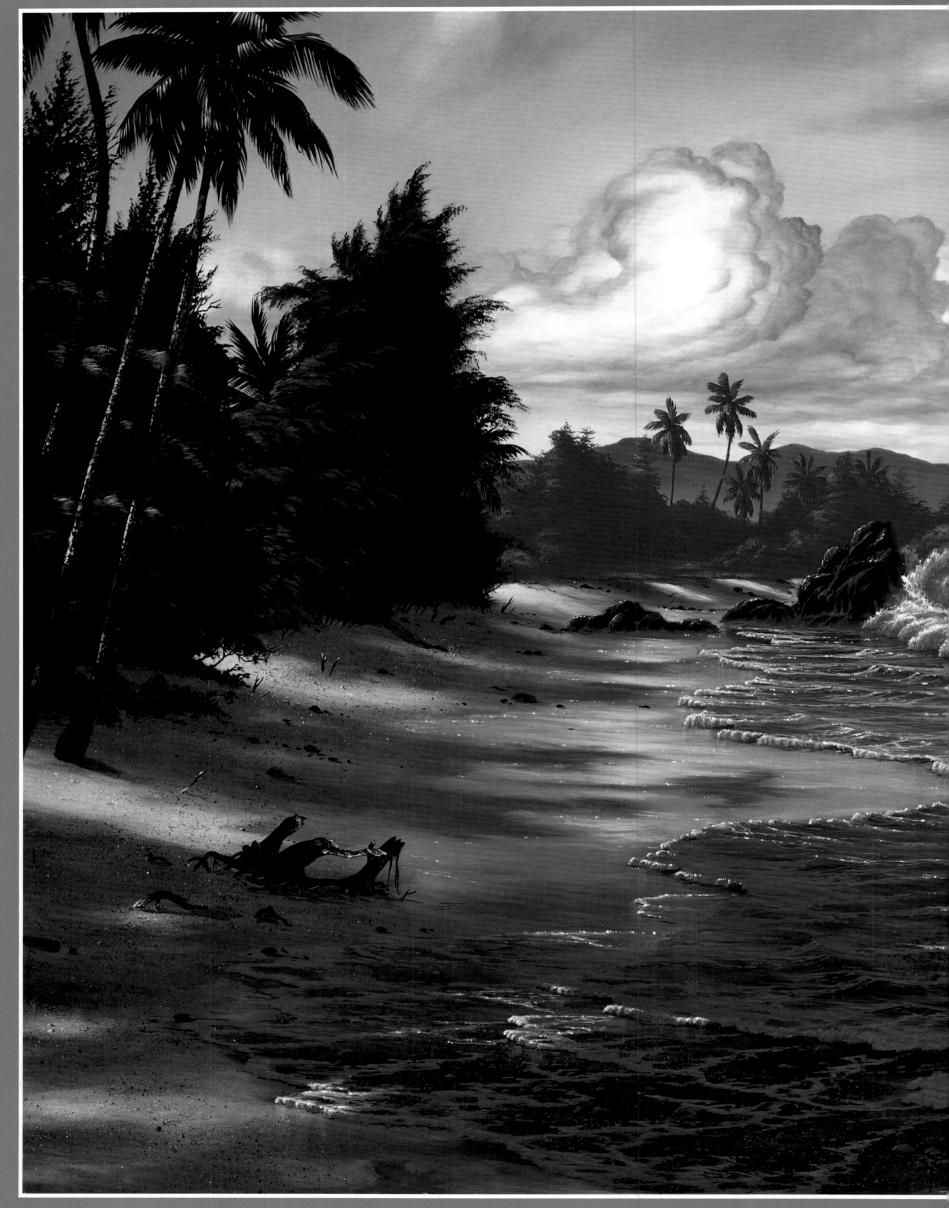

PLATE 7 • **SPRECKELSVILLE**

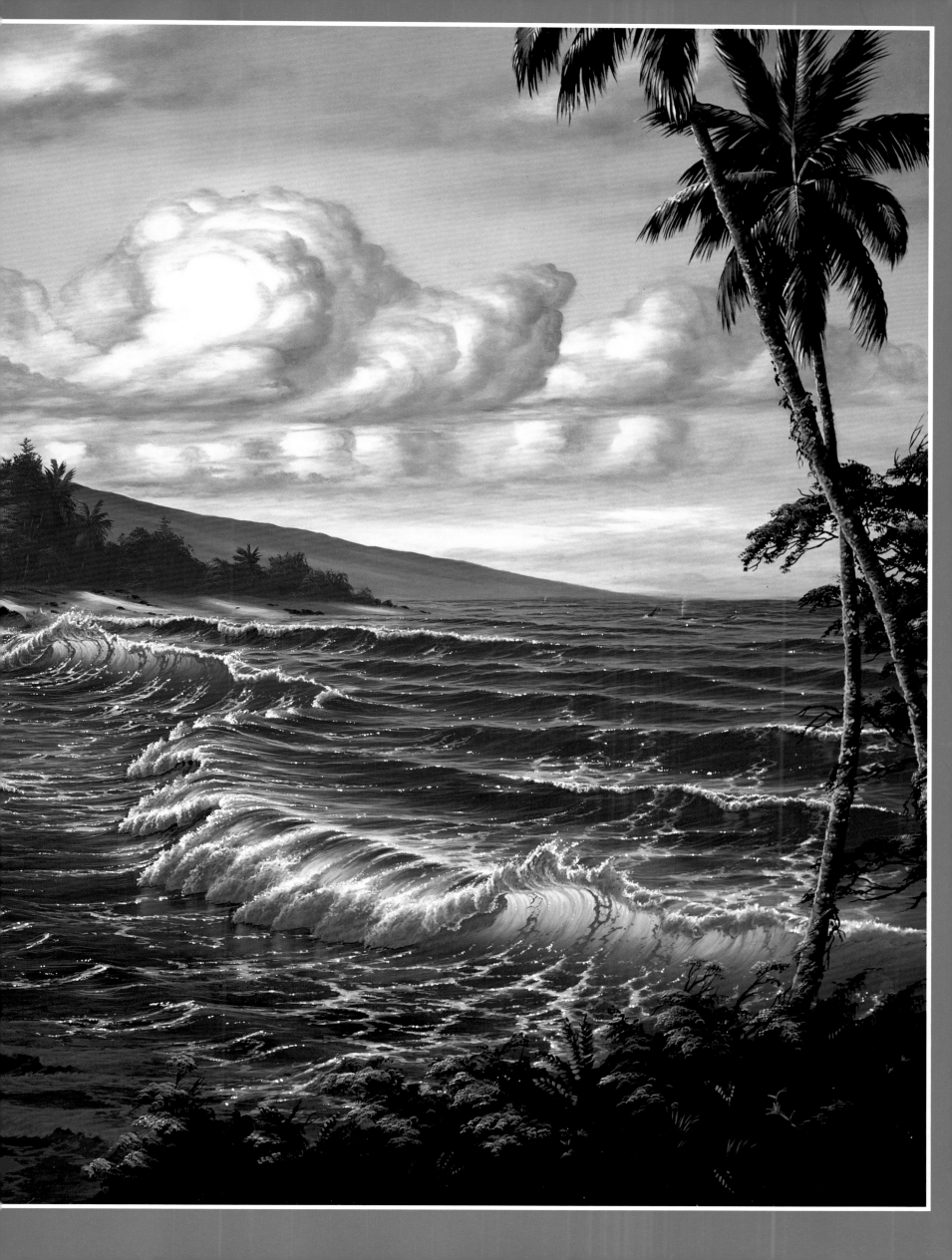

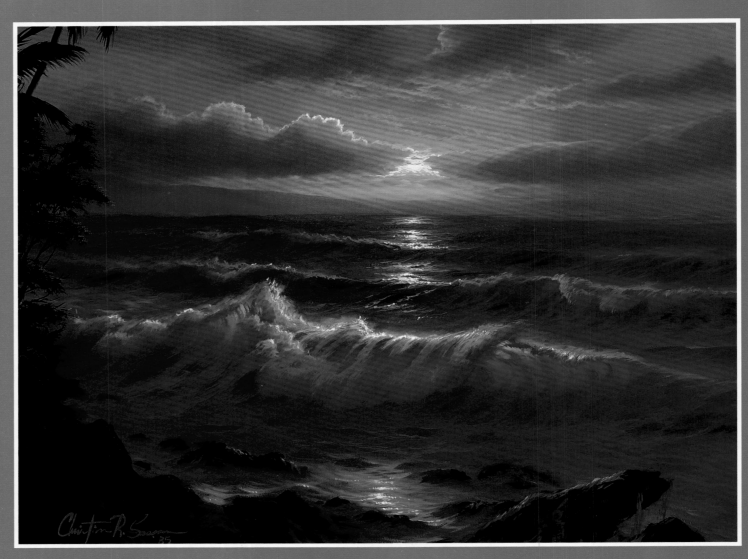

PLATE 8 • TROPICAL EVE

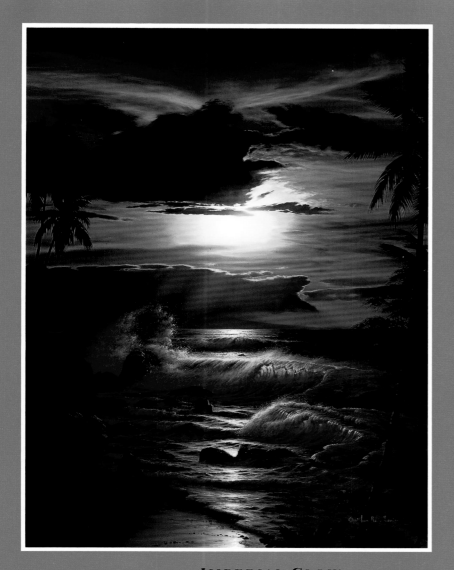

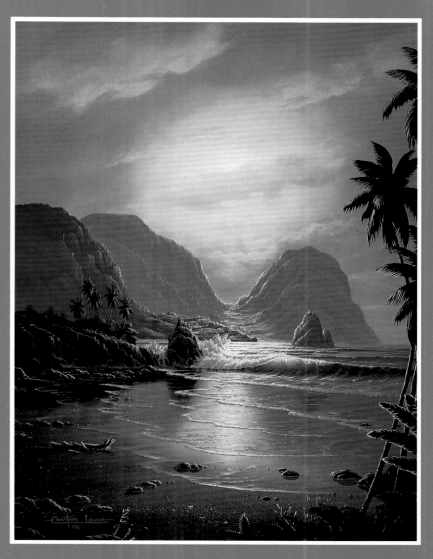

PLATE 9 ◆ **IMPERIAL GLOW** PLATE 10 ◆ **MOLOKAI ENCHANTMENT**

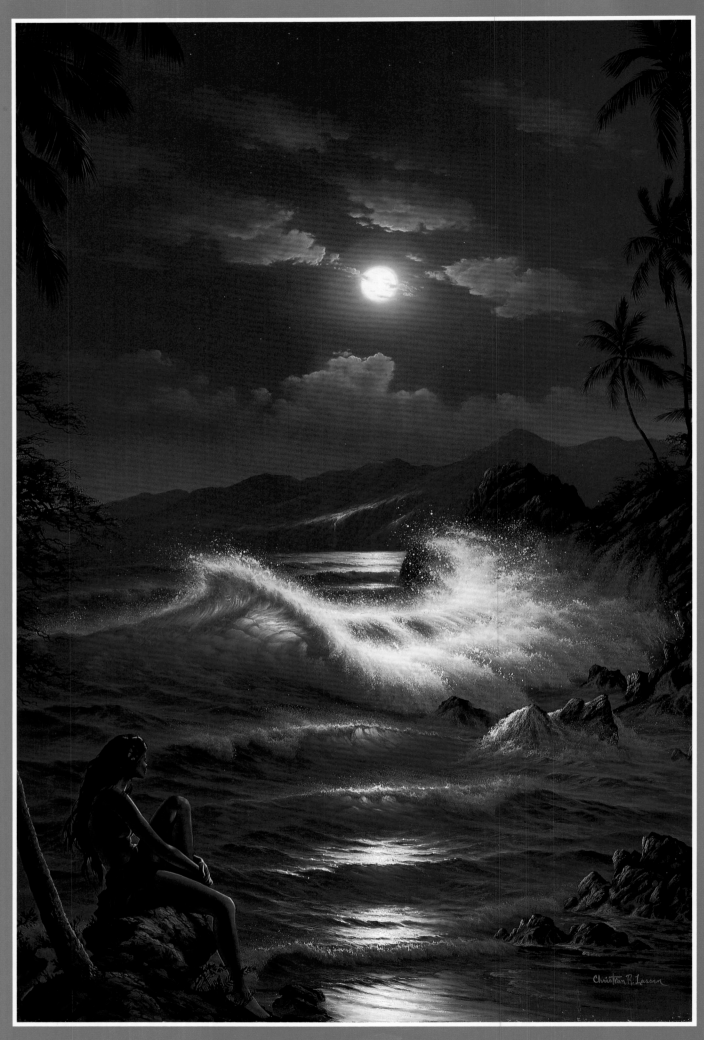

PLATE 11 ◆ **BLUE HANA MOON**

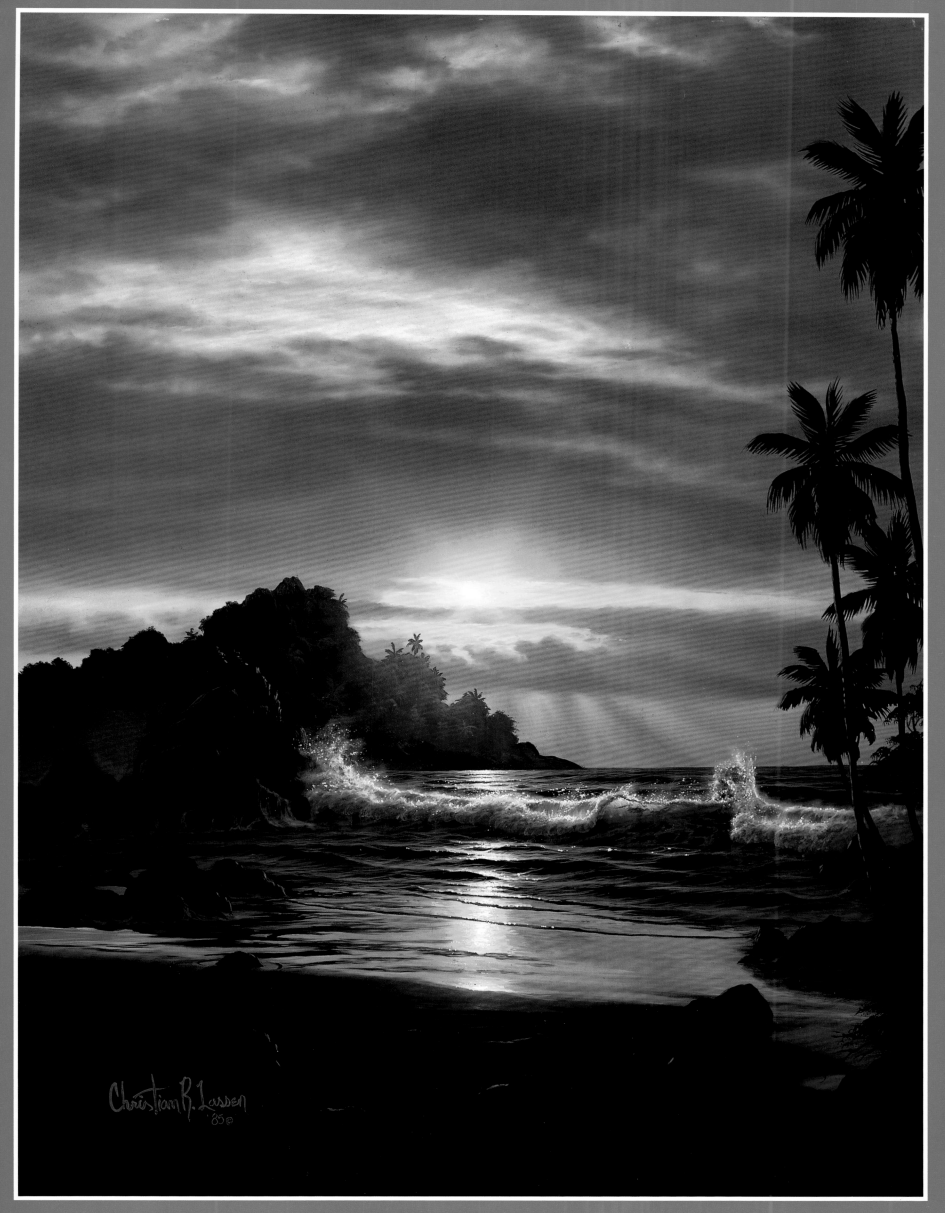

PLATE 12 ◆ **TROPICAL DUSK**

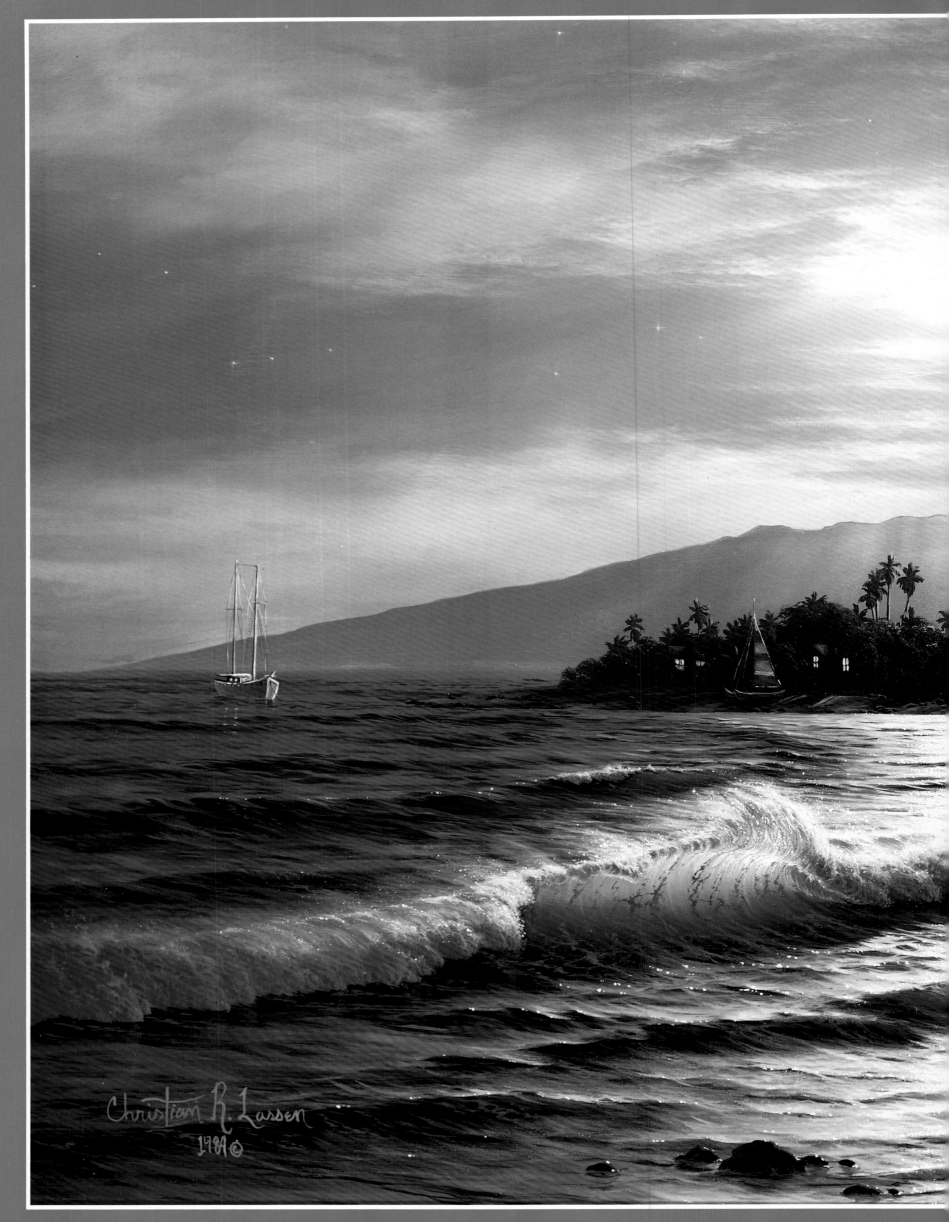

PLATE 13 • **PEACEFUL LAHAINA EVE**

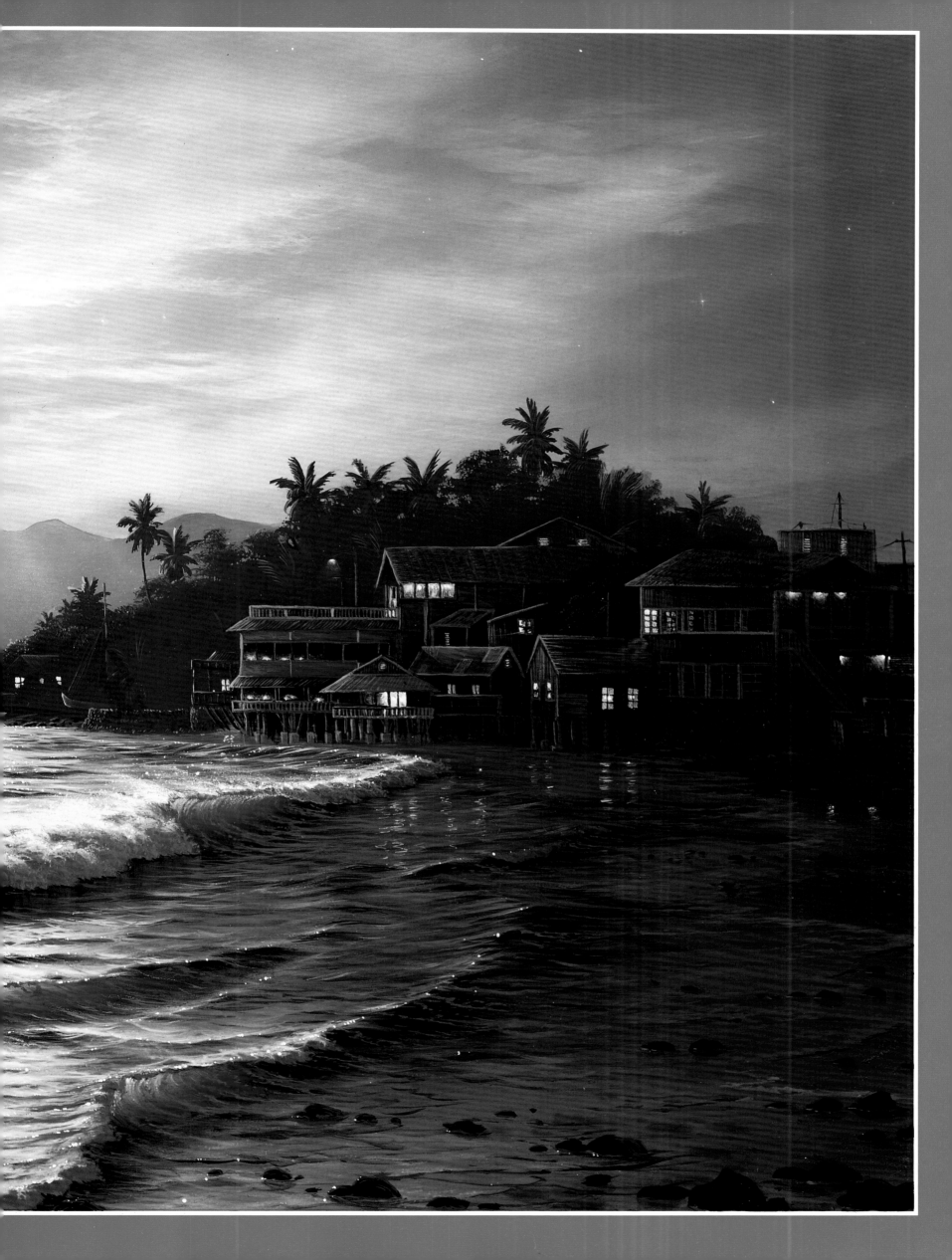

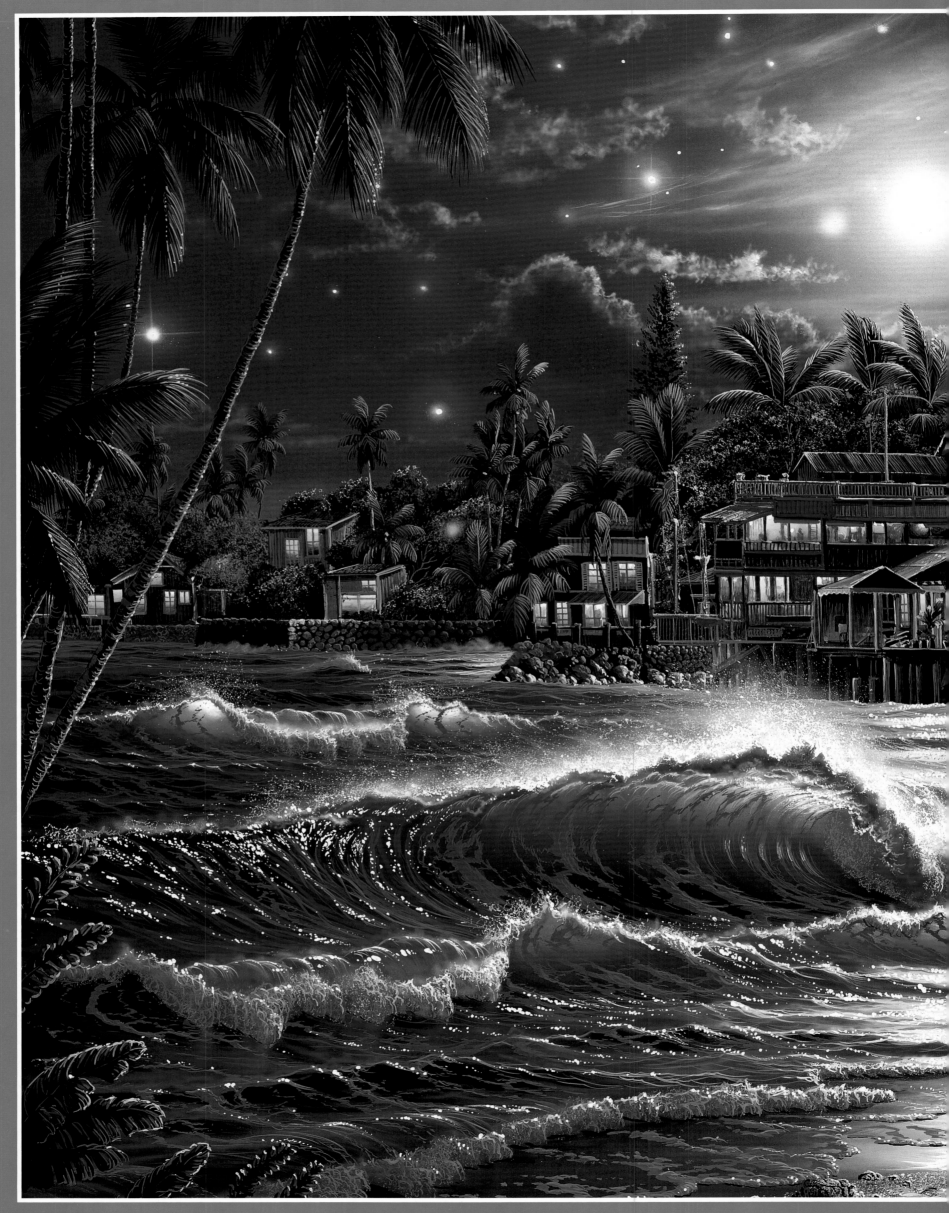

PLATE 14 ◆ **LAHAINA STARLIGHT II**

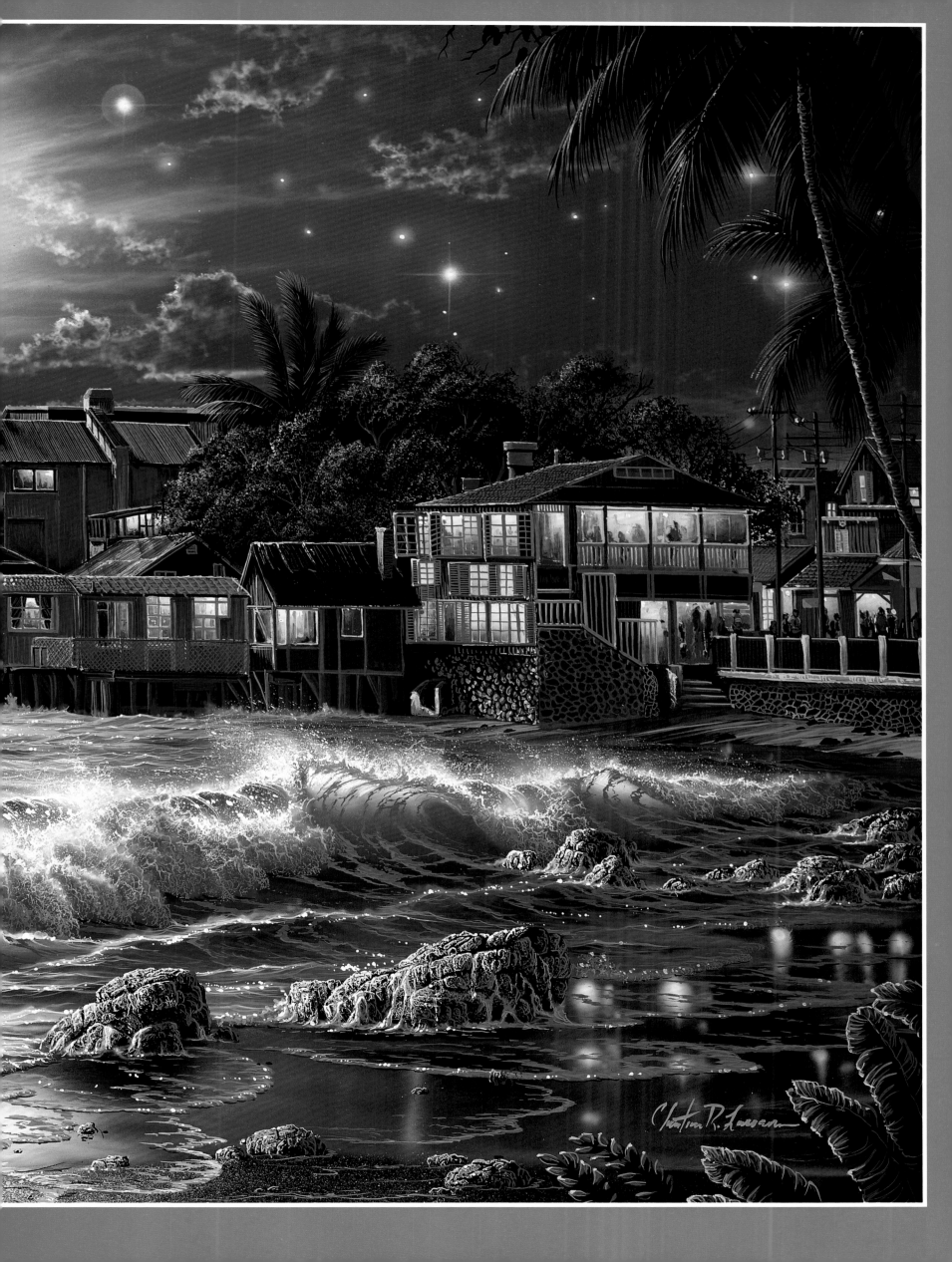

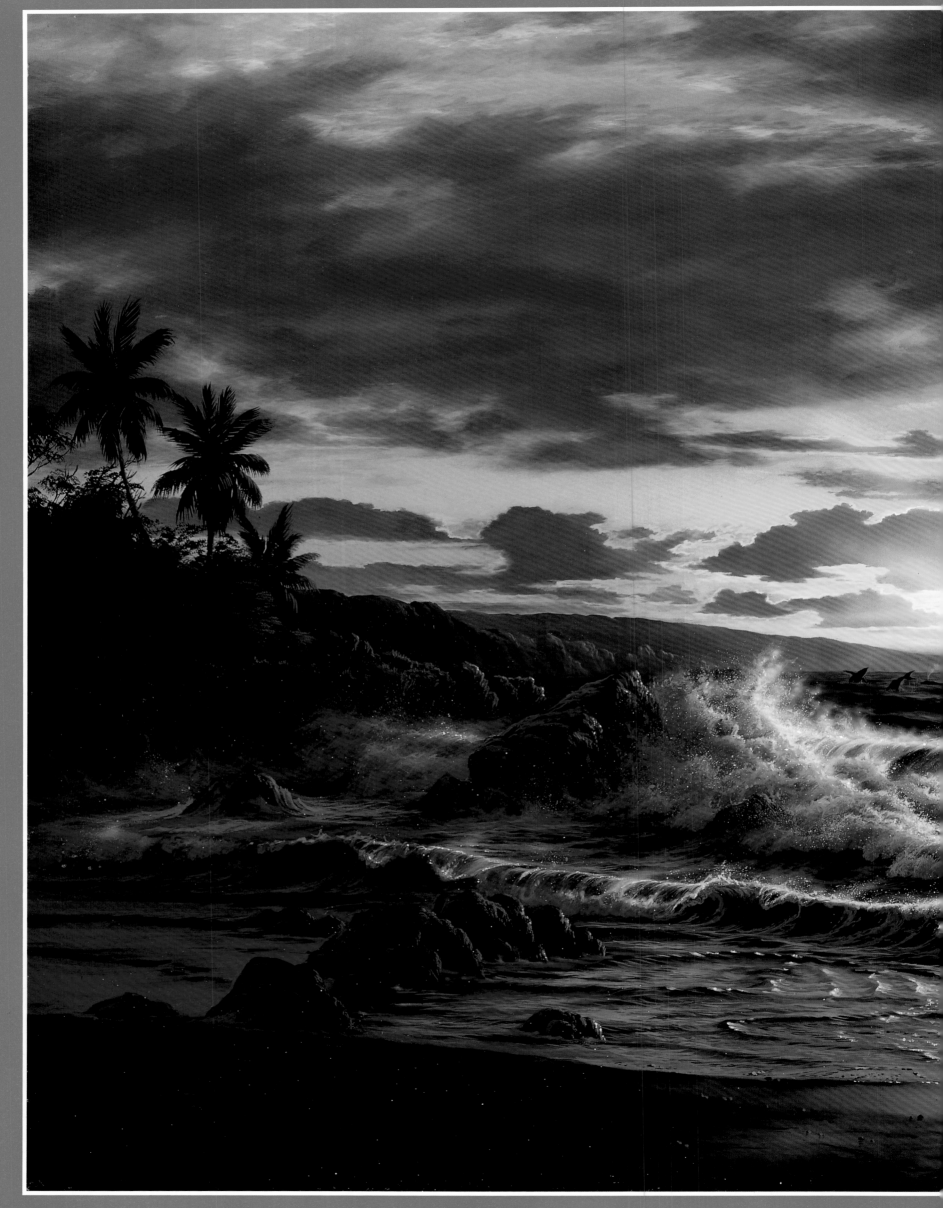

PLATE 15 • **ROMANCE OF THE SEA**

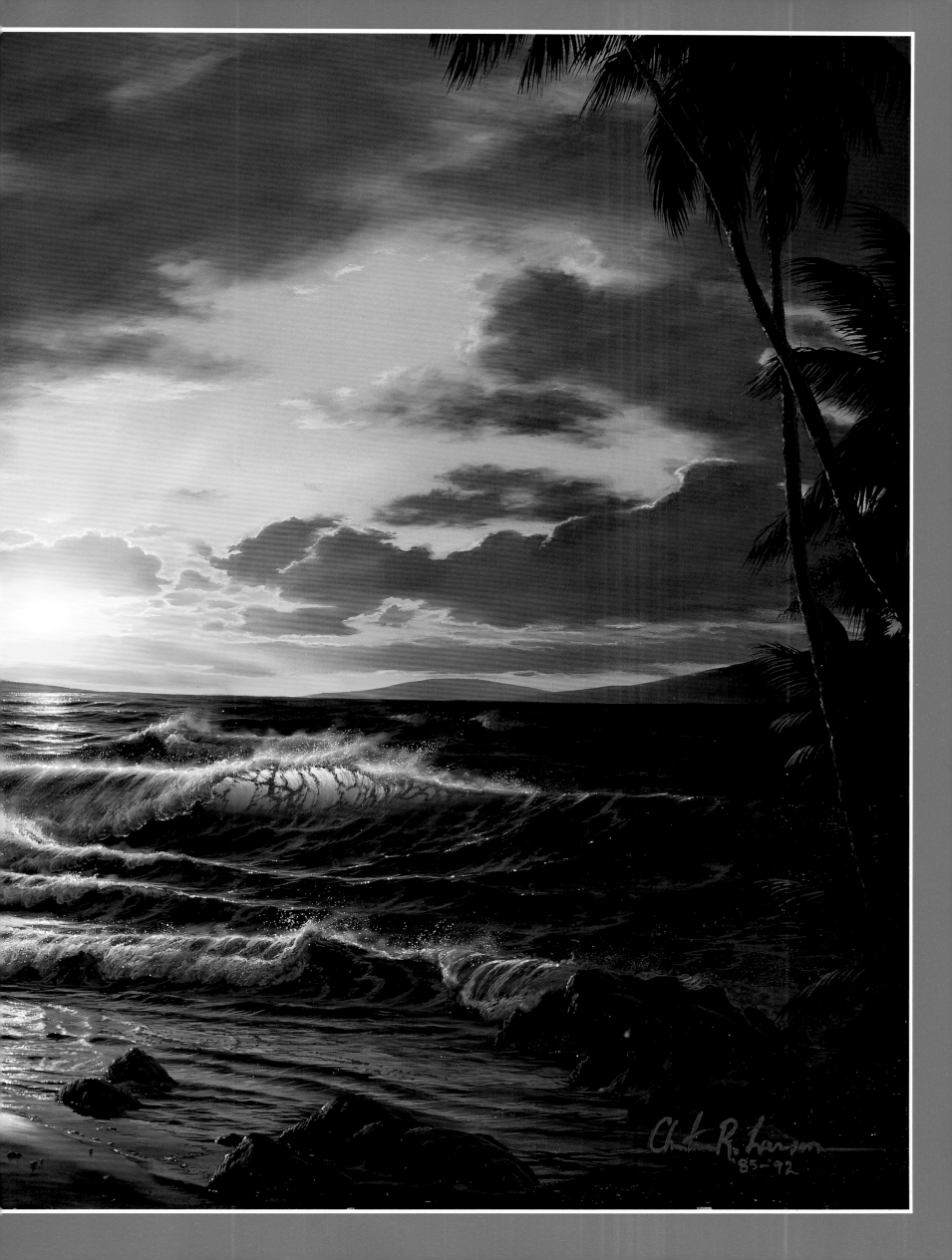

Christian R. Lassen
'85-'92

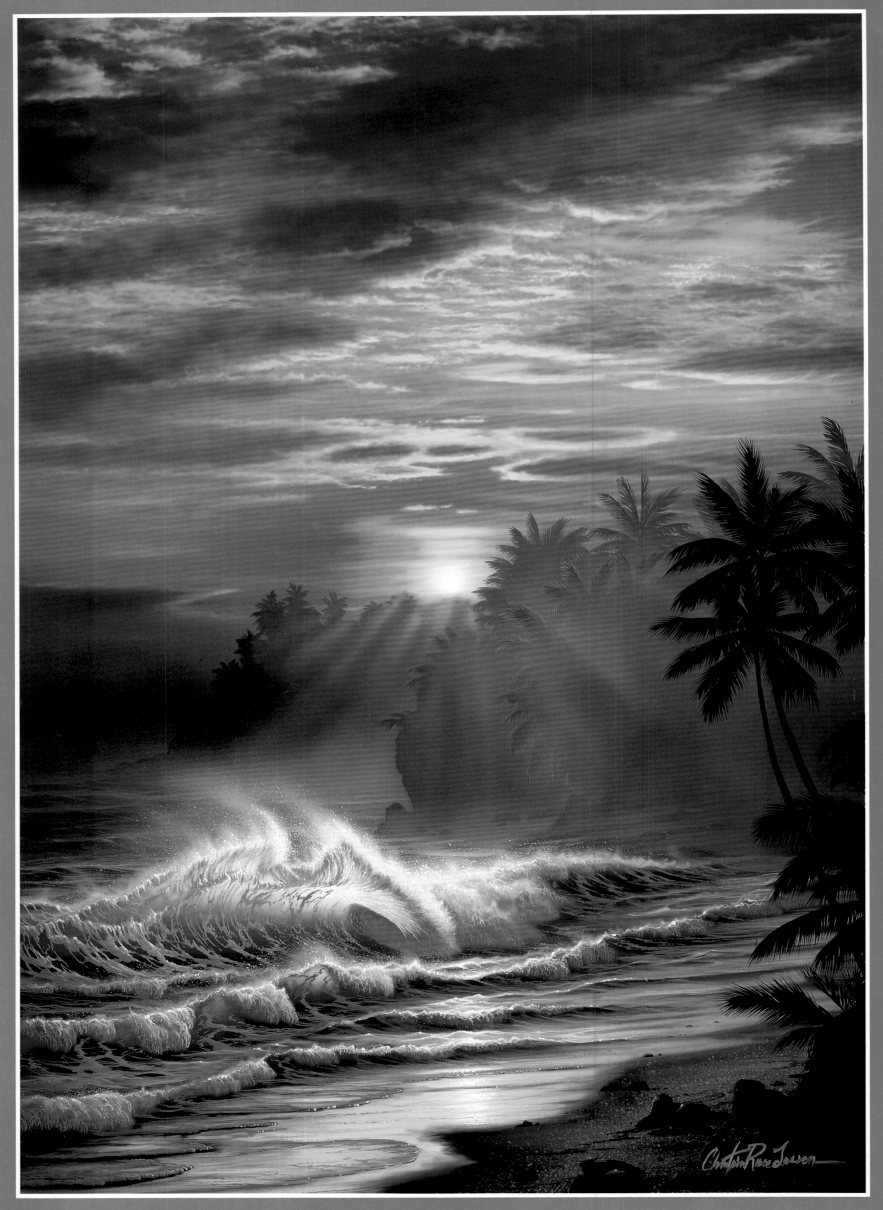

PLATE 16 ◆ **GOLDEN MOMENT**

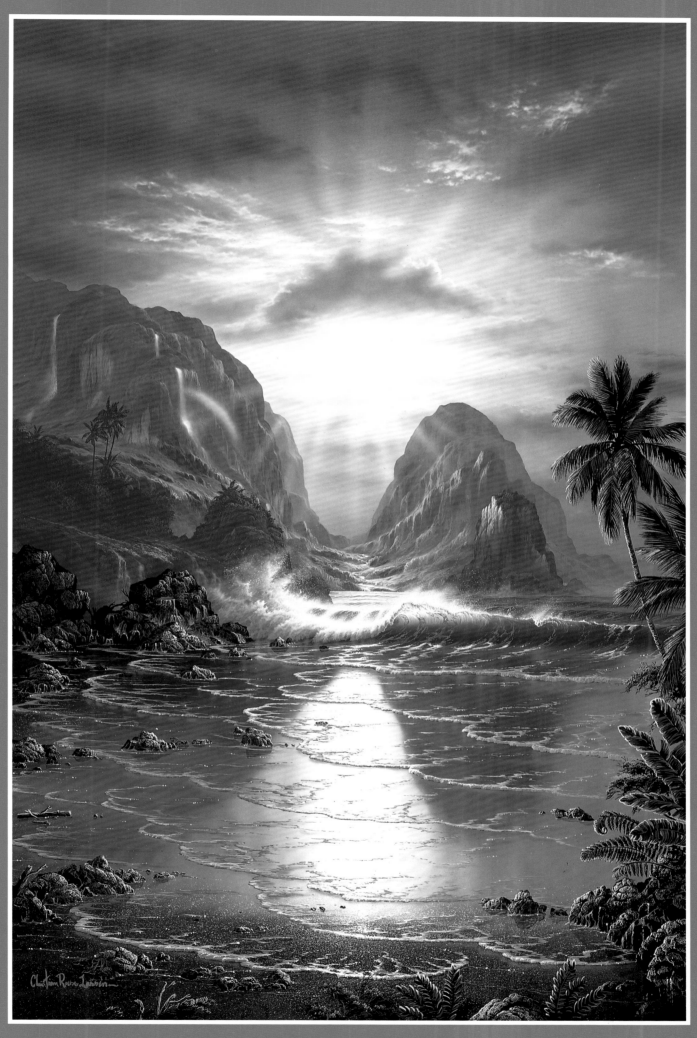

PLATE 17 ◆ **HEAVEN**

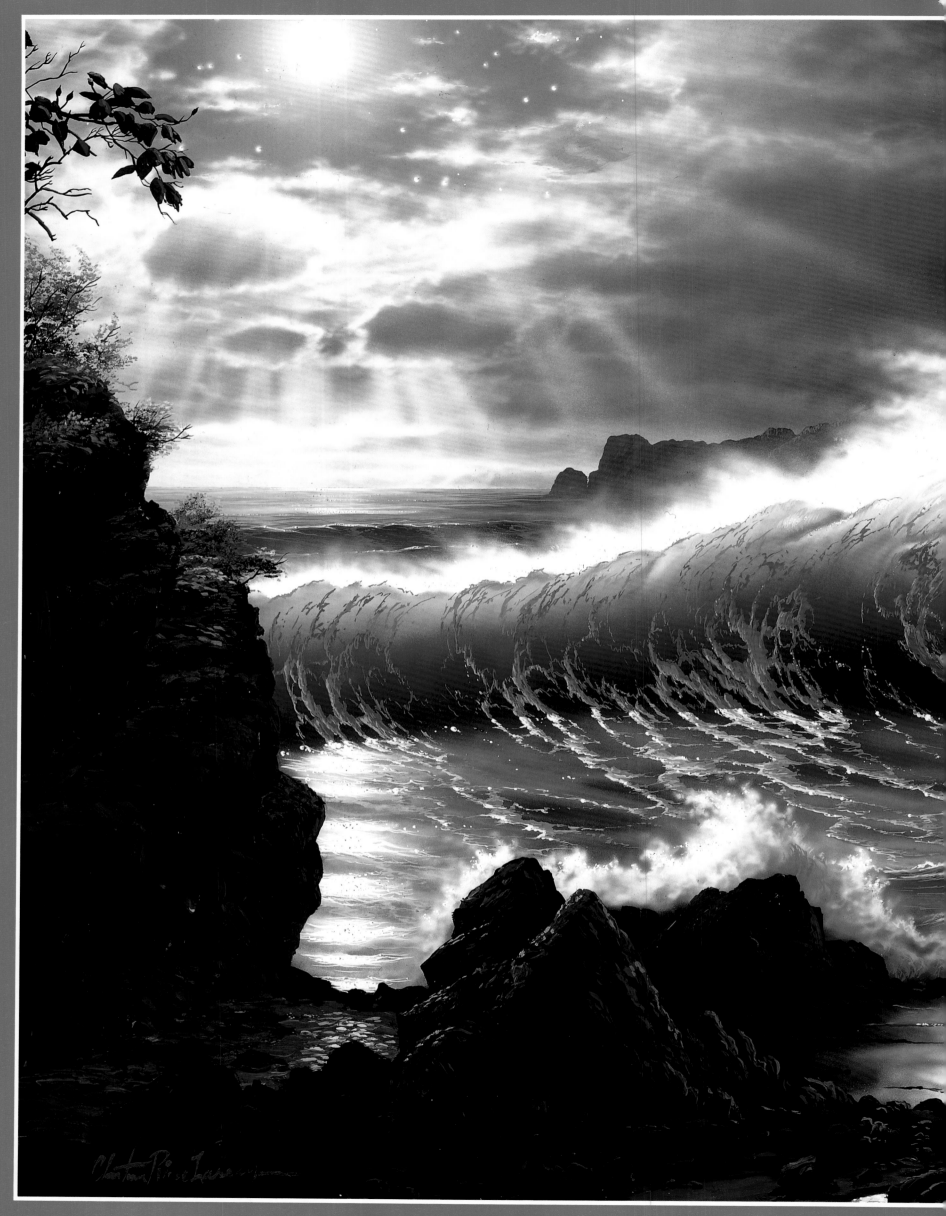

PLATE 18 • CLIFFS OF KAPALUA

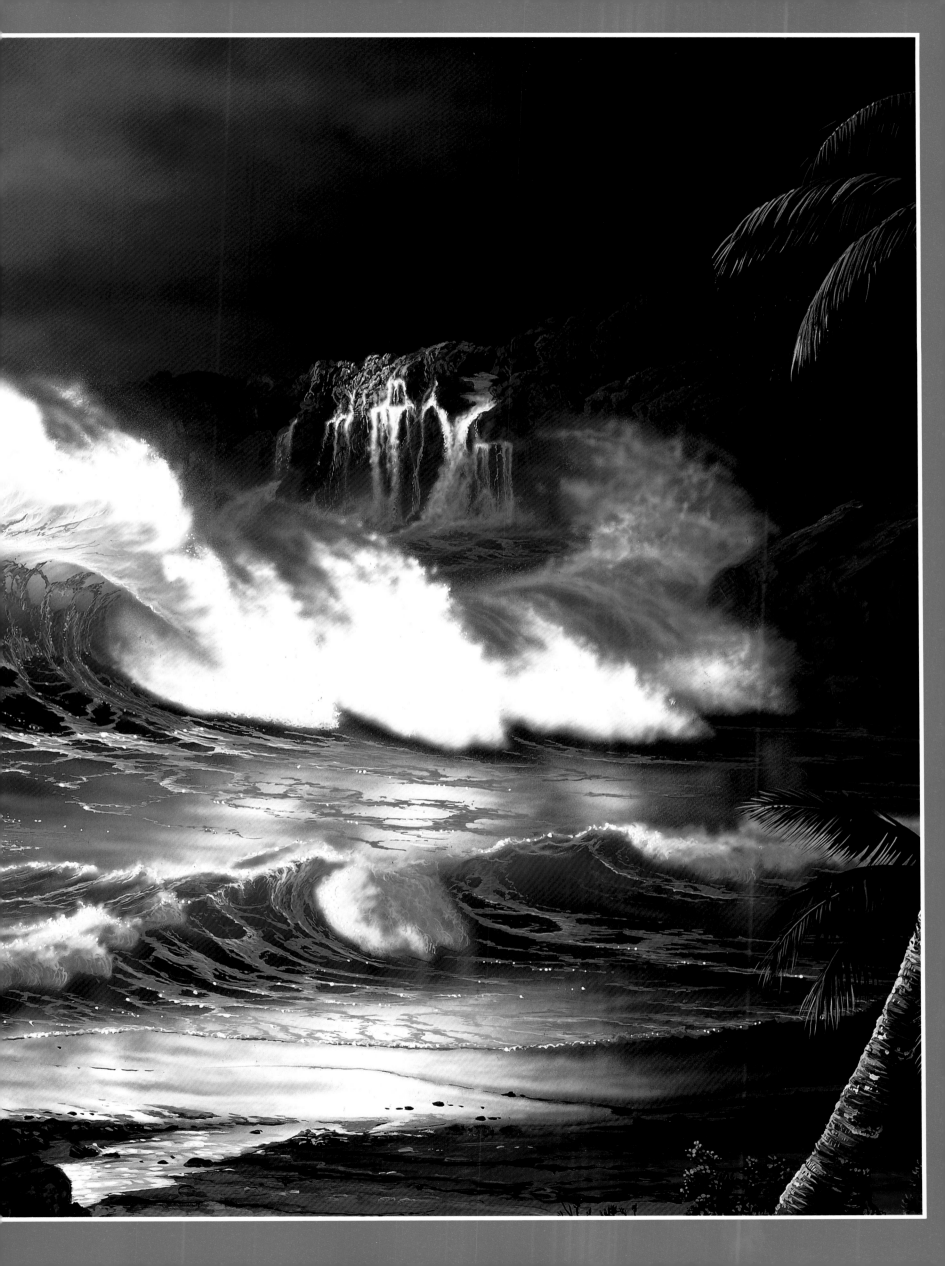

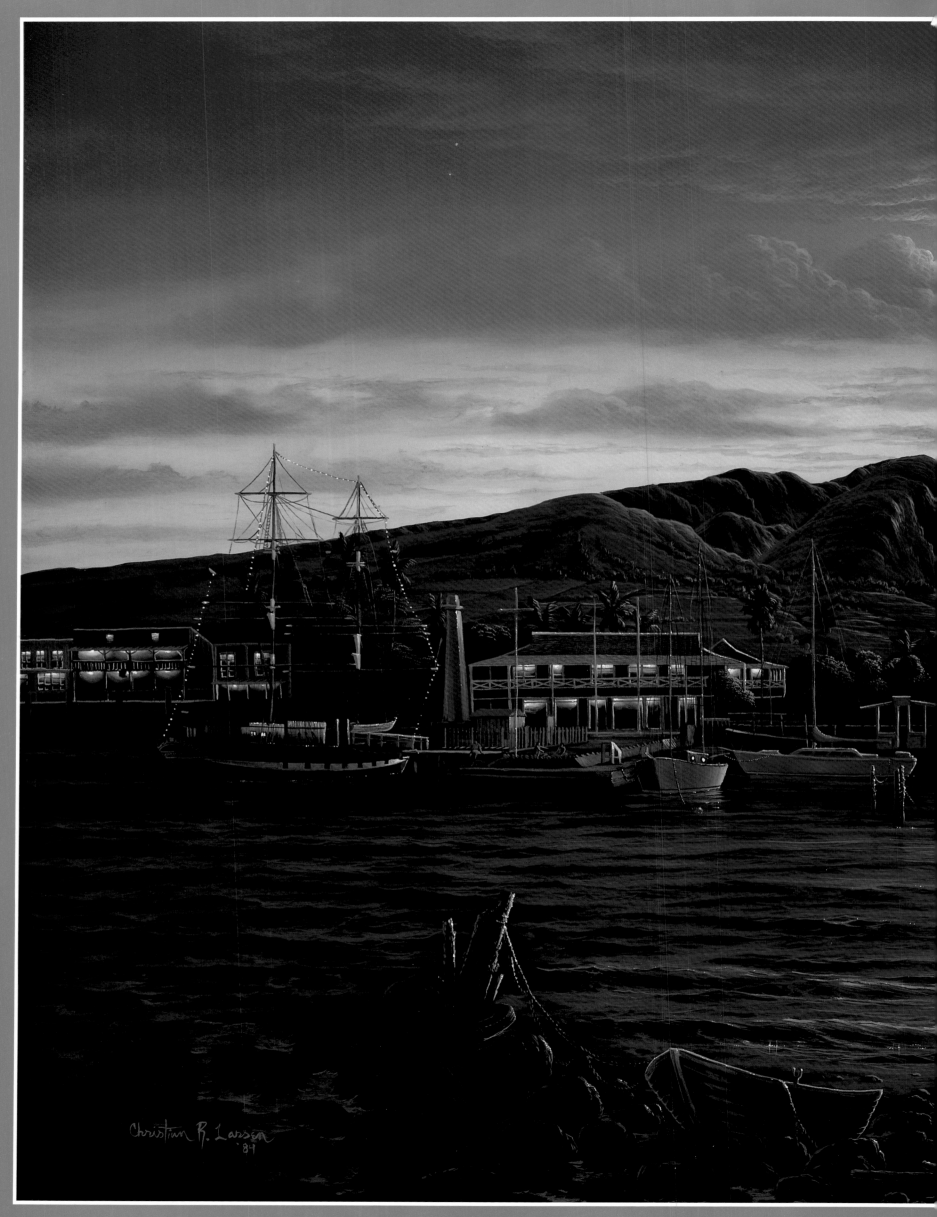

Christian R. Larsen
'84

PLATE 19 • HOME FROM THE SEA

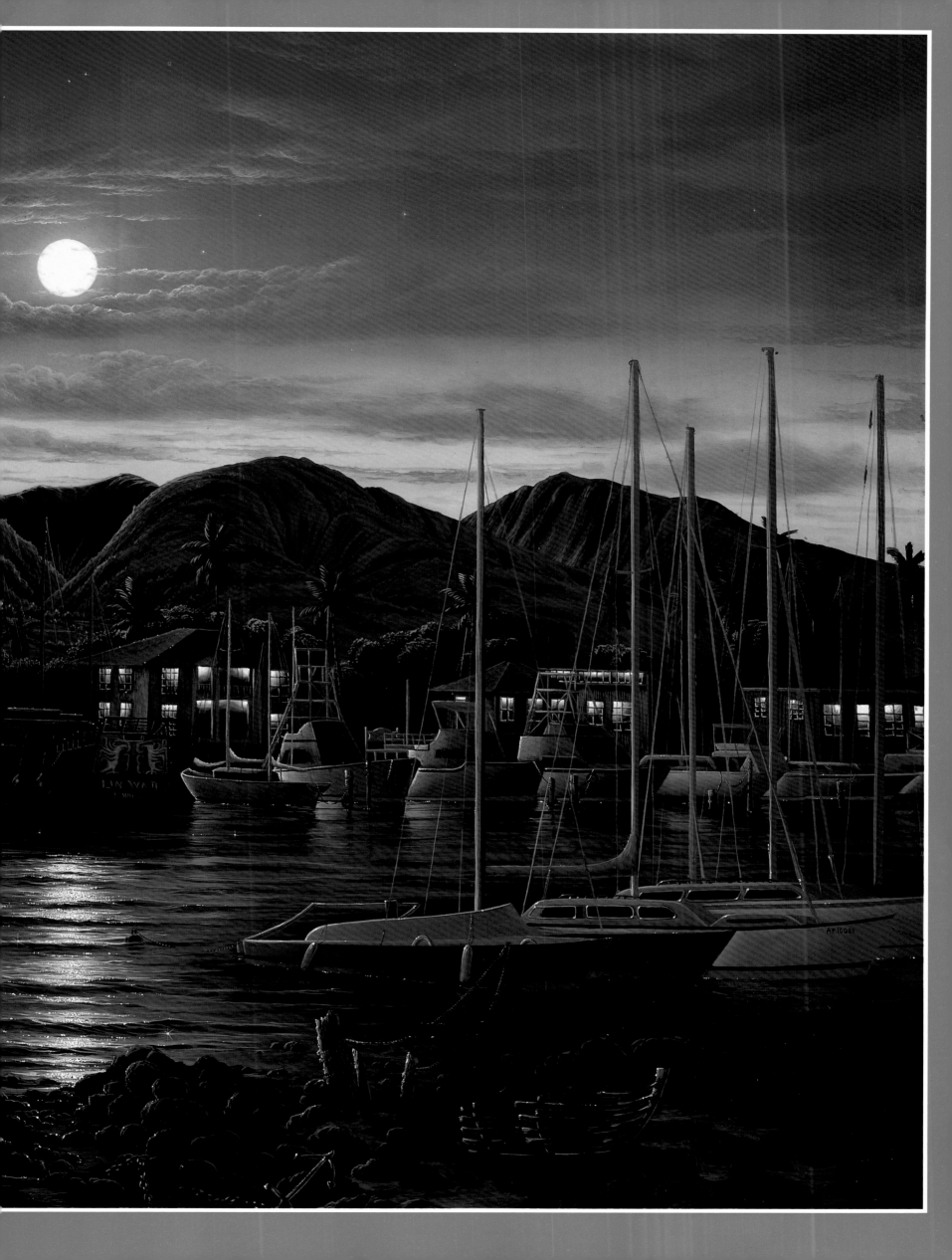

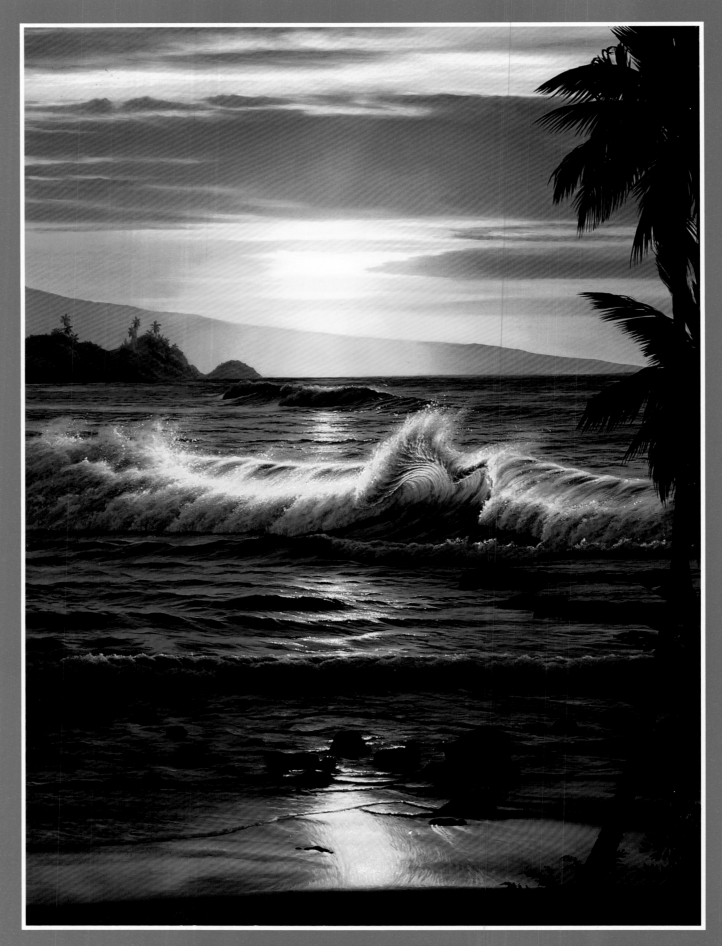

PLATE 20 ◆ NAPILI COVE

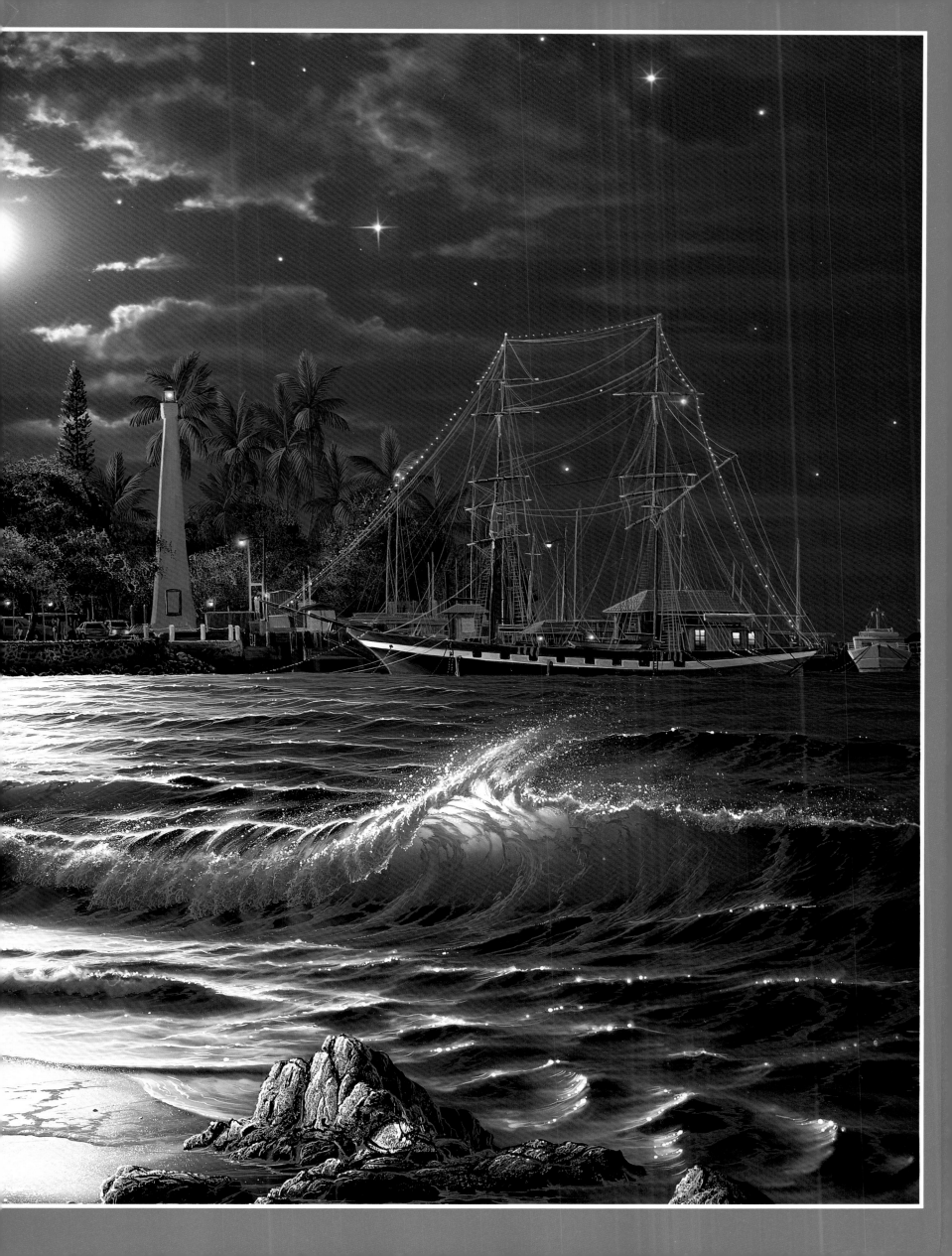

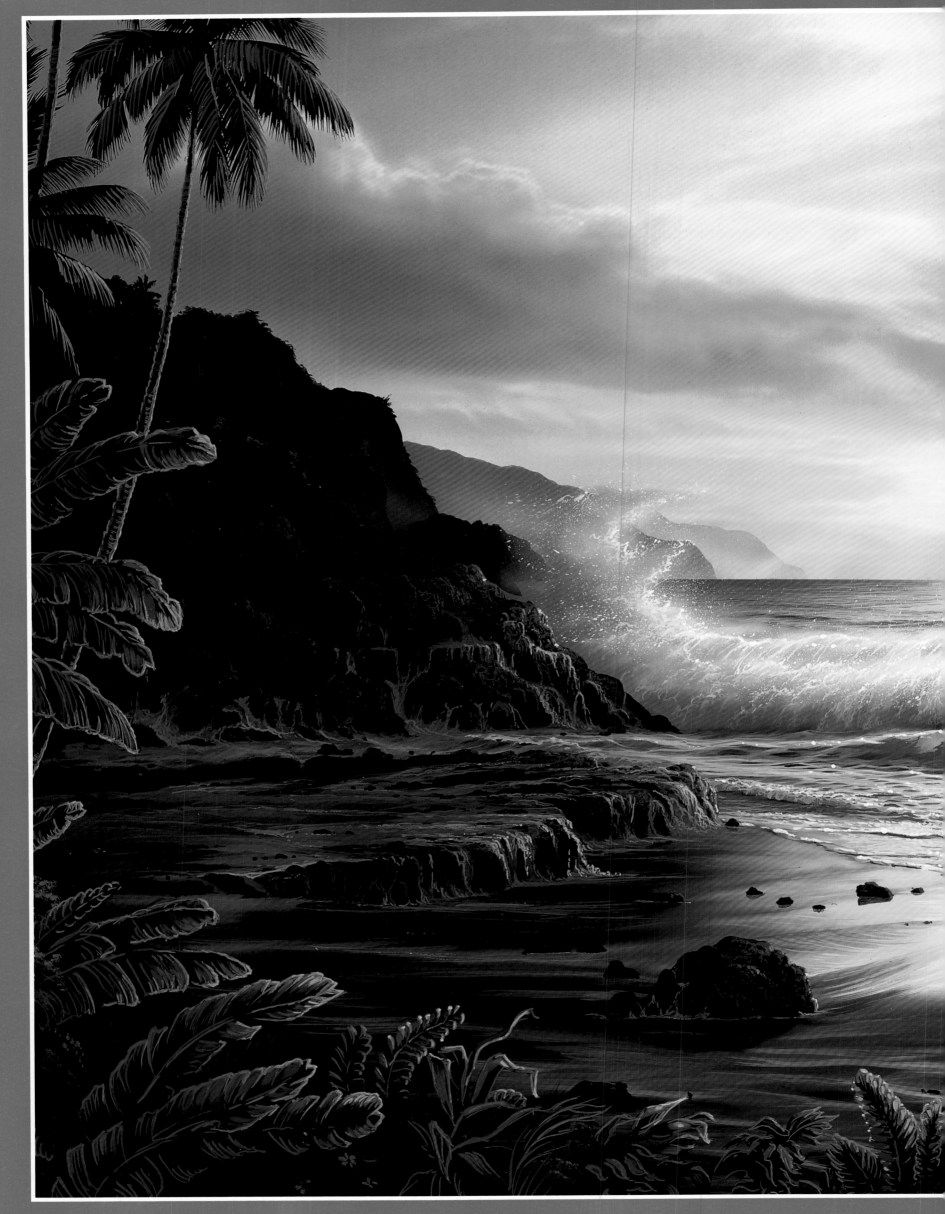

PLATE 23 • **Maui Gold**

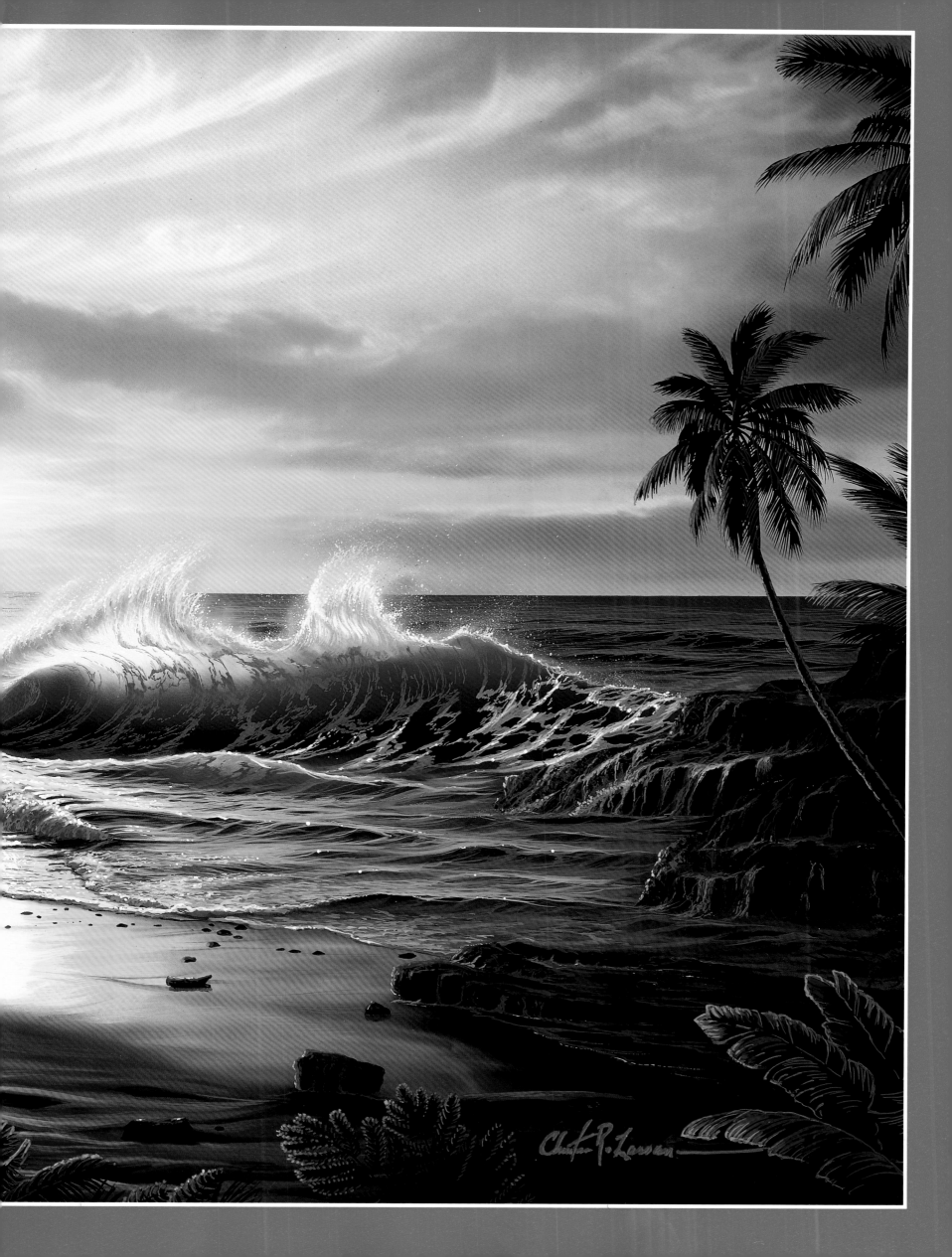

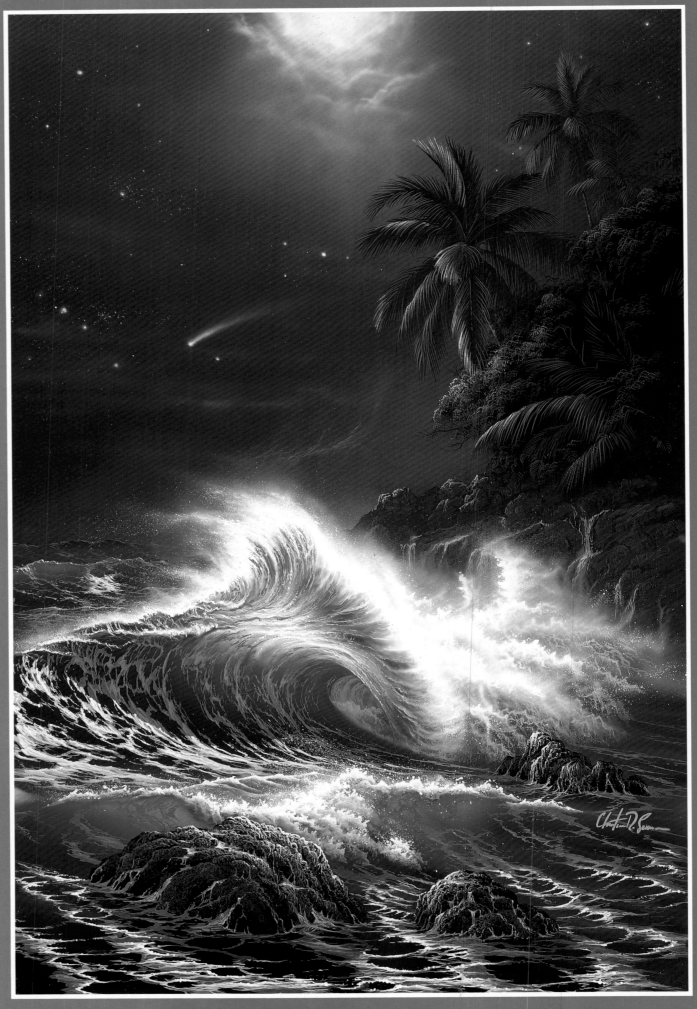

PLATE 24 ◆ **NIGHT DANCER**

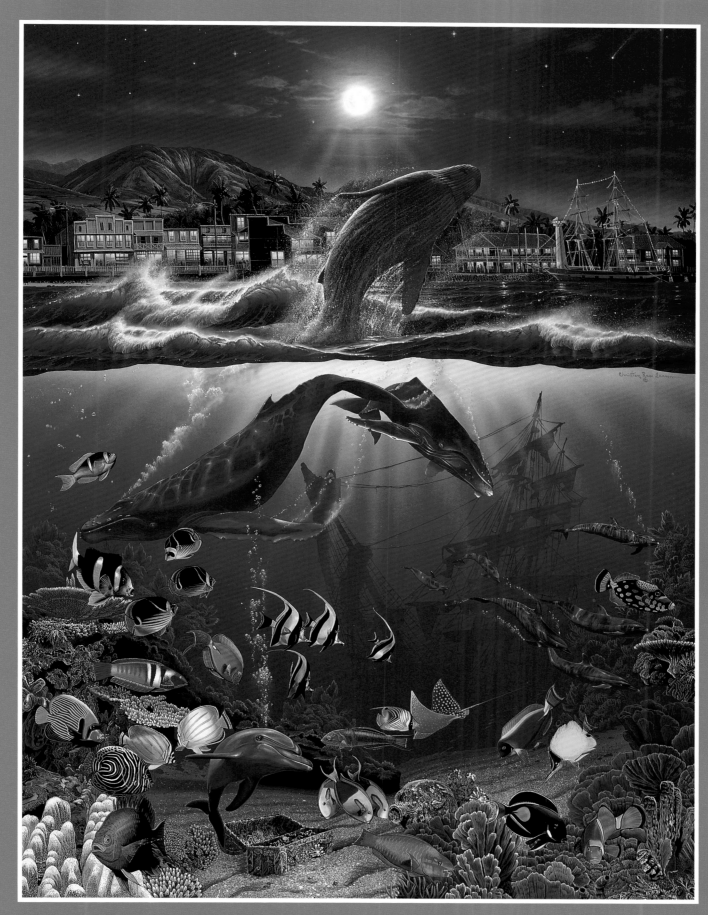

PLATE 27 ✦ **ISLAND TREASURES**

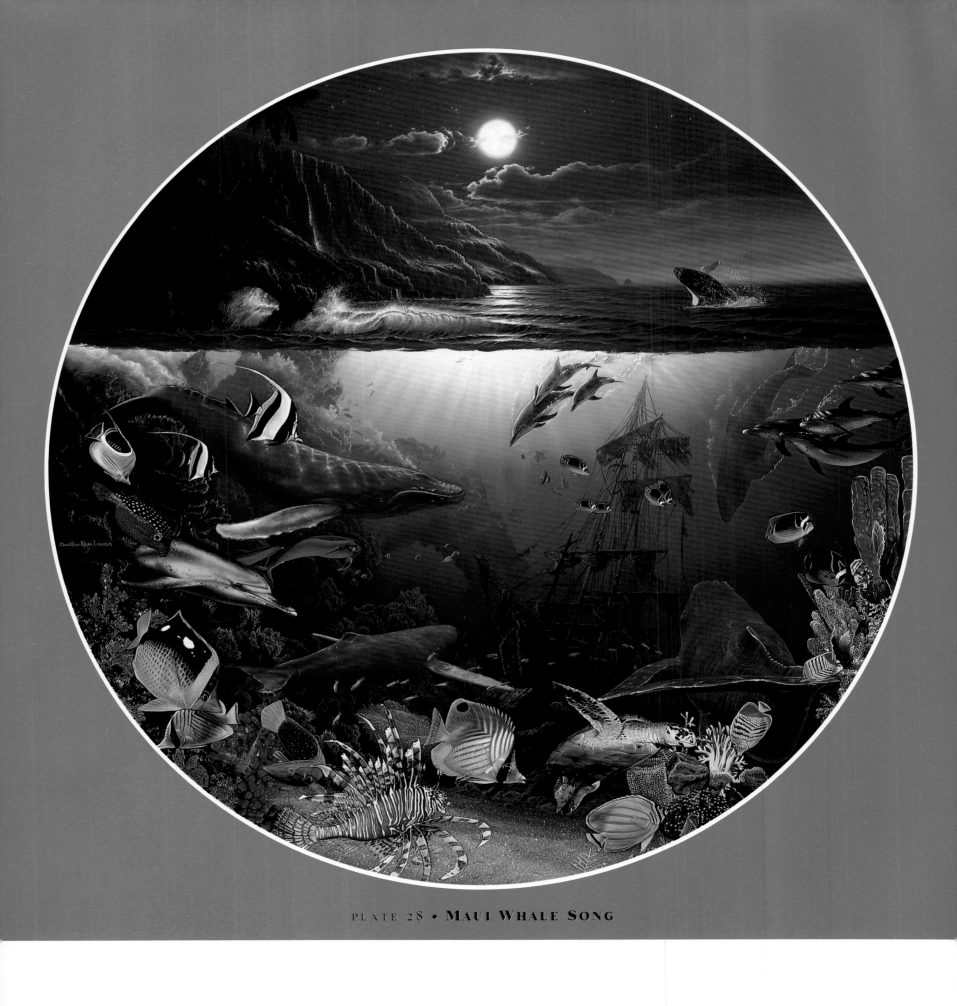

PLATE 28 • Maui Whale Song

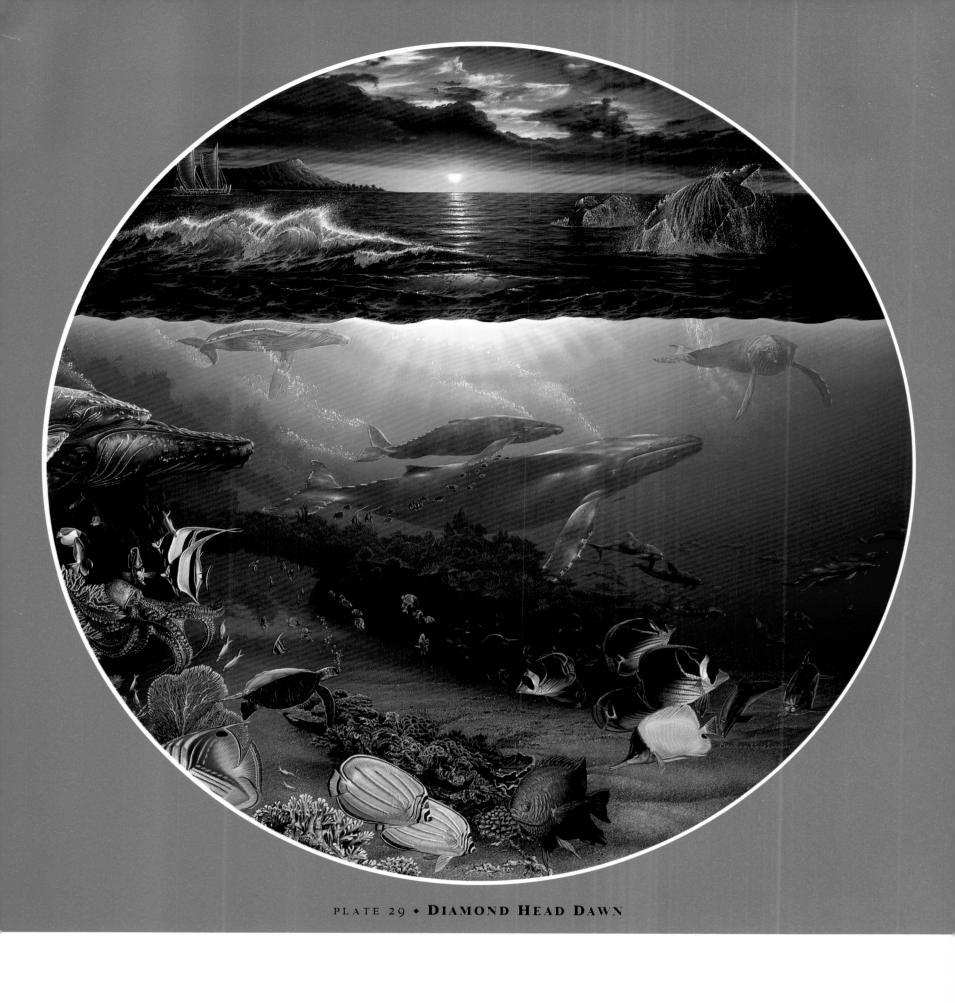

PLATE 29 ◆ **DIAMOND HEAD DAWN**

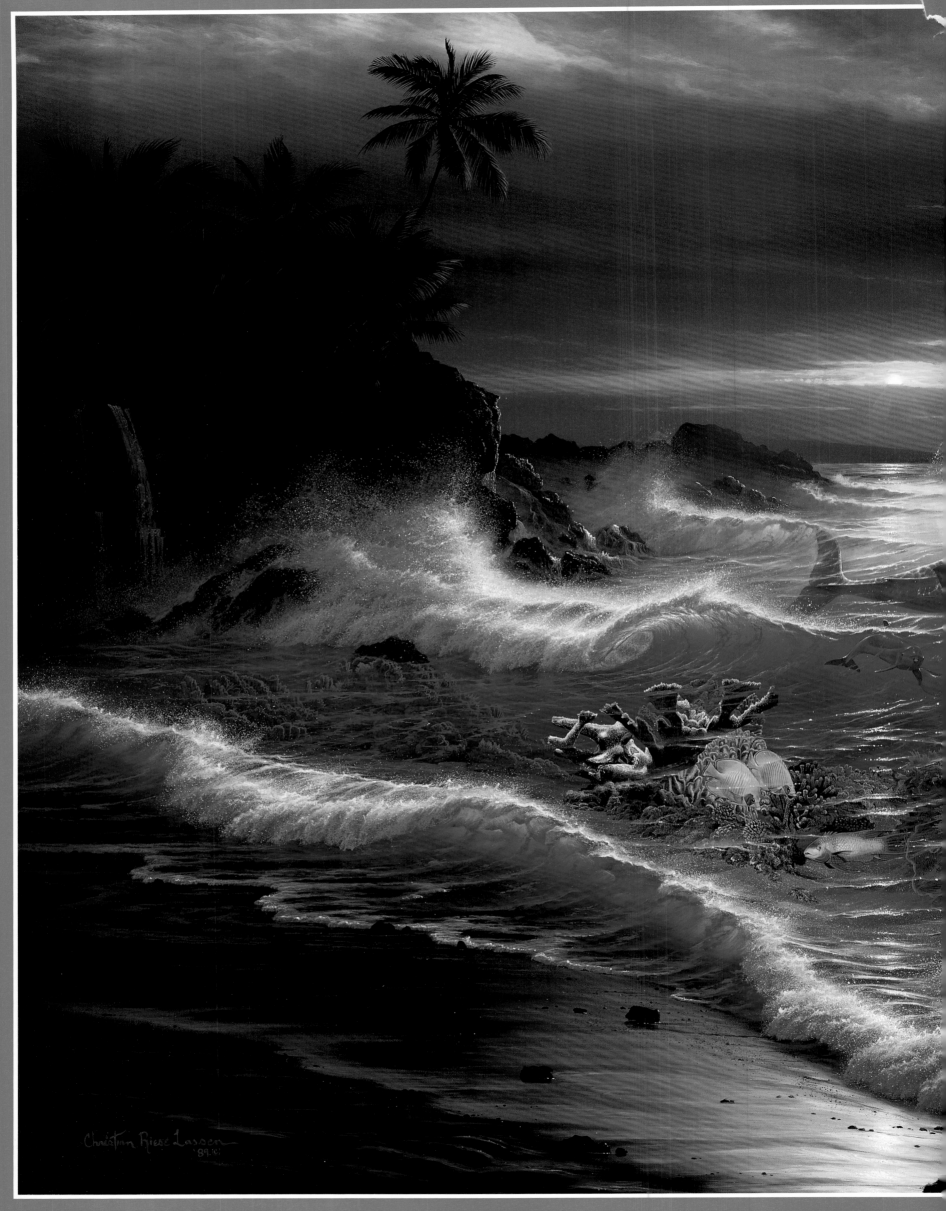

PLATE 30 • **SEA VISION**

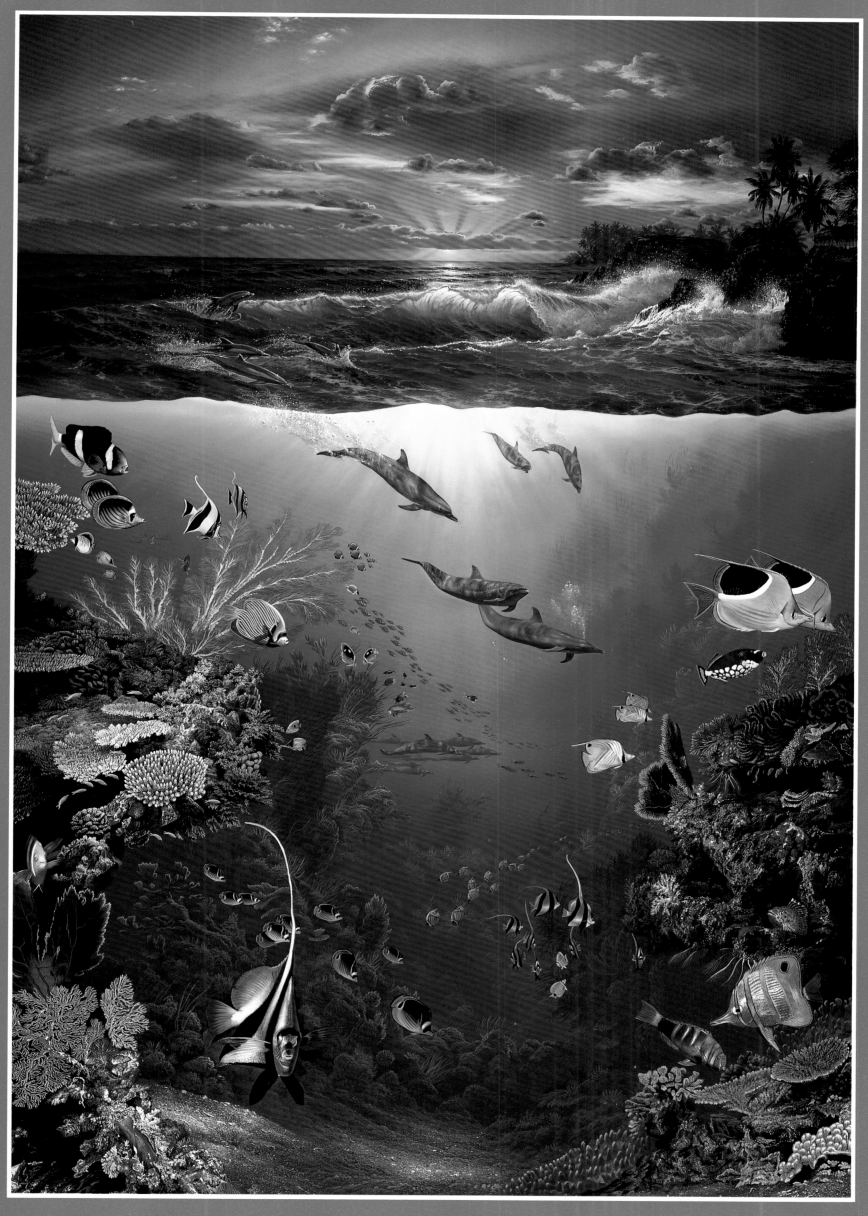

PLATE 35 ✦ **OUR WORLD**

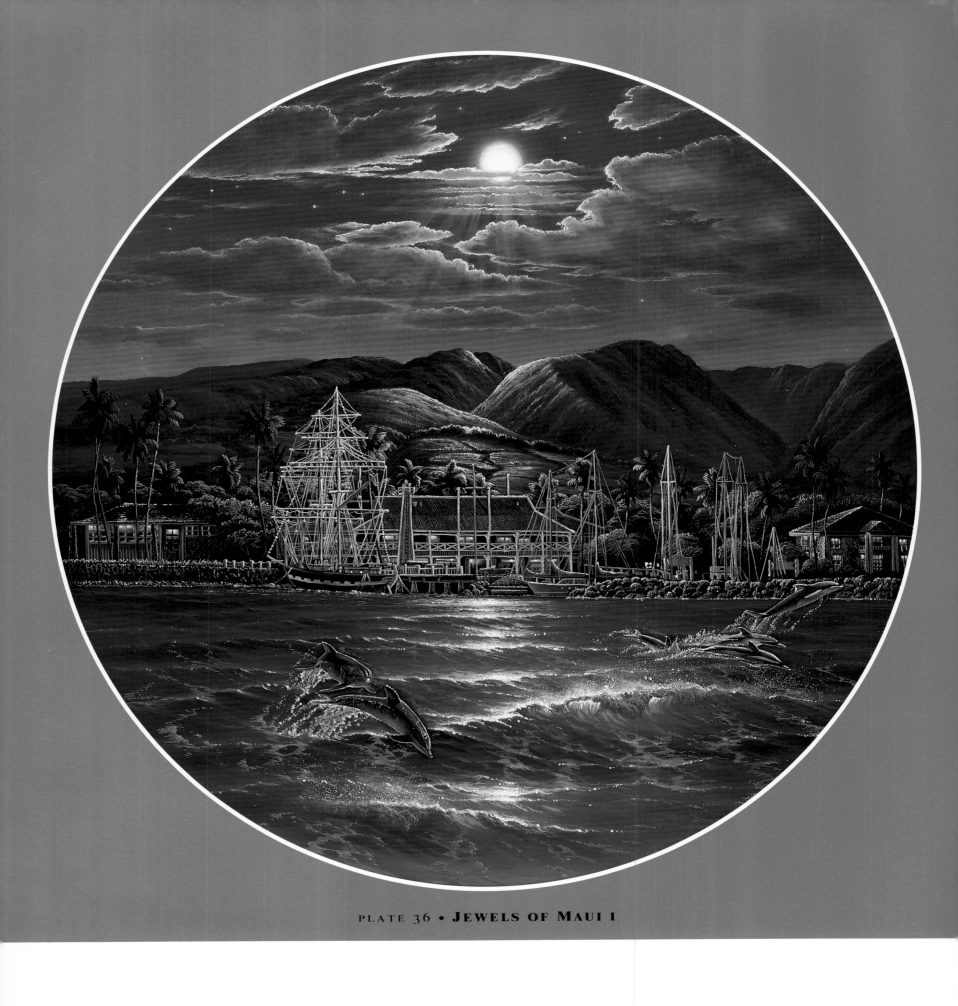

PLATE 36 • JEWELS OF MAUI I

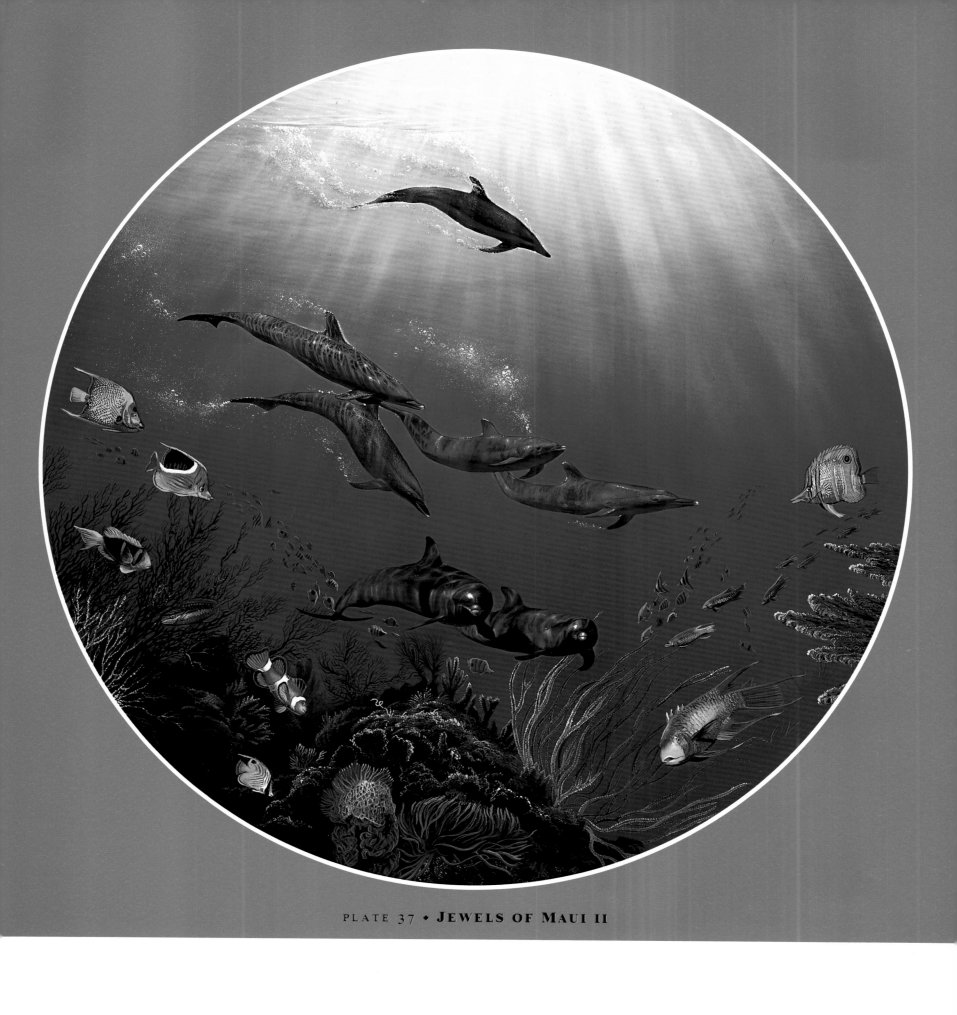

PLATE 37 • **JEWELS OF MAUI II**

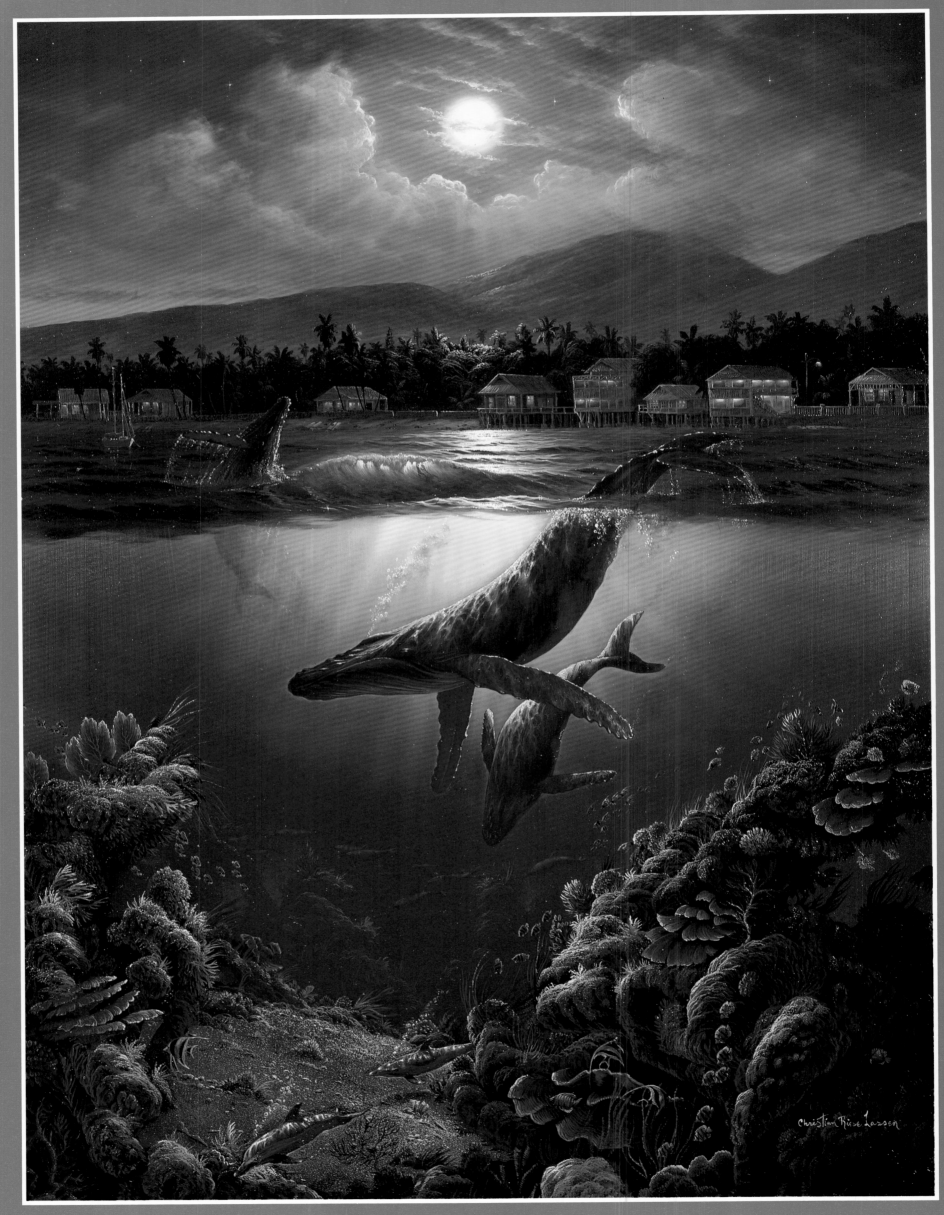

PLATE 38 • **Maui Whale Symphony**

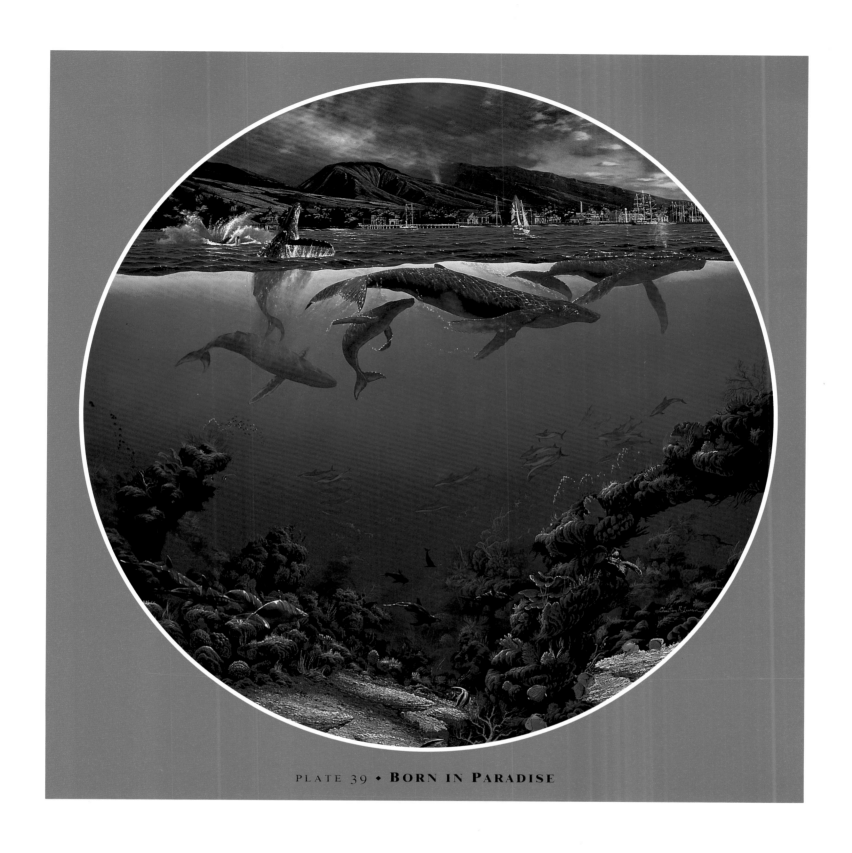

PLATE 39 • **BORN IN PARADISE**

Perhaps this perspective

—the amphibian or porpoise-eye view—

first achieved recognition with the artist

Andrew Wyeth in his 1945

split vision of a trout in a stream.

Certainly today it has become an

especially popular and effective way

of looking at two very different worlds

simultaneously, and also of suggesting

the interdependencies of all living systems.

No artist has so successfully rendered this

perspective as has Christian Riese Lassen.

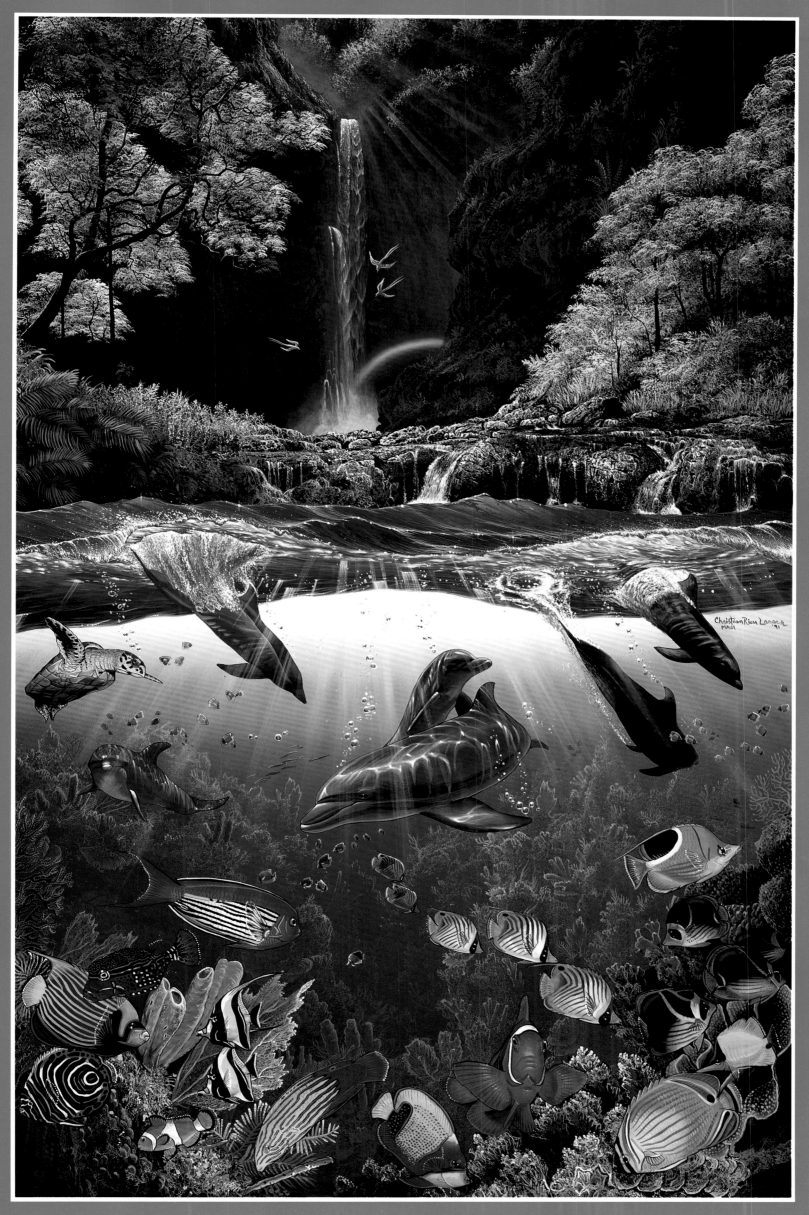

PLATE 40 • **THE INFINITE WAY**

PLATE 41 • **DOLPHIN QUEST II**

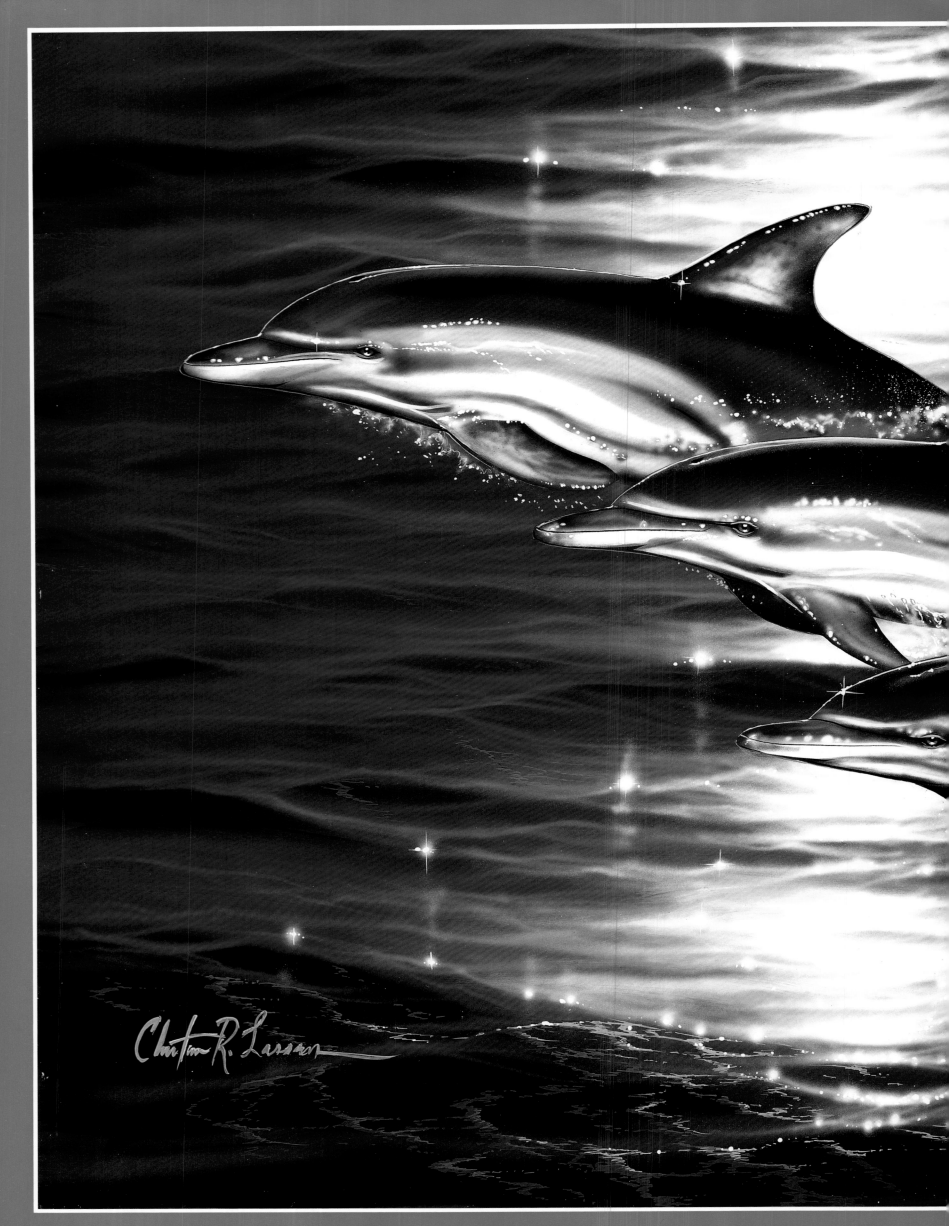

PLATE 42 ◆ SEA FLIGHT

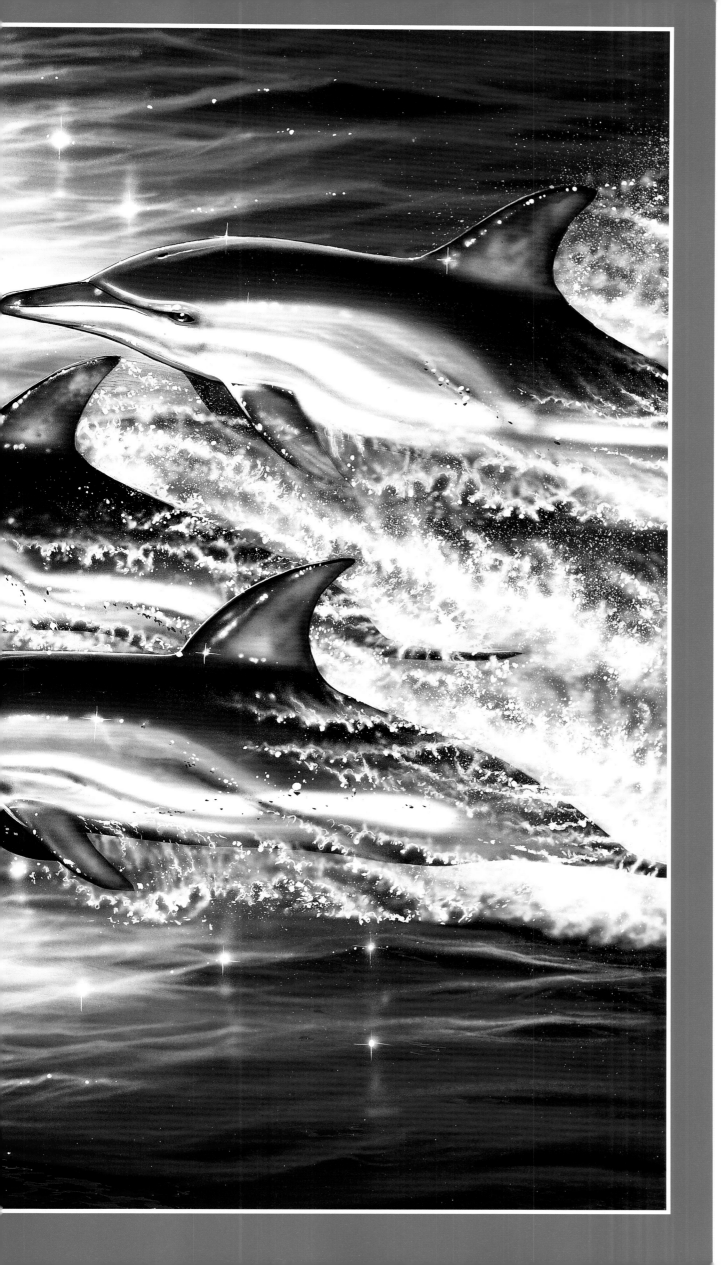

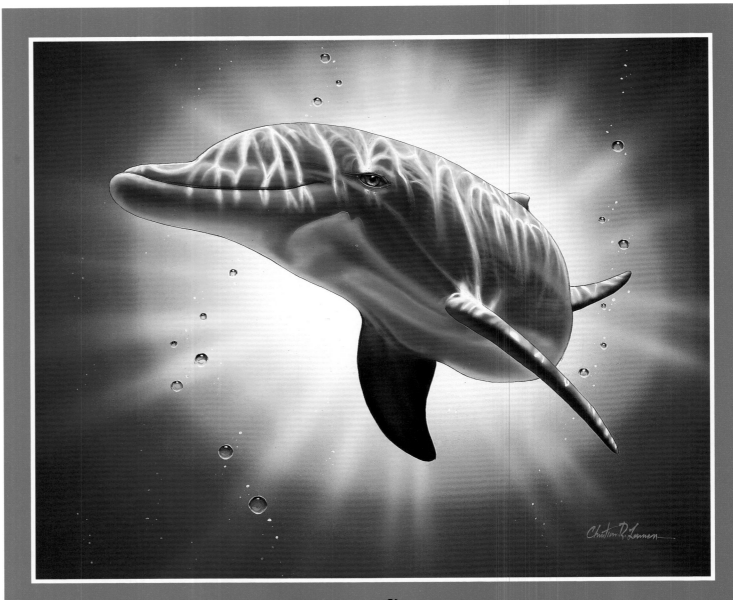

PLATE 43 ◆ **KOLOHE**

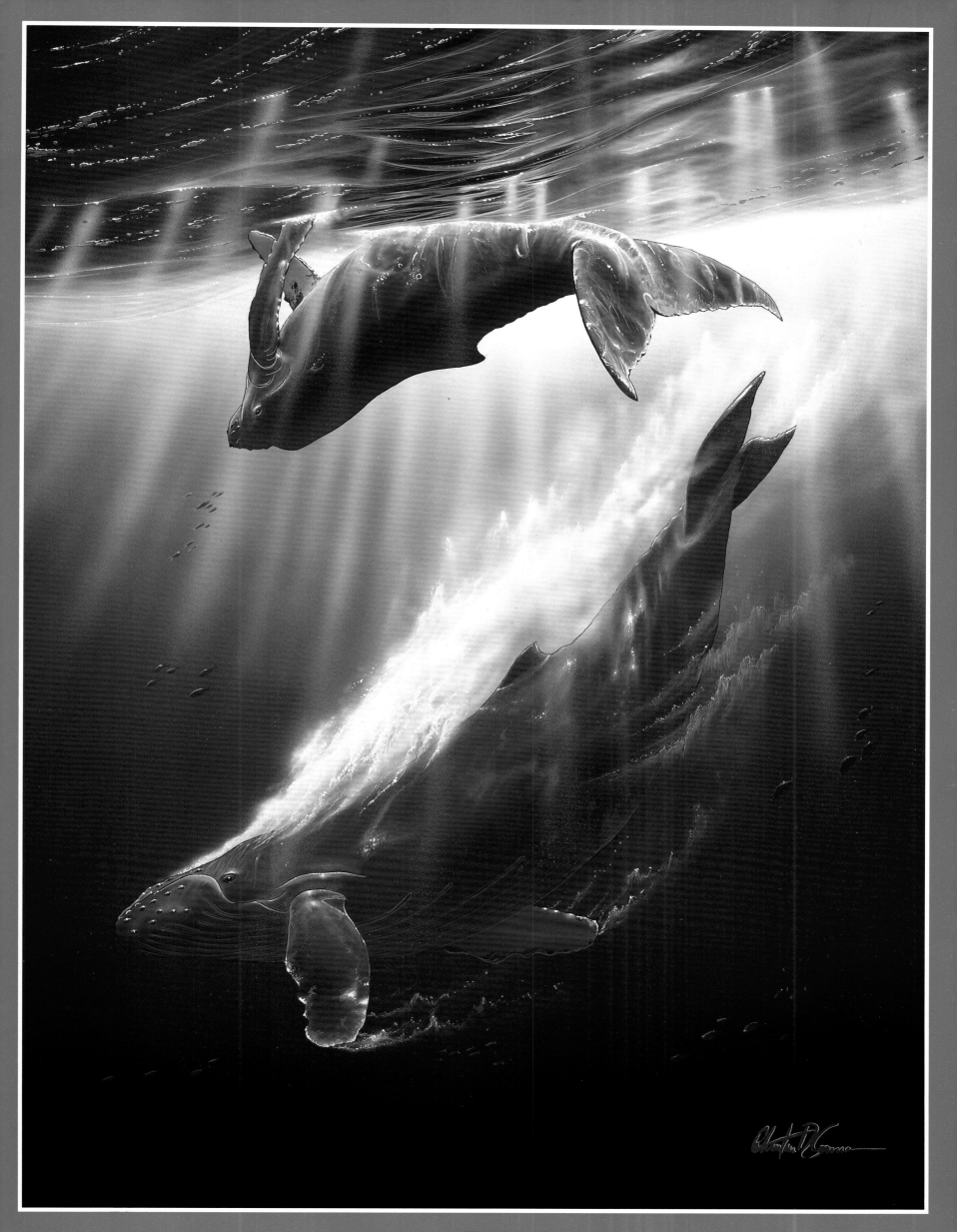

PLATE 44 ◆ **WHALE SONG**

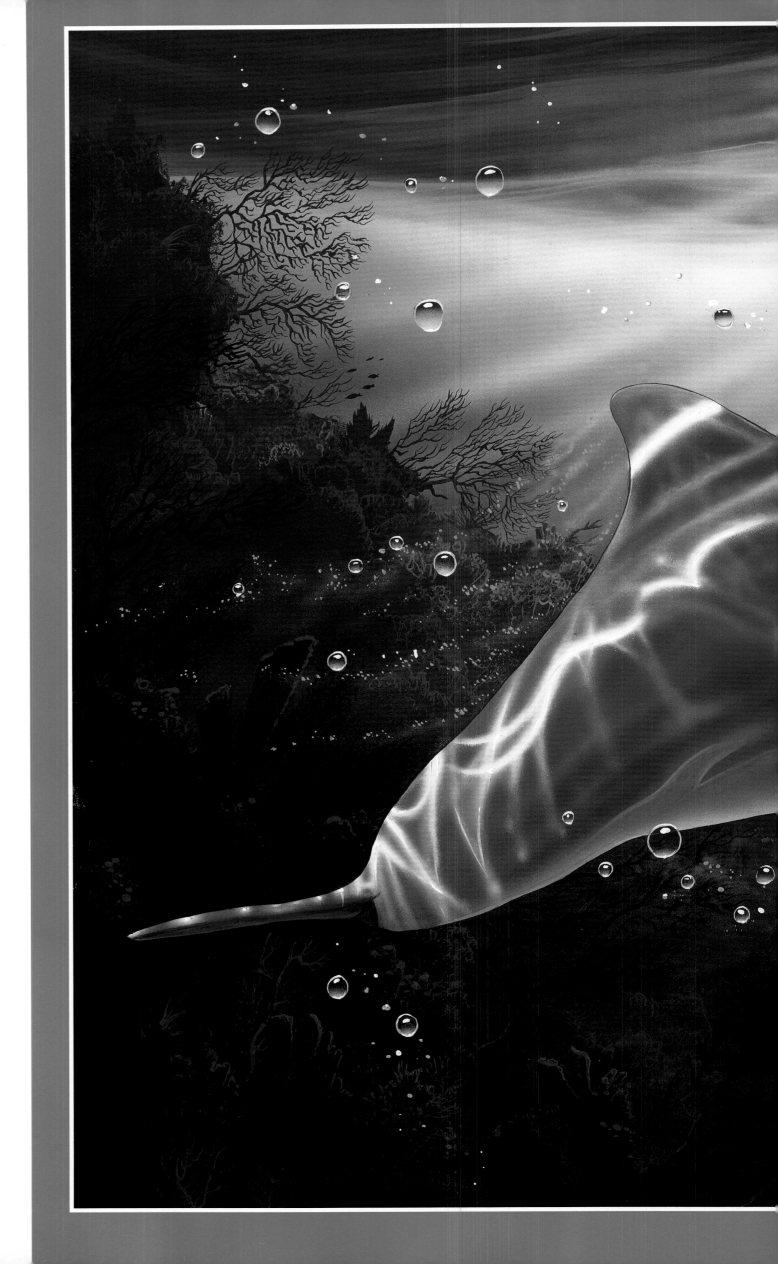

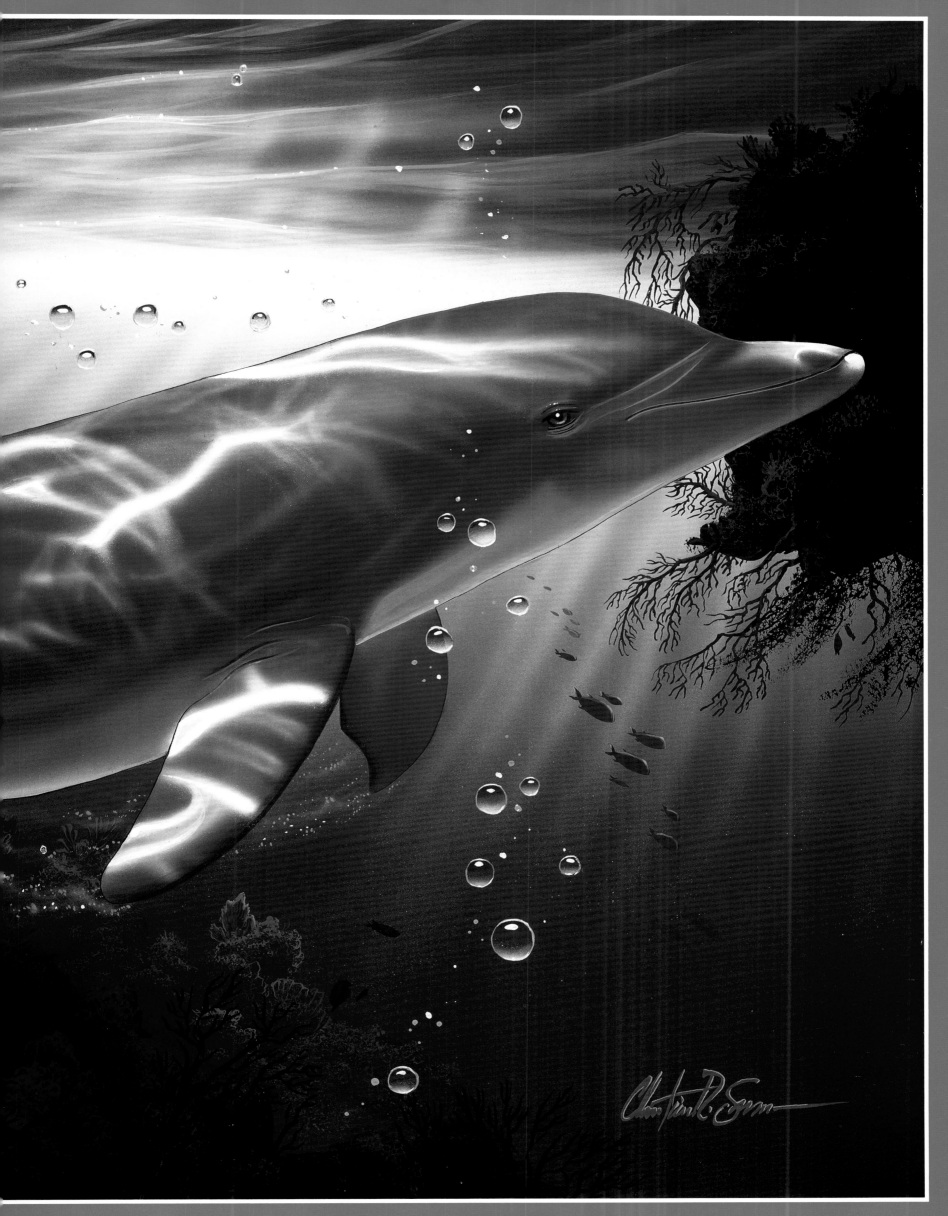

PLATE 45 • **DOLPHIN VISION**

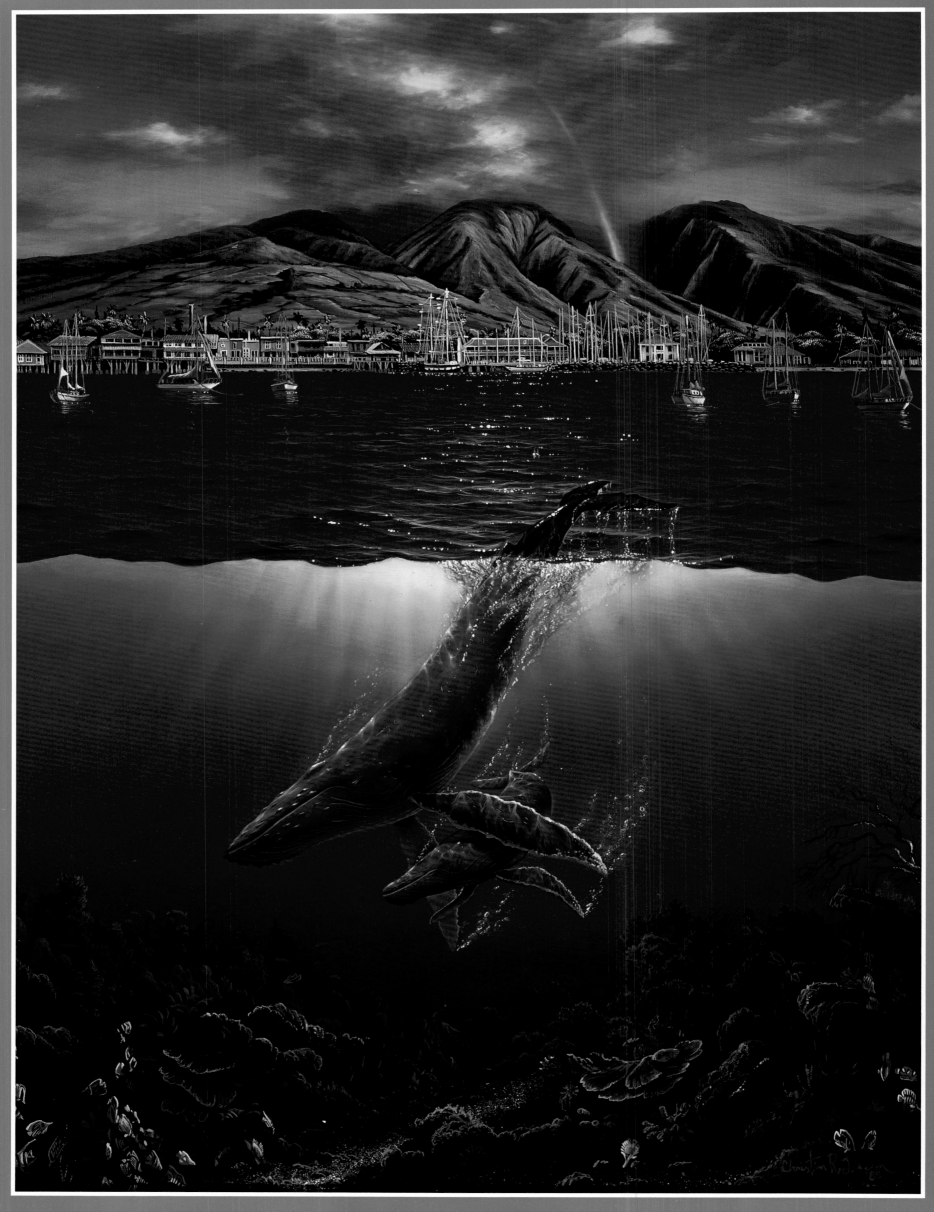

PLATE 46 • HUMPBACKS OFF LAHAINA

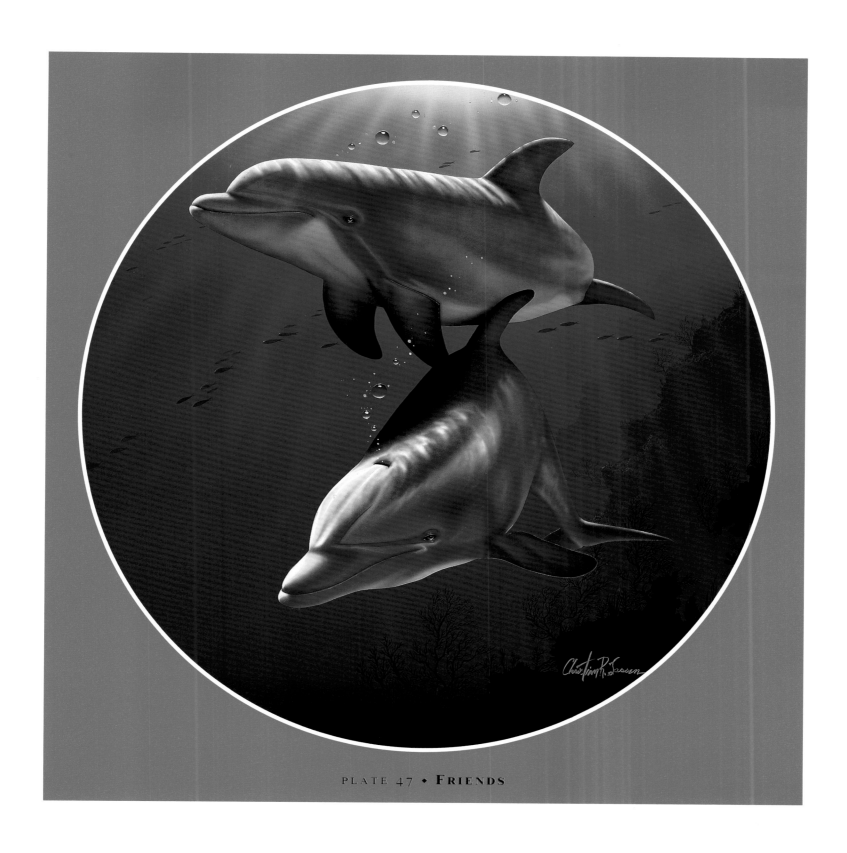

PLATE 47 • **Friends**

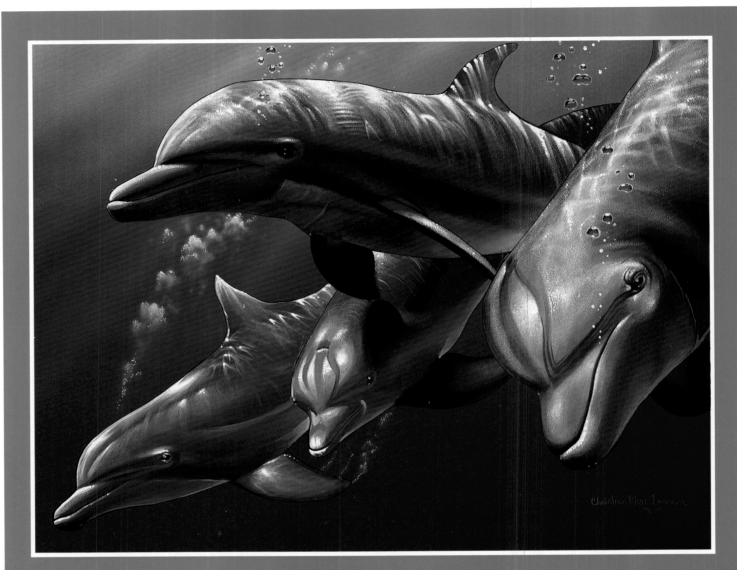

PLATE 48 • **DOLPHIN QUEST I**

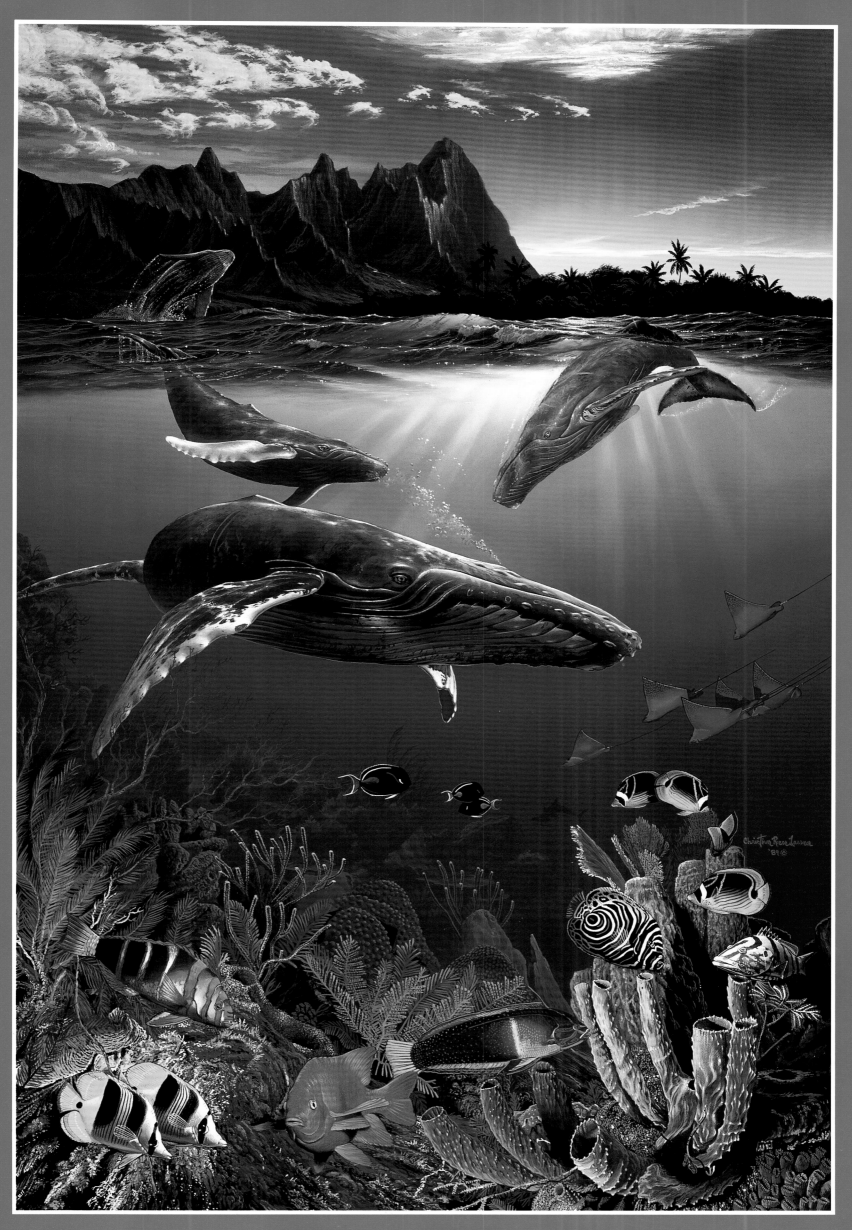

PLATE 49 • **HAWAII SEA PASSAGE**

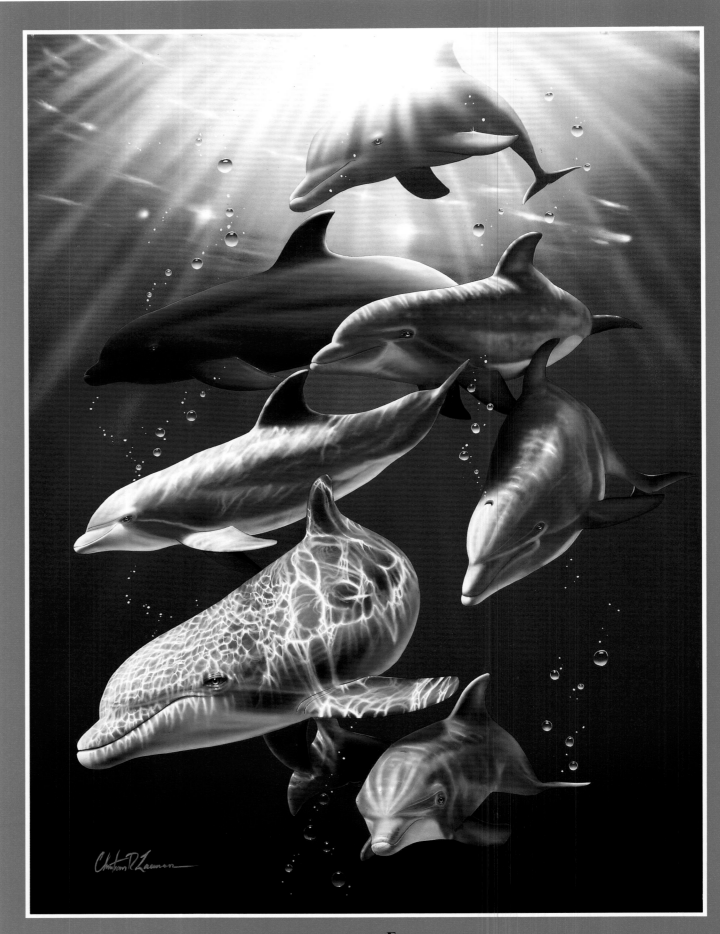

PLATE 50 ◆ **FAMILY**

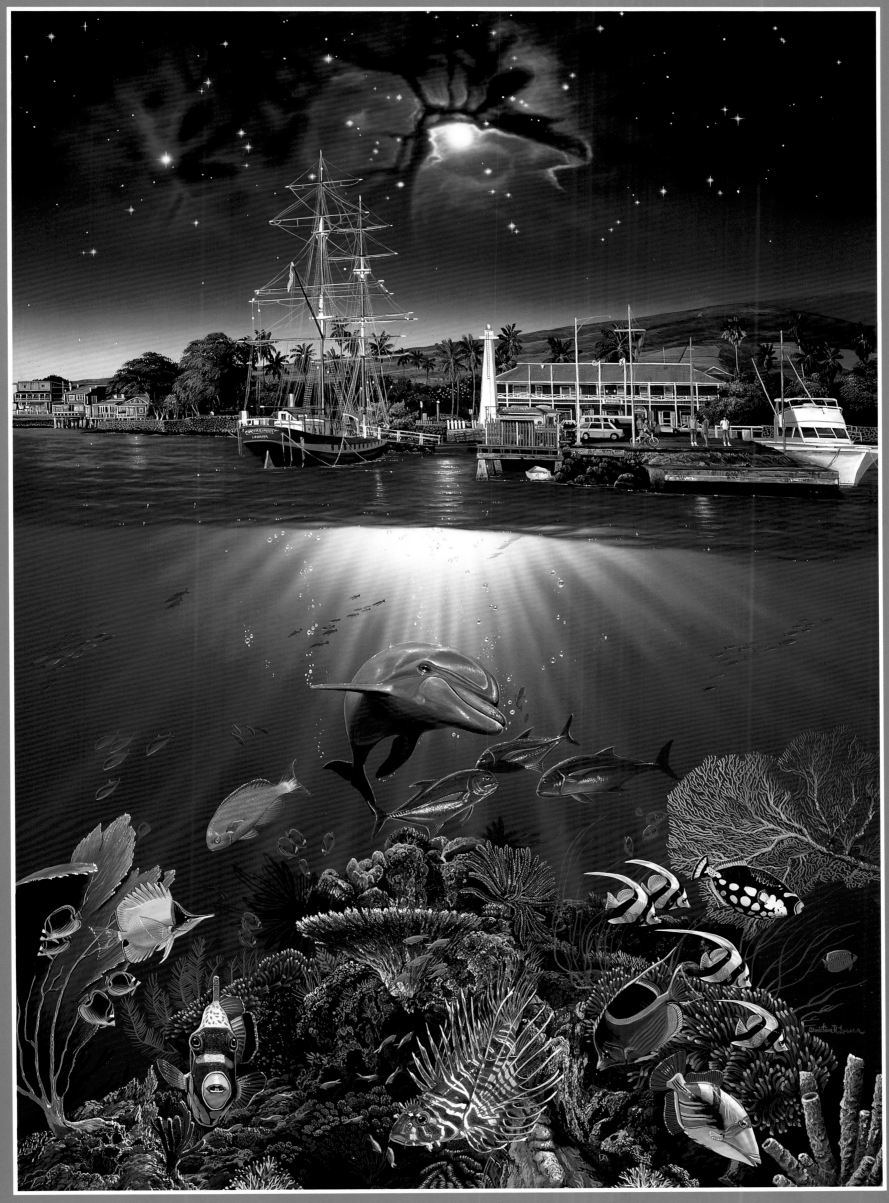

PLATE 51 ◆ LAHAINA DREAMS

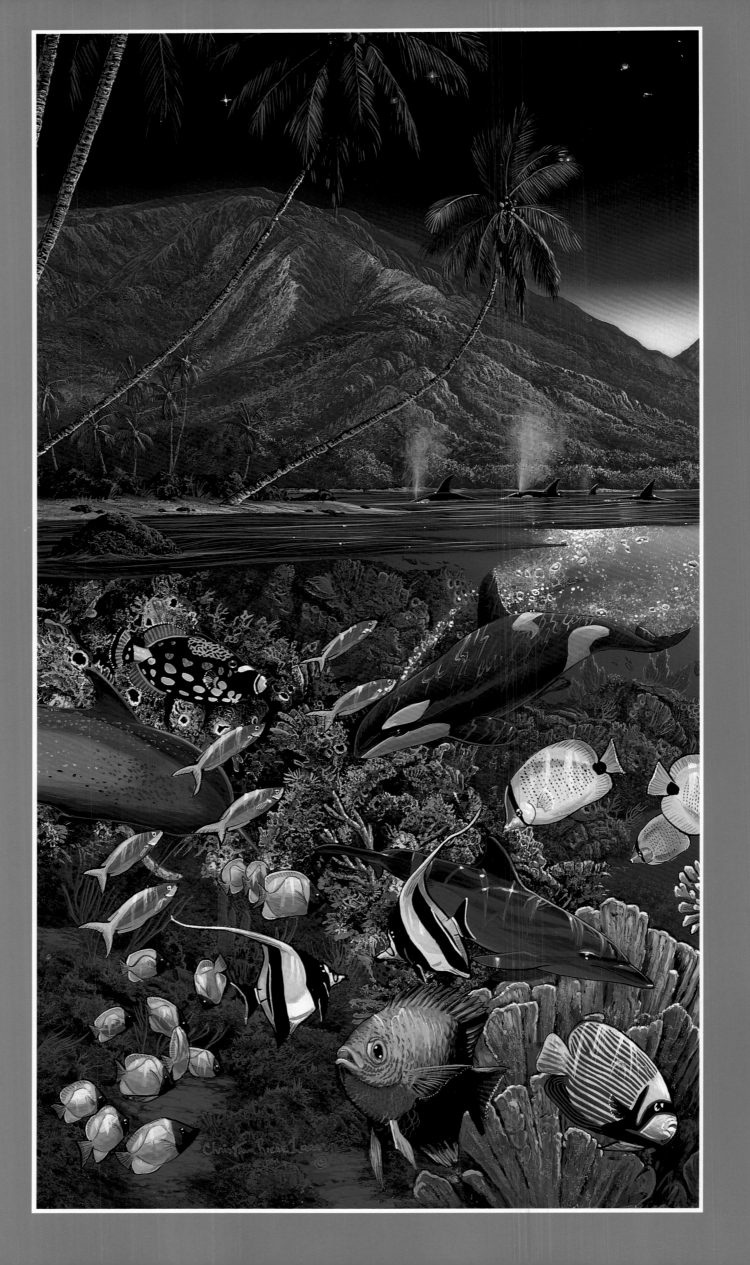

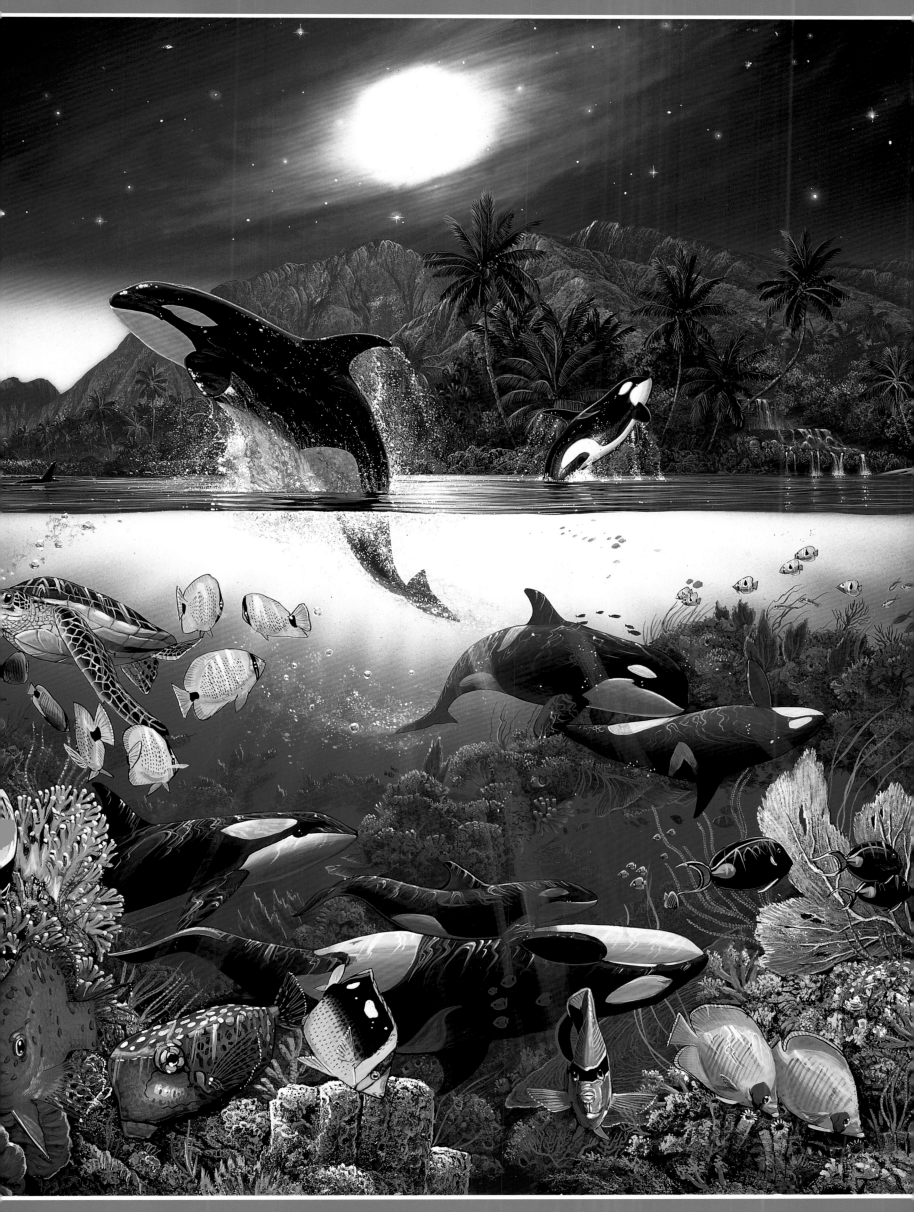

PLATE 52 • **HARMONY**

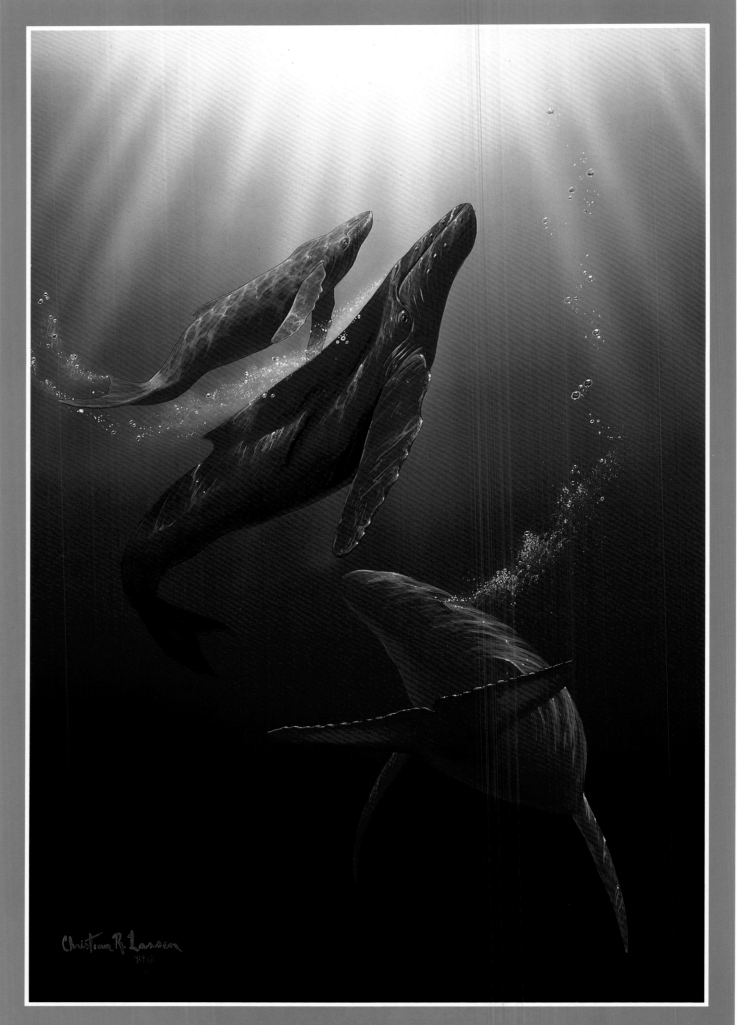

PLATE 53 • LORDS OF THE SEA

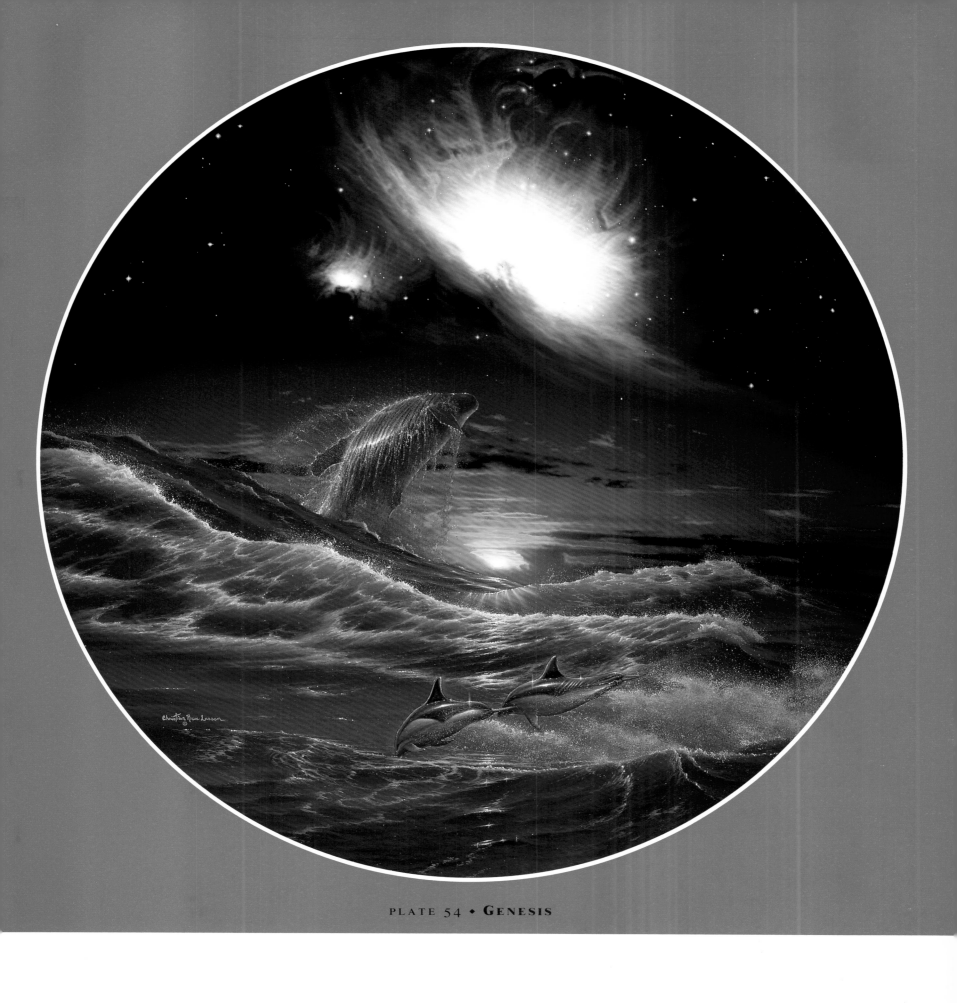

PLATE 54 ◆ **GENESIS**

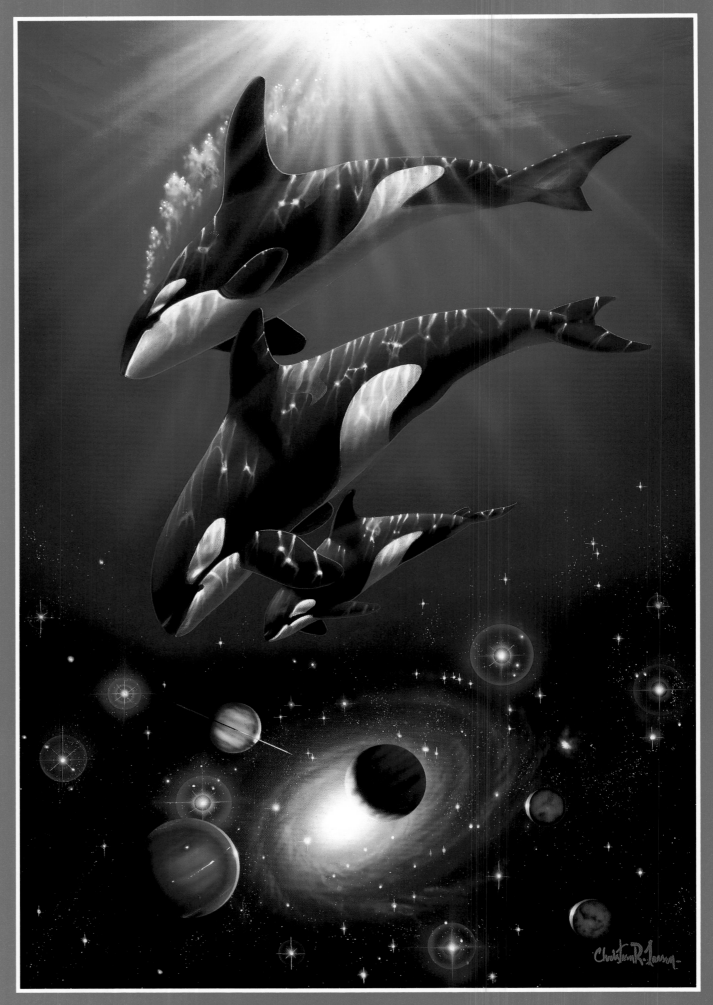

PLATE 55 ✦ **CHILDREN OF THE STARS**

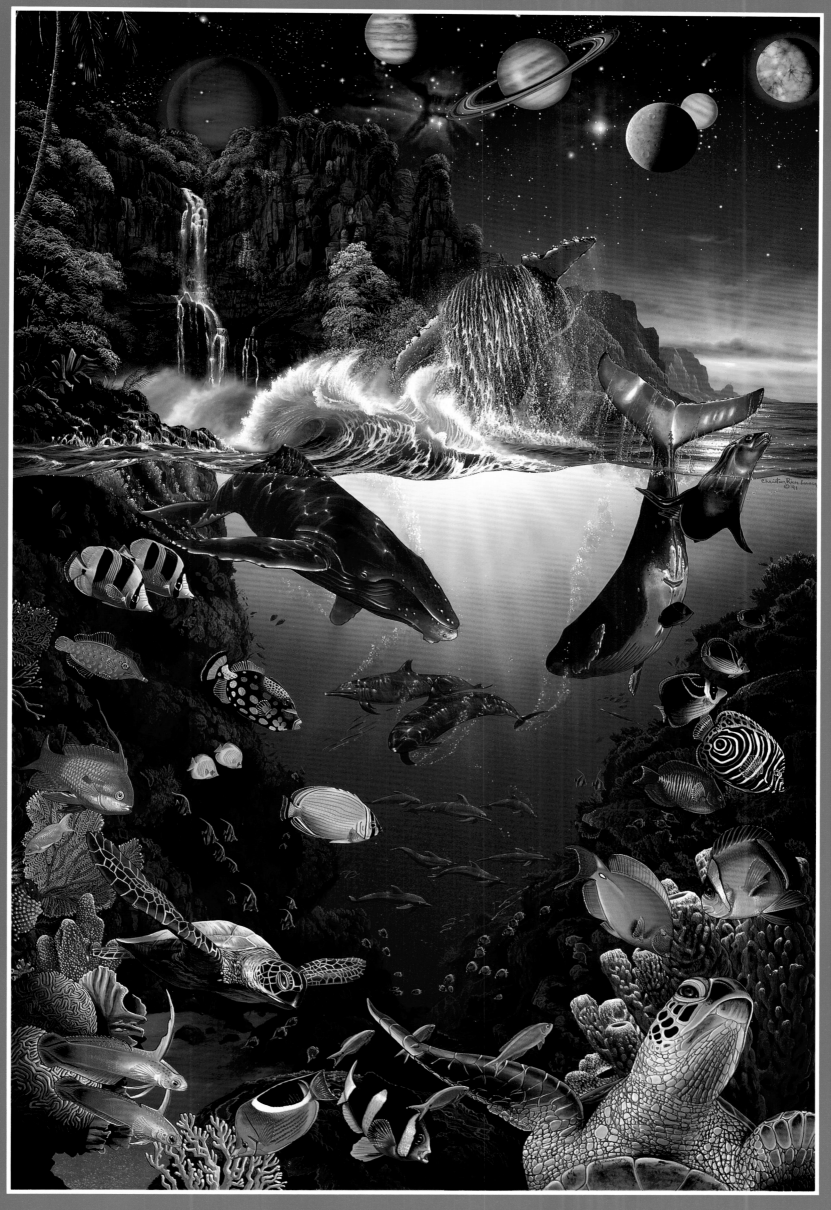

PLATE 56 • THE COSMOS

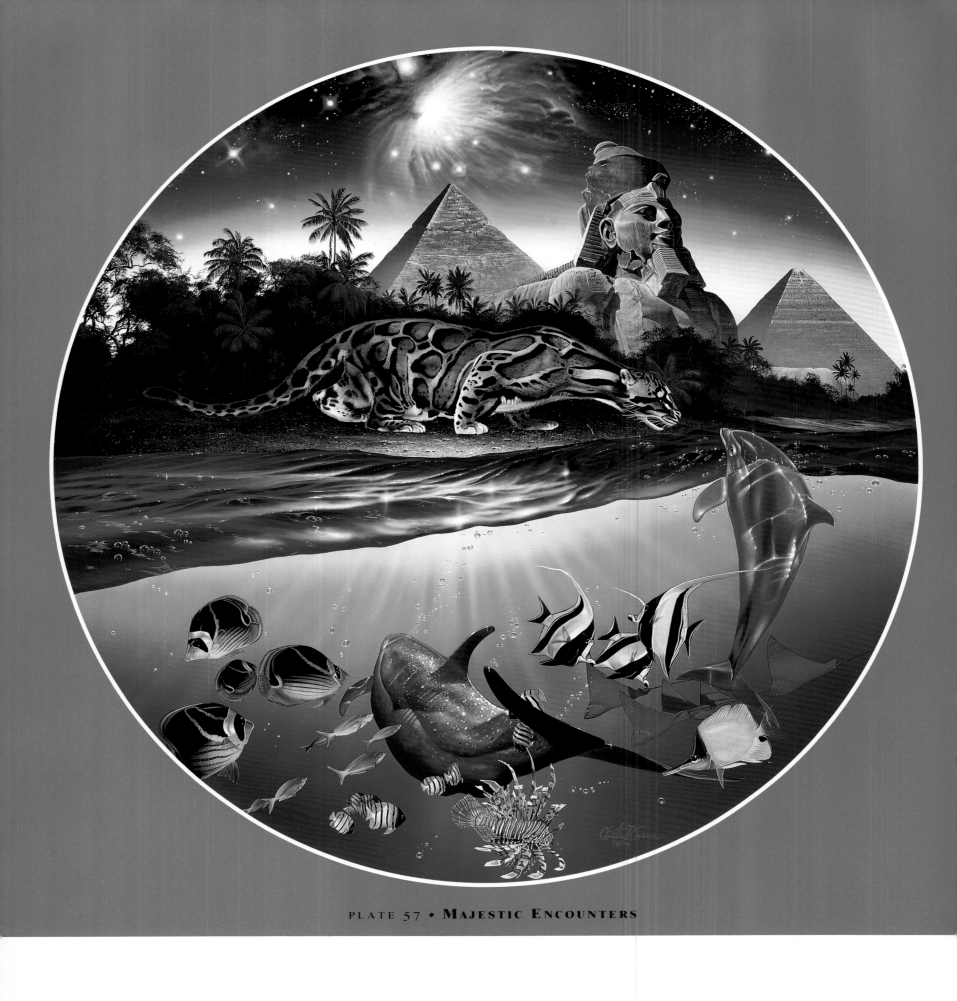

PLATE 57 • **MAJESTIC ENCOUNTERS**

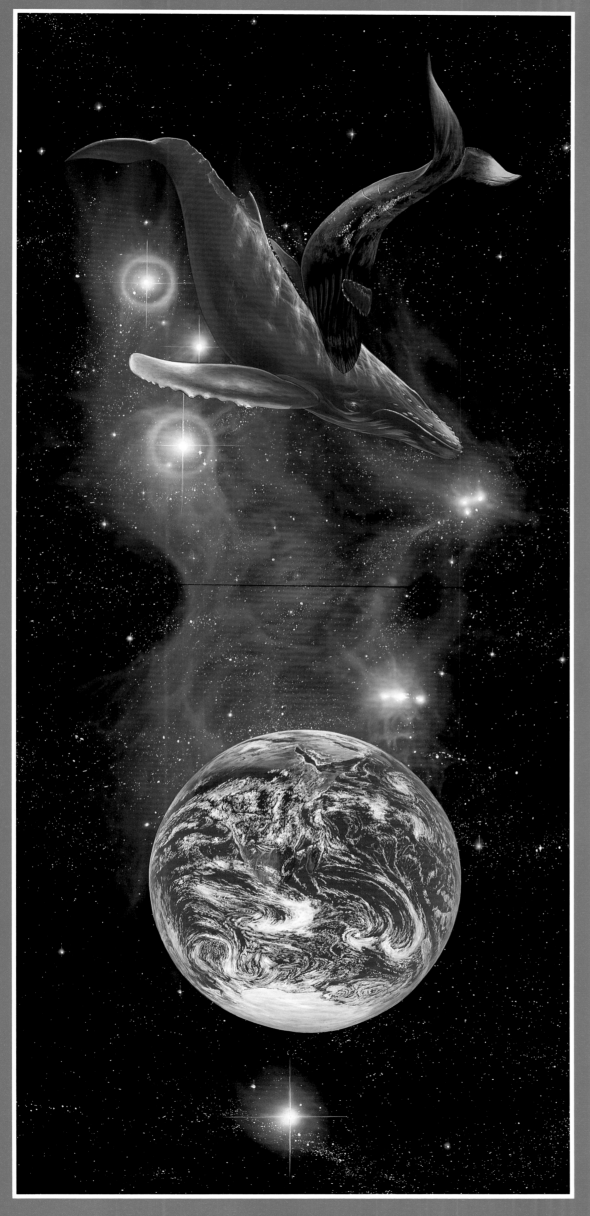

PLATE 61 ◆ **REVELATIONS**

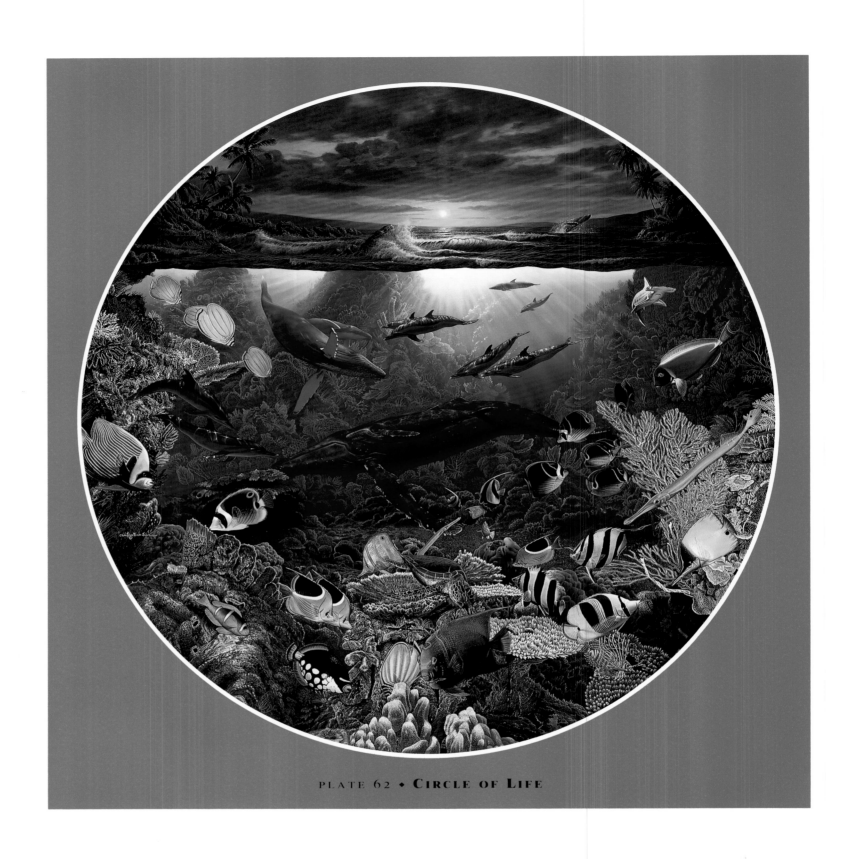

PLATE 62 ◆ **CIRCLE OF LIFE**

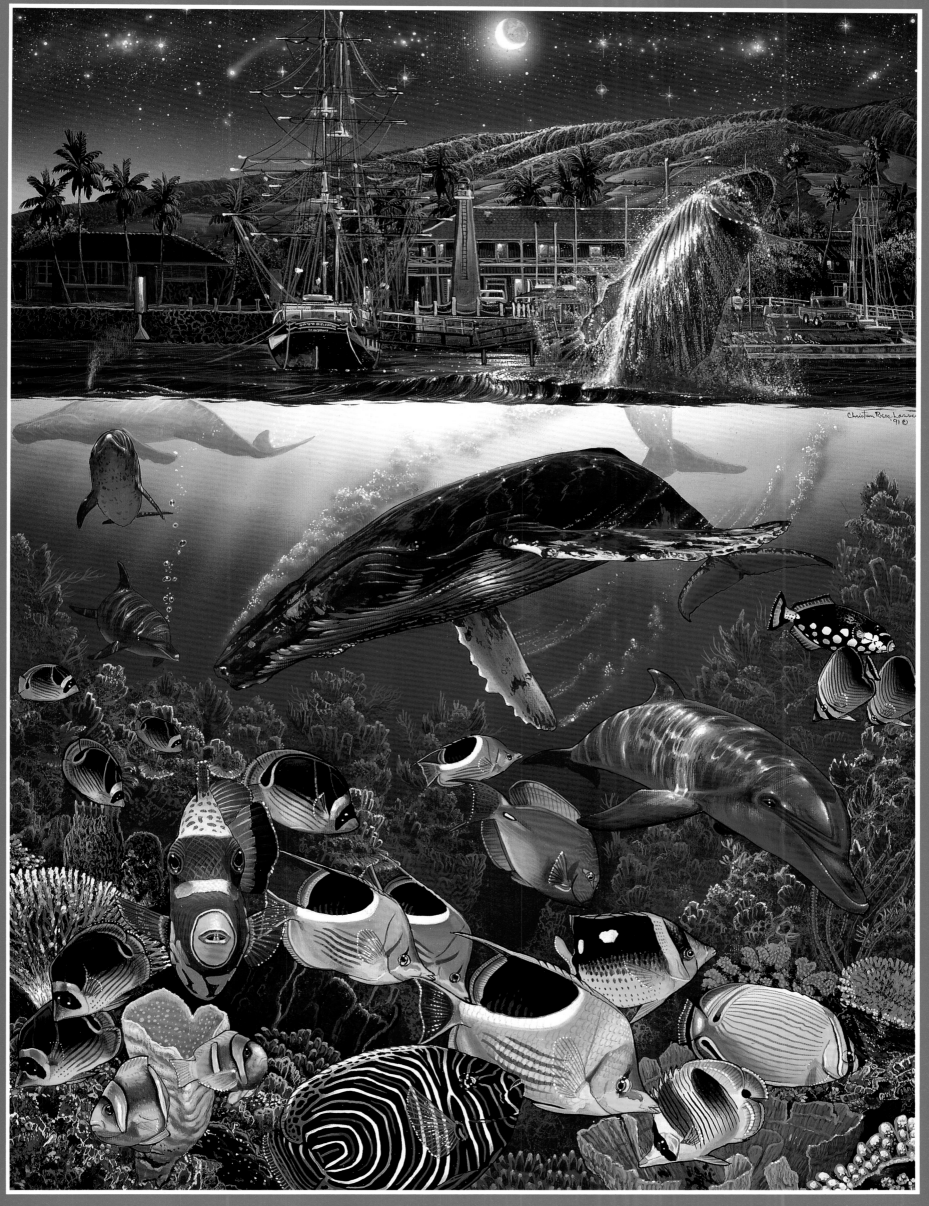

PLATE 63 ◆ CRYSTAL WATERS OF MAUI

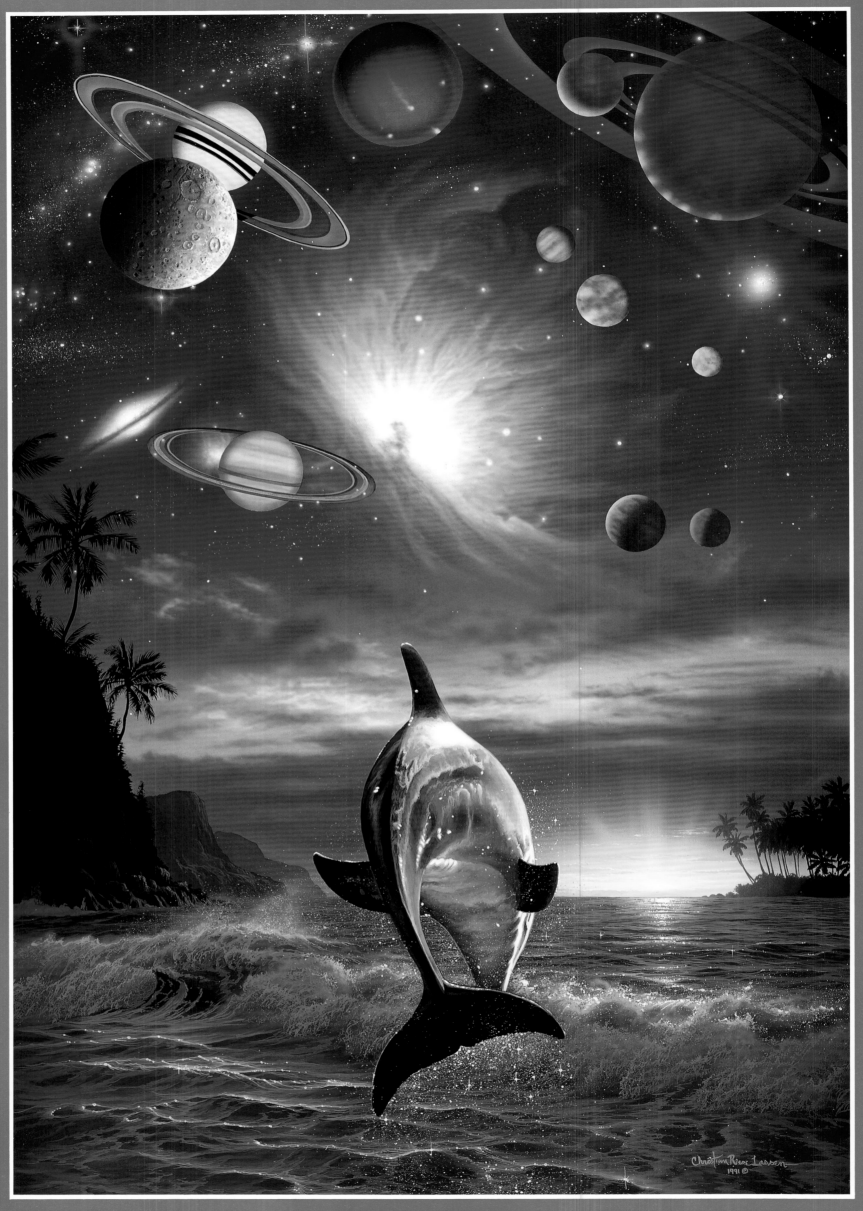

PLATE 64 ◆ **ETERNITY**

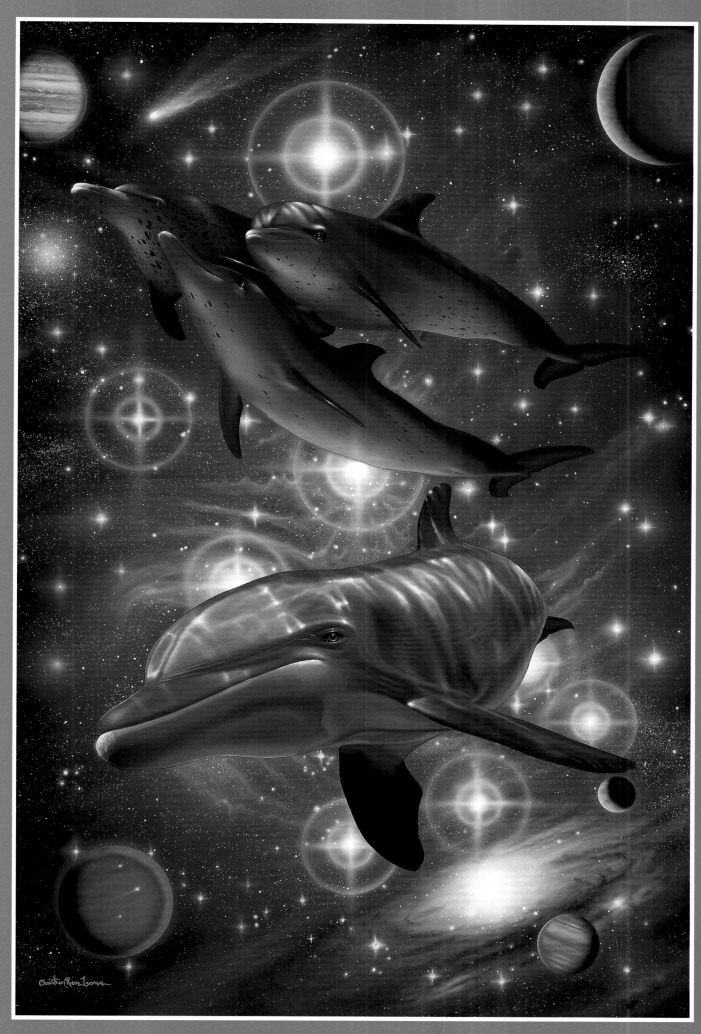

PLATE 65 • INFINITY

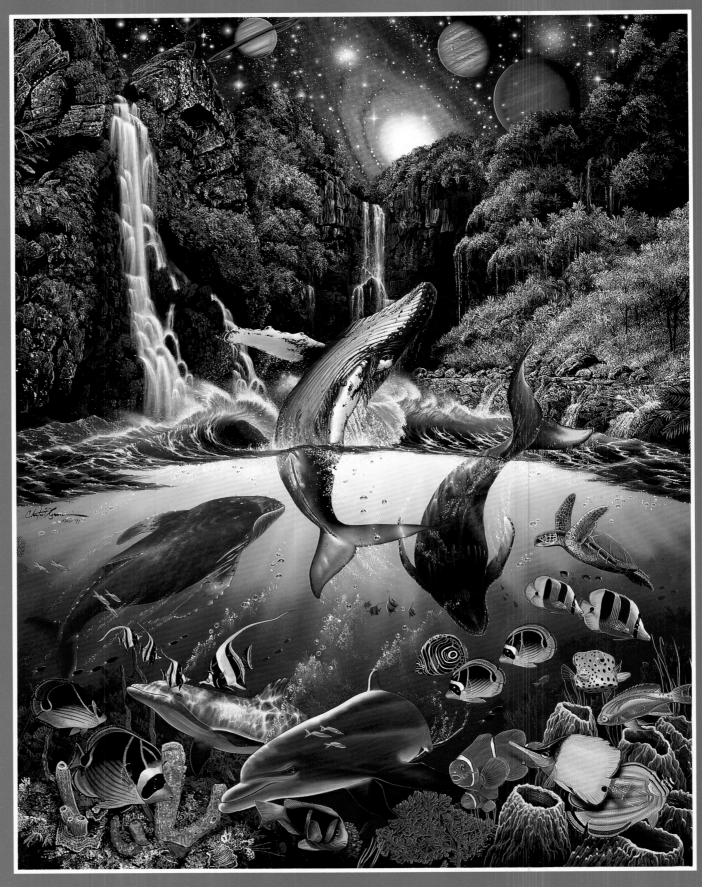

PLATE 66 ◆ **SANCTUARY**

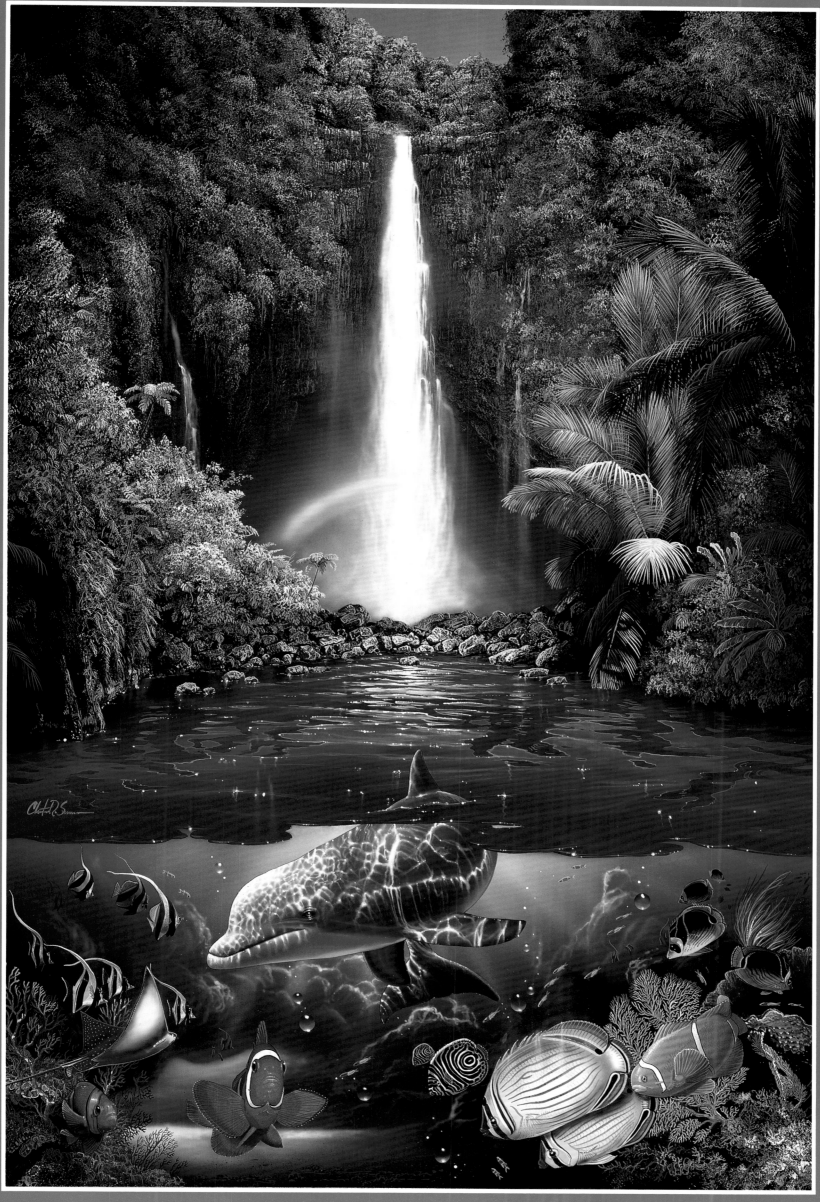

PLATE 67 • **KAHANA FALLS**

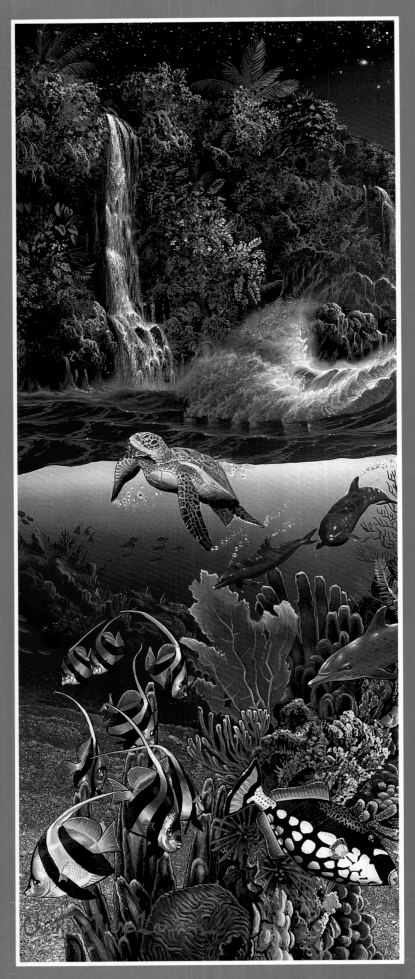
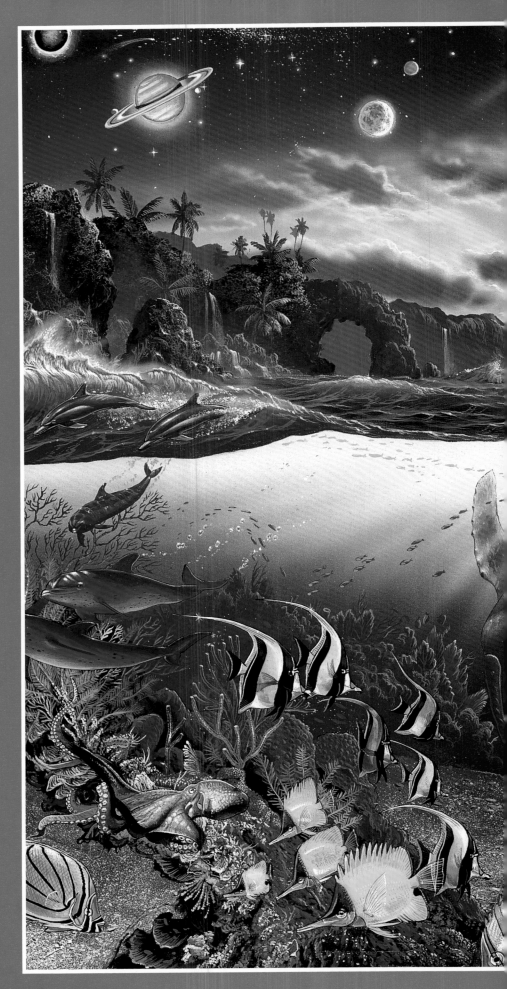

PLATE 68 ◆ MYSTIC PLACES

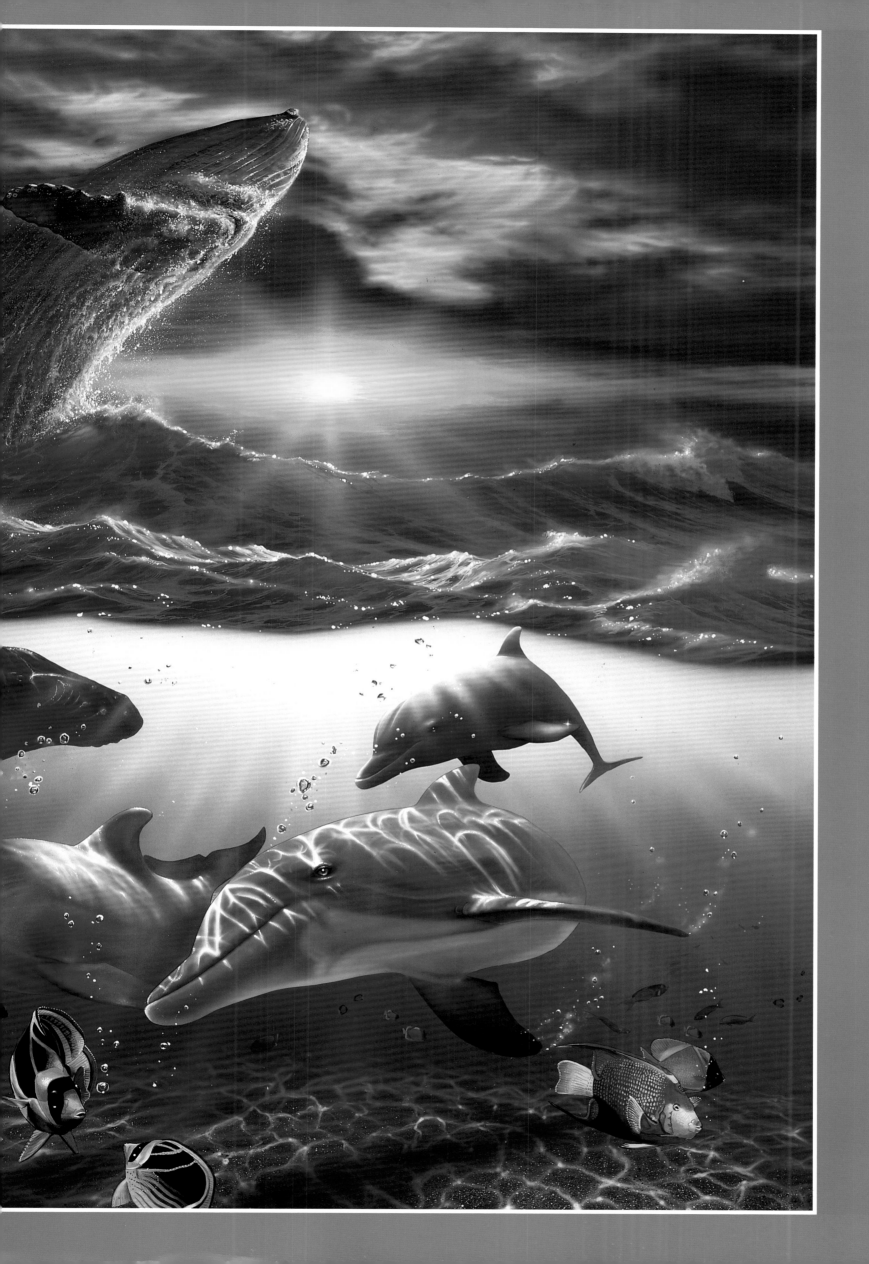

EXPLORATION

"That was the turning point of his life, I believe. The day he finished the self-portrait... From that point on he took control of his life. He had come to the realization that only he was in control of his own destiny."

—CAROL RIESE LASSEN

"That was the turning
point of his life, I believe.

The day he finished
the self-portrait...

From that point on
he took control of his life.

He had come to the
realization that only he

was in control
of his own destiny."

—CAROL RIESE LASSEN

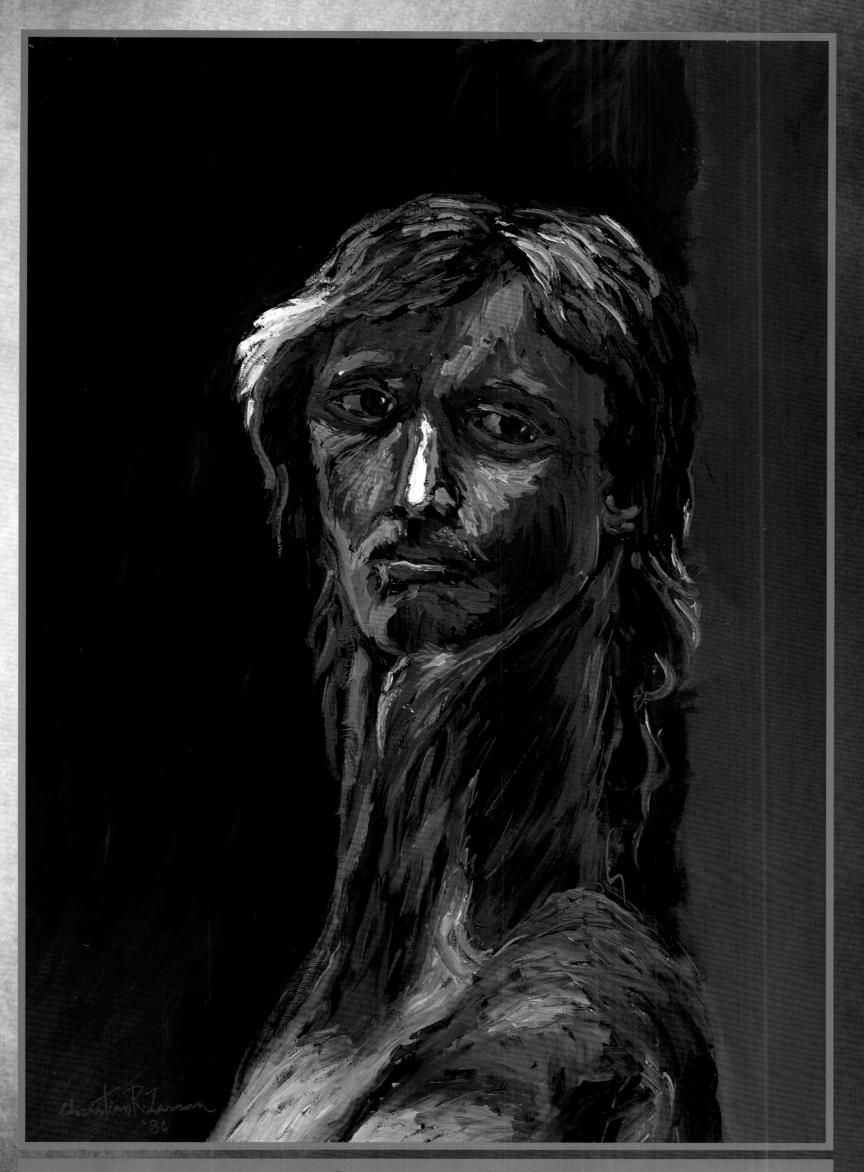

PLATE 70 • **IMPRESSIONISTIC SELF-PORTRAIT**

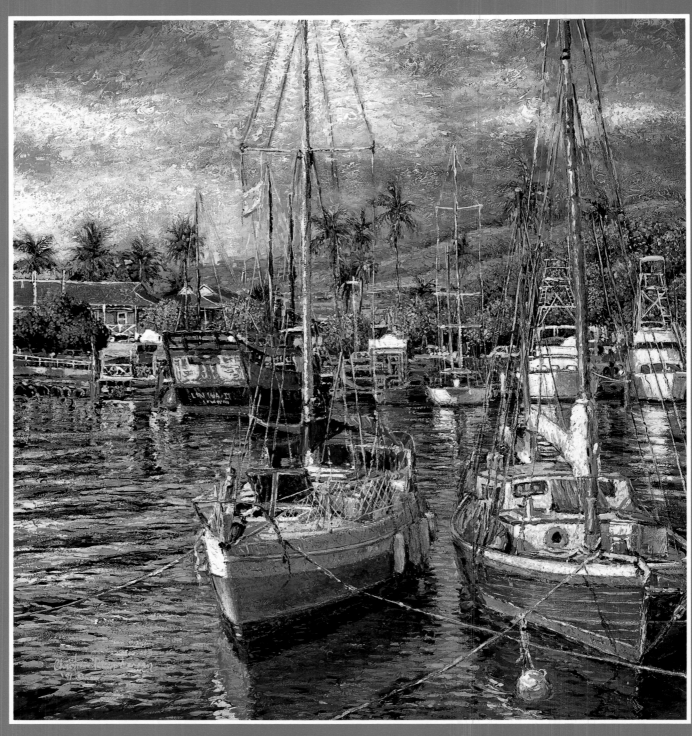

PLATE 71 ◆ **IMPRESSIONS OF MAUI**

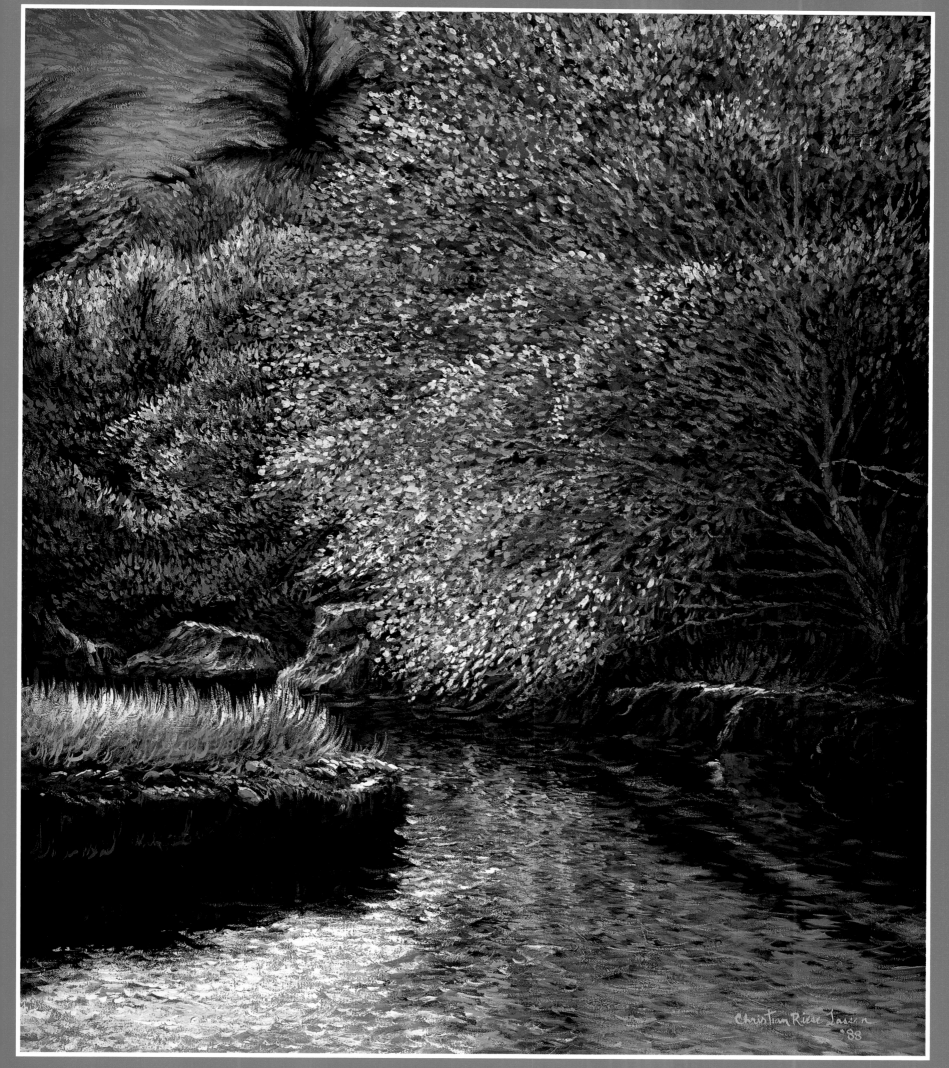

PLATE 72 ♦ **MAUI GARDENS**

The artist's 1985 trip to Europe—and especially his visits to the Louvre in Paris—inspired him to experiment with a variety of new approaches to his medium and milieu. The result was an outpouring of wonderful impressionist, abstract impressionist, expressionist, and abstract paintings reflecting, too, a broader topical palette.

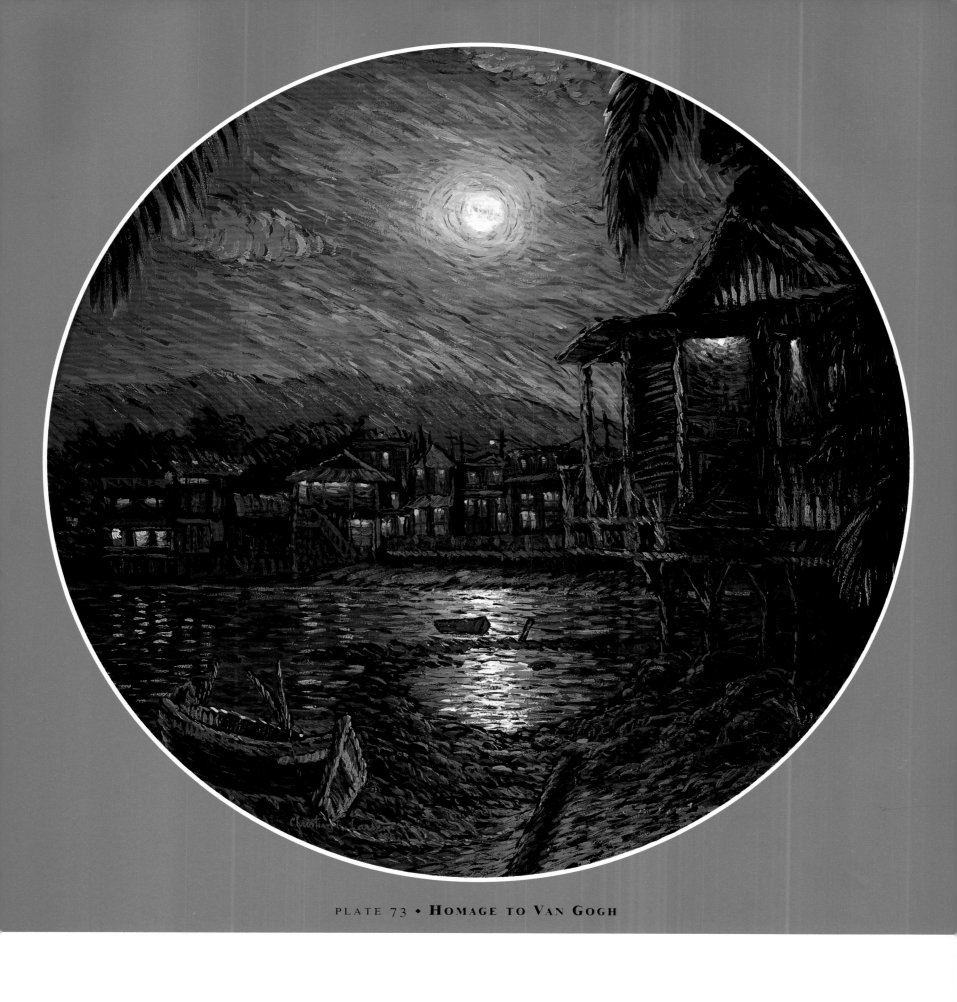

PLATE 73 ◆ **HOMAGE TO VAN GOGH**

PLATE 74 • KOI IMPRESSIONS

PLATE 75 • **KANAHA POND**

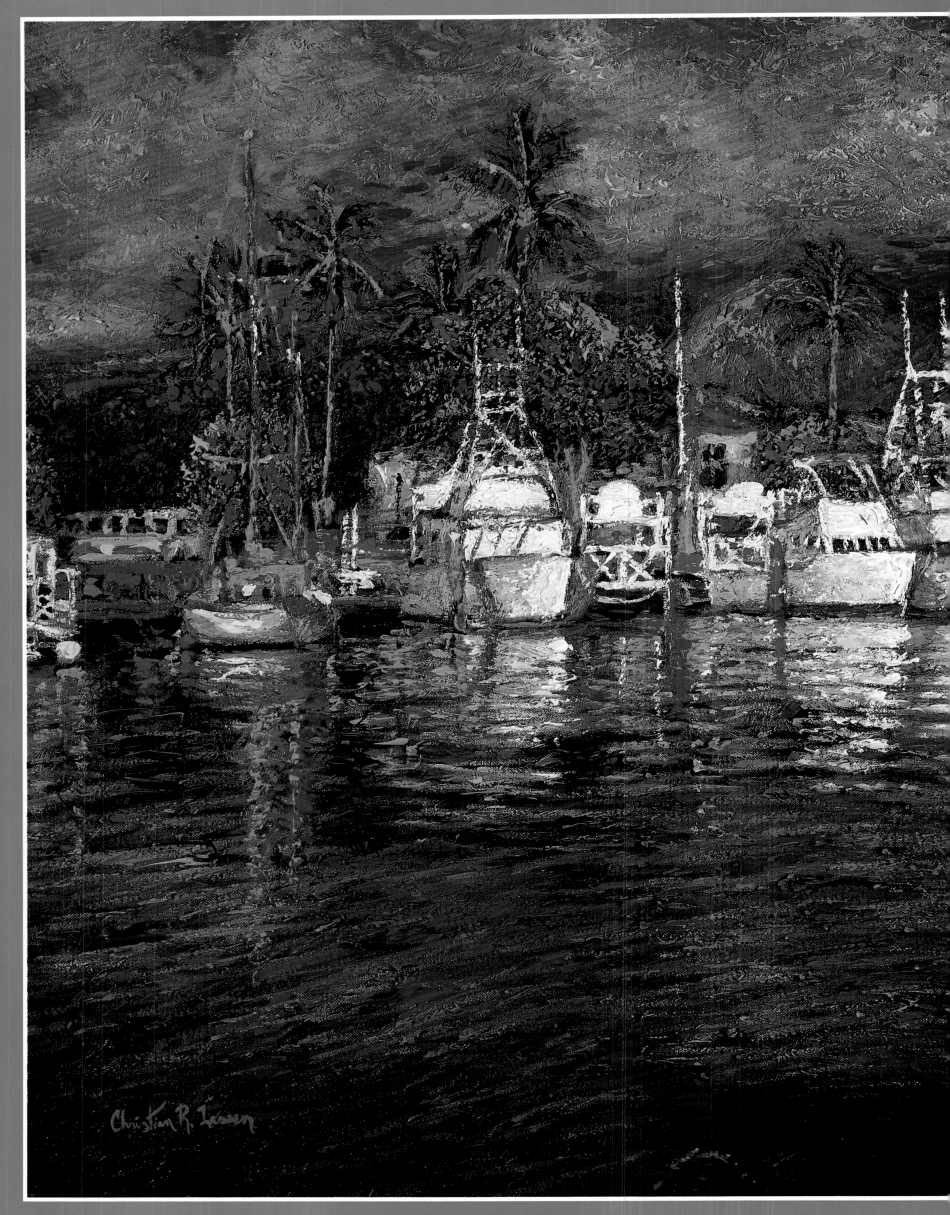

Christian R. Lassen

PLATE 76 • **MAUI COLORS**

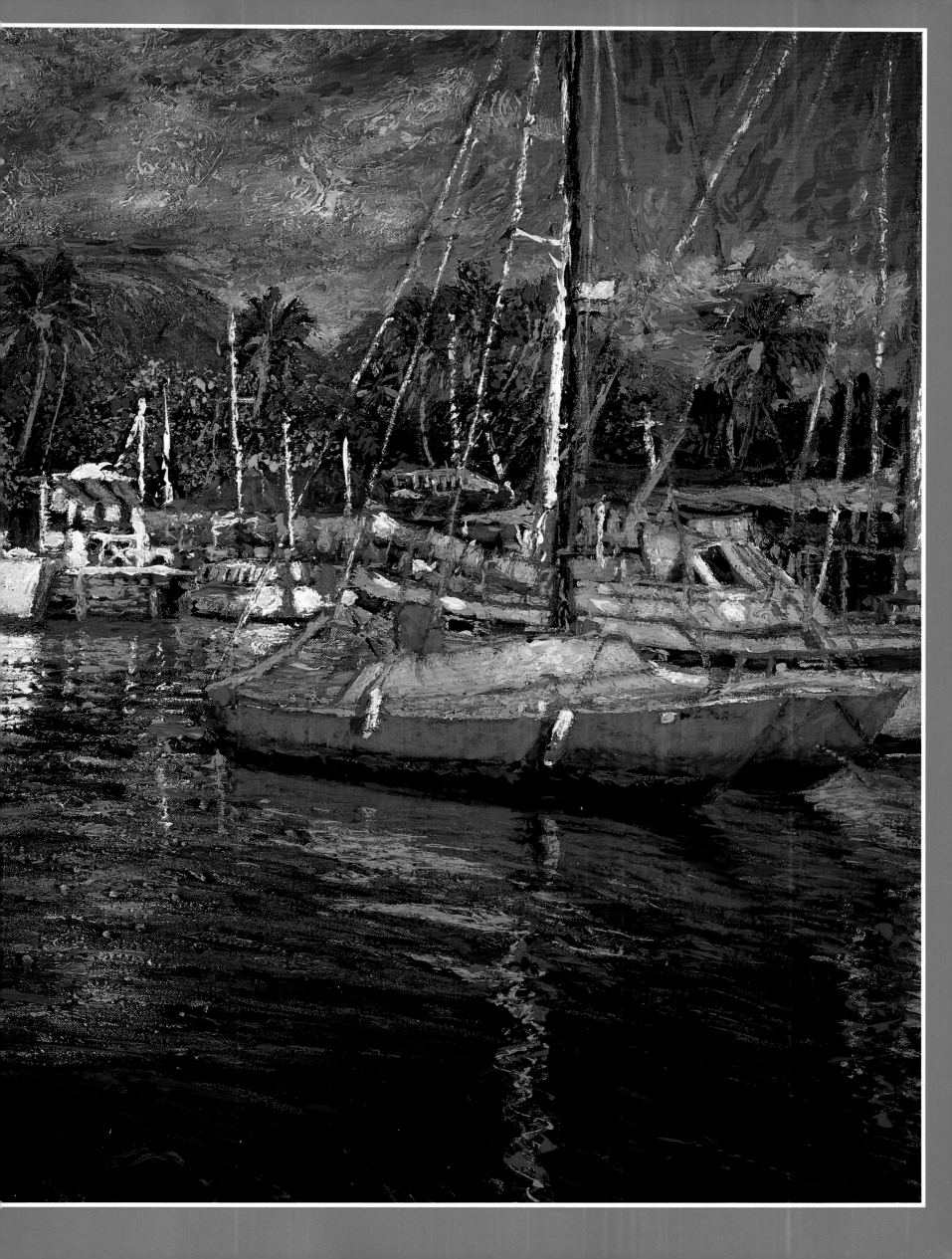

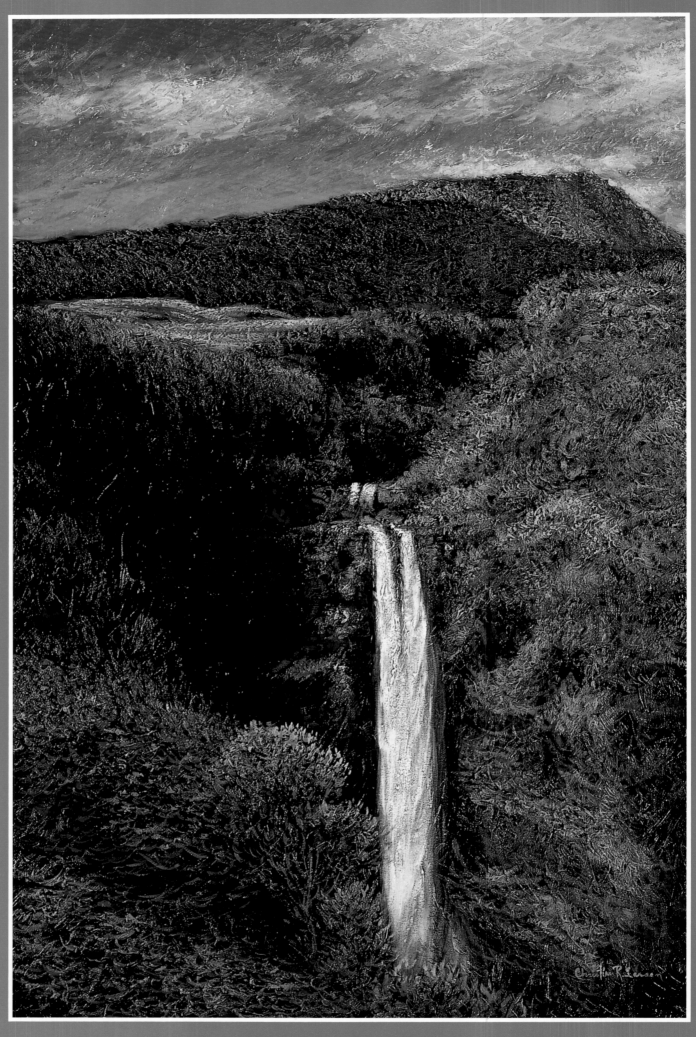

PLATE 77 • **TWIN FALLS**

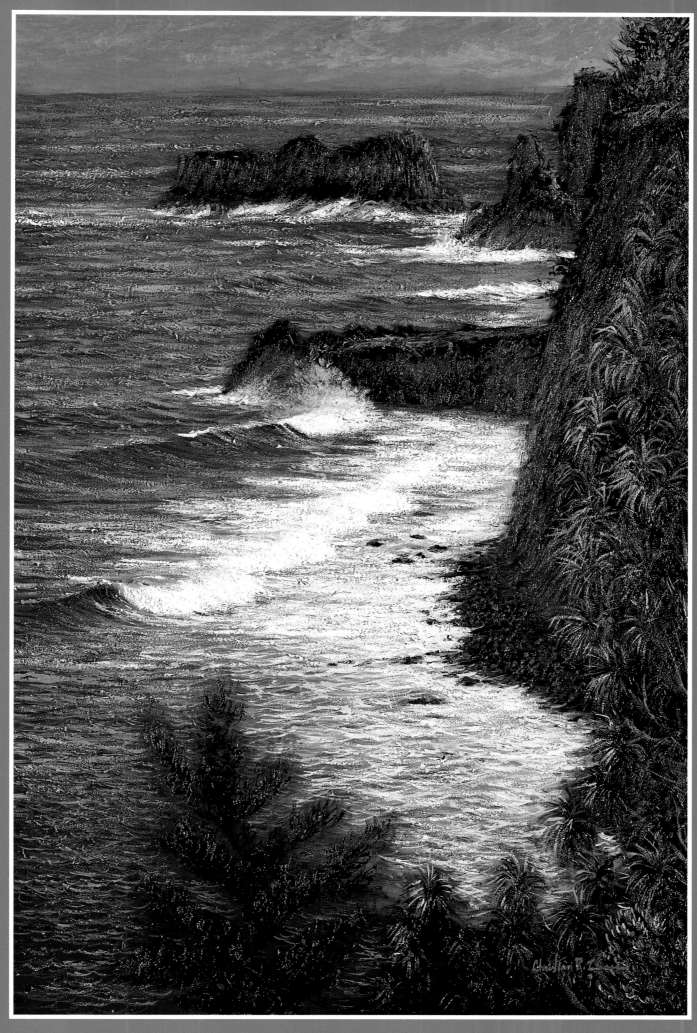

PLATE 78 ◆ **HANA COAST**

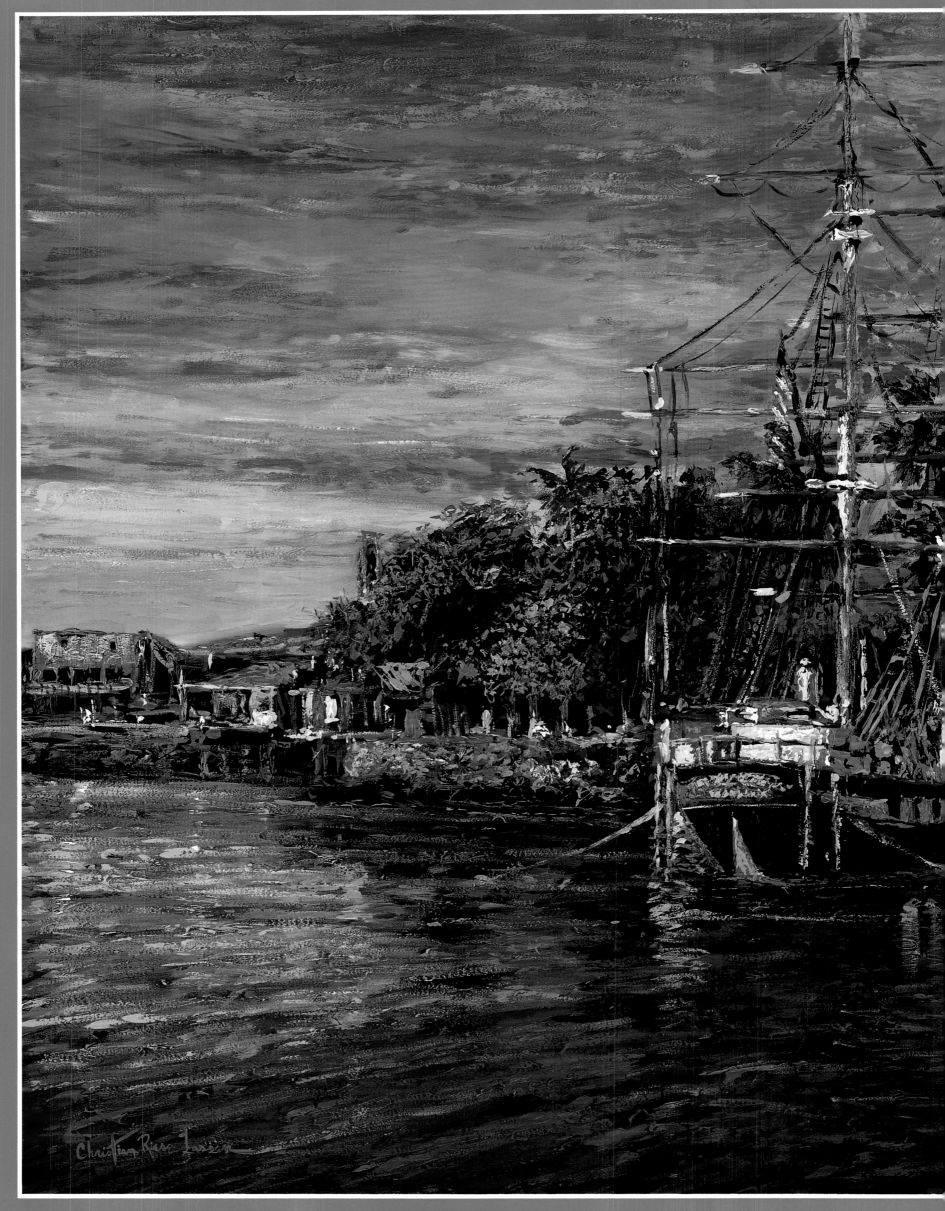

PLATE 79 • LAHAINA IMPRESSIONS

A derivative of semi-abstraction and impressionism with the illusory depth created by the application of shadows and shapes that appear to be floating within the image, Lassen's kinetic style is an extra-ordinarily involving way to capture sport. "Sport usually deals with a lot of motion and kinetic energy," the artist explains. "In all the sports and subjects I chose to paint in this way, I seem to have been able to capture some of the elements of speed and force in the act of performance."

PLATE 83 • **IMPACT II**

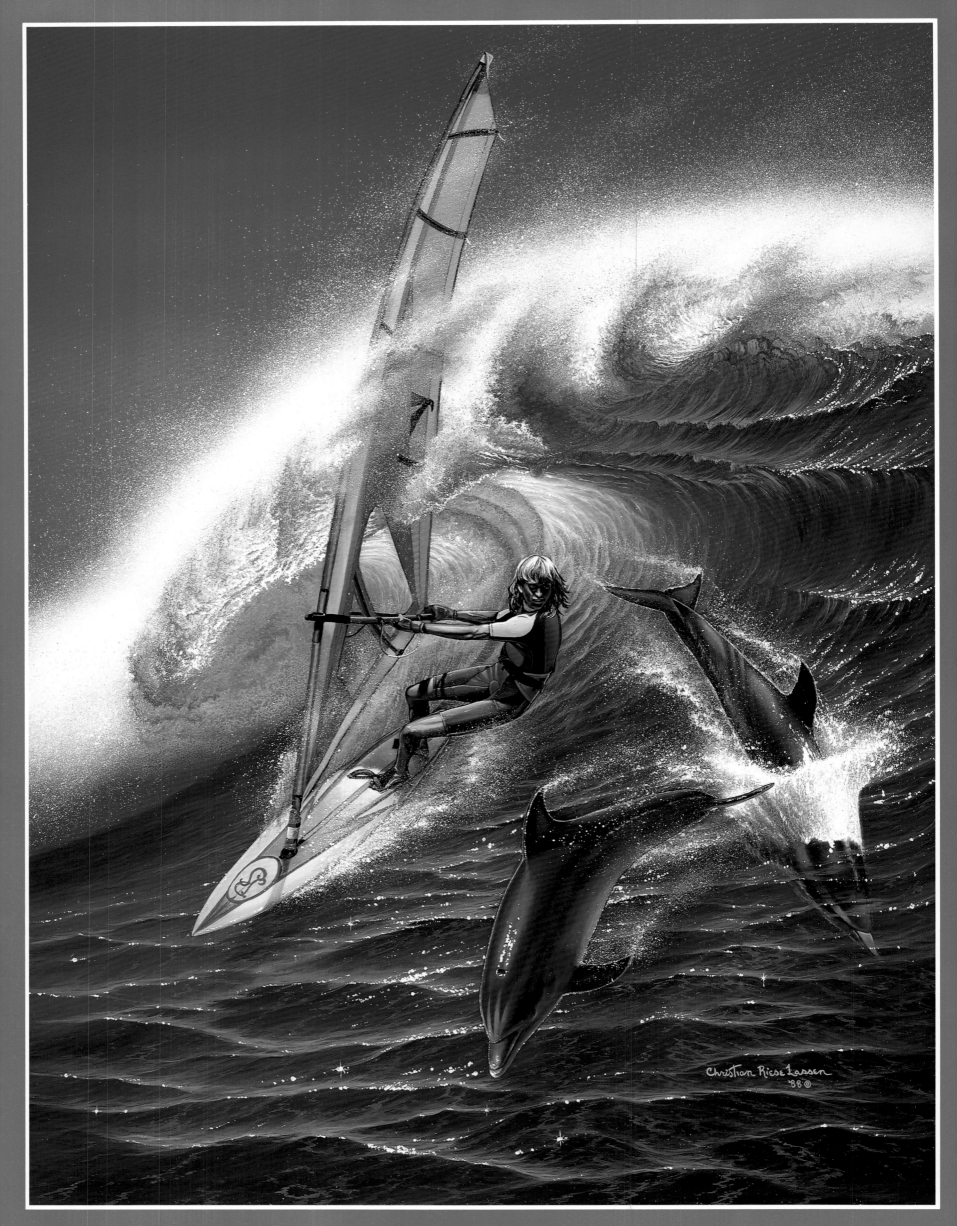

PLATE 84 • **WIND SURF FANTASY**

PLATE 85 • **POWER DRIVE**

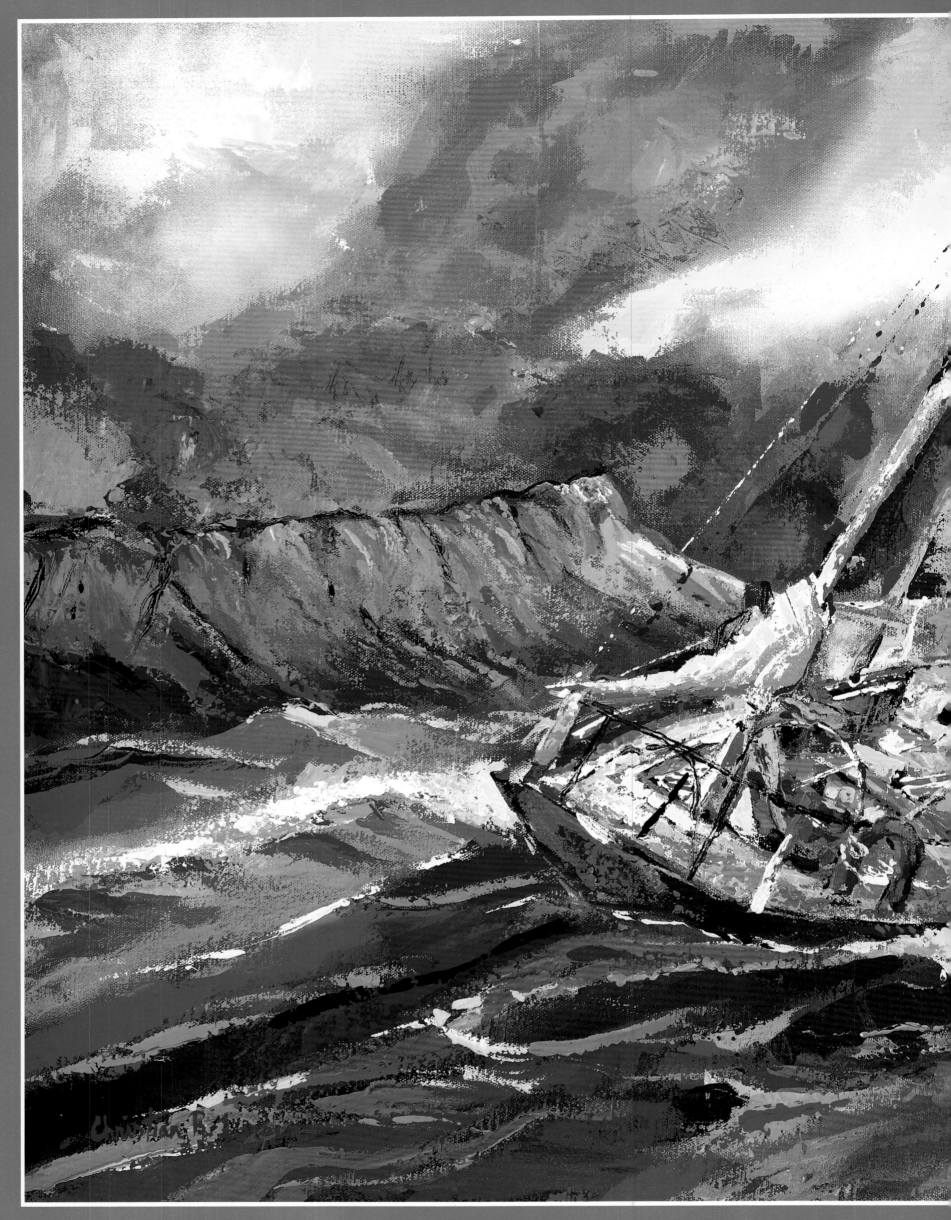

PLATE 86 • **WINDWARD PASSAGE**

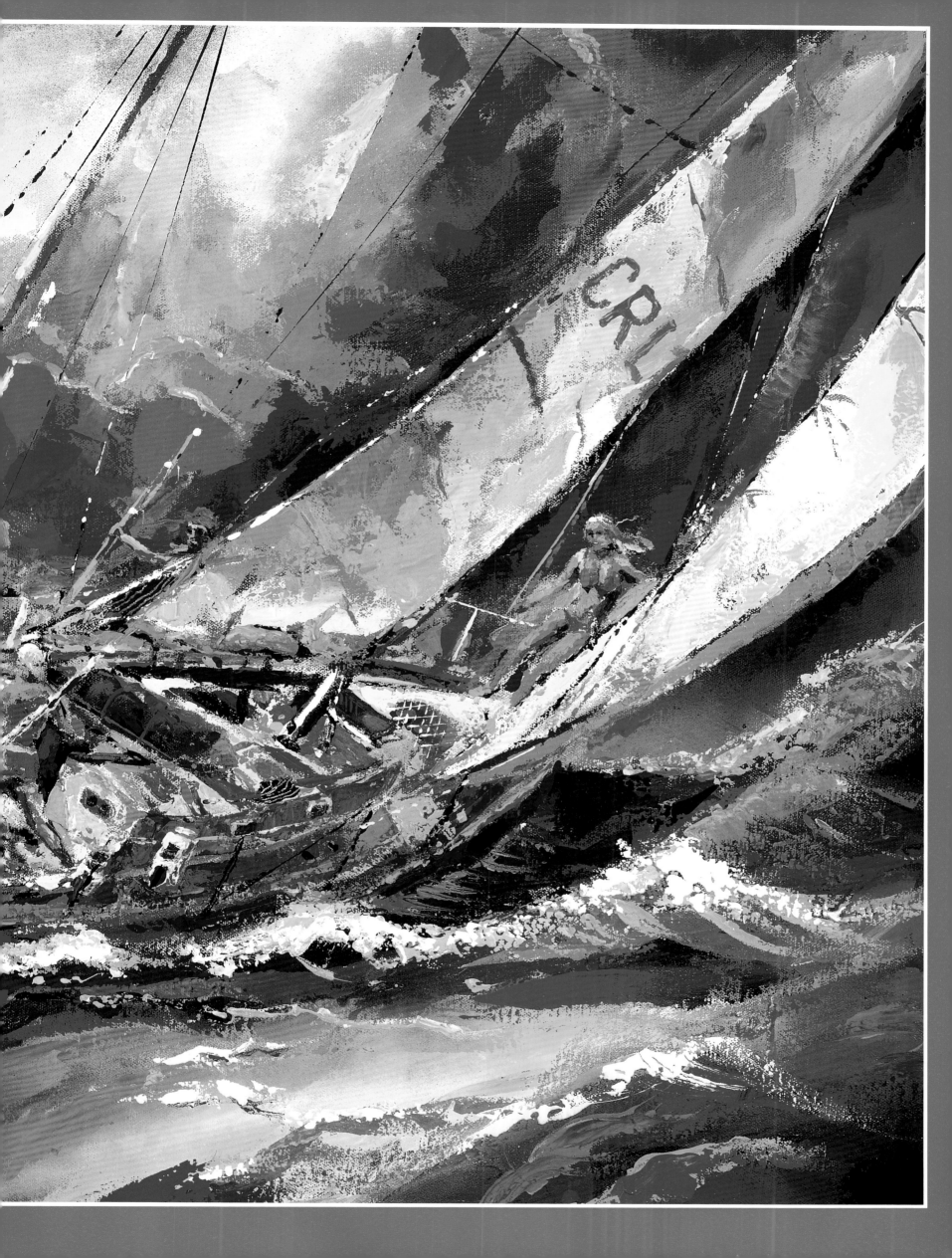

PLATE 87 ◆ **FREESTYLE**

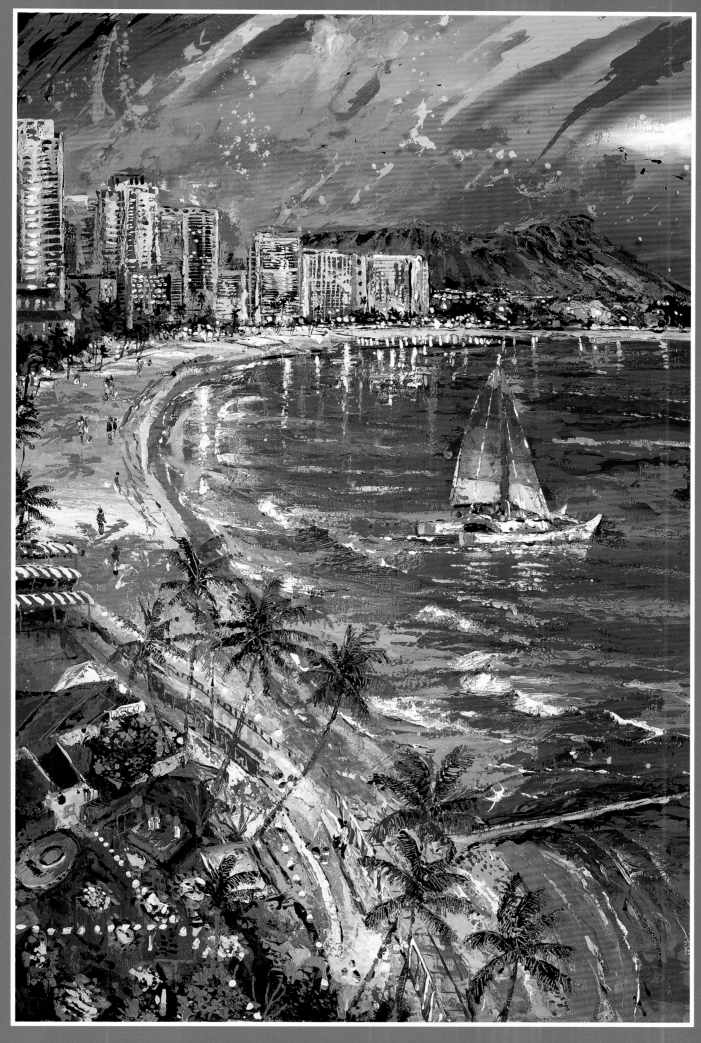

PLATE 88 • **Waikiki Nights**

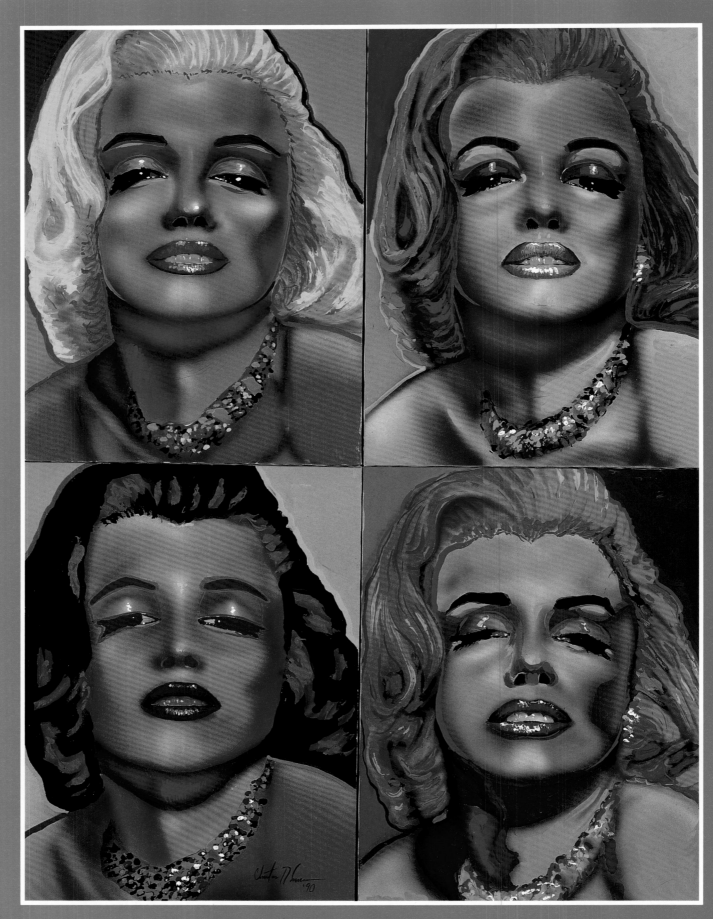

PLATE 89 • **Four Marilyns**

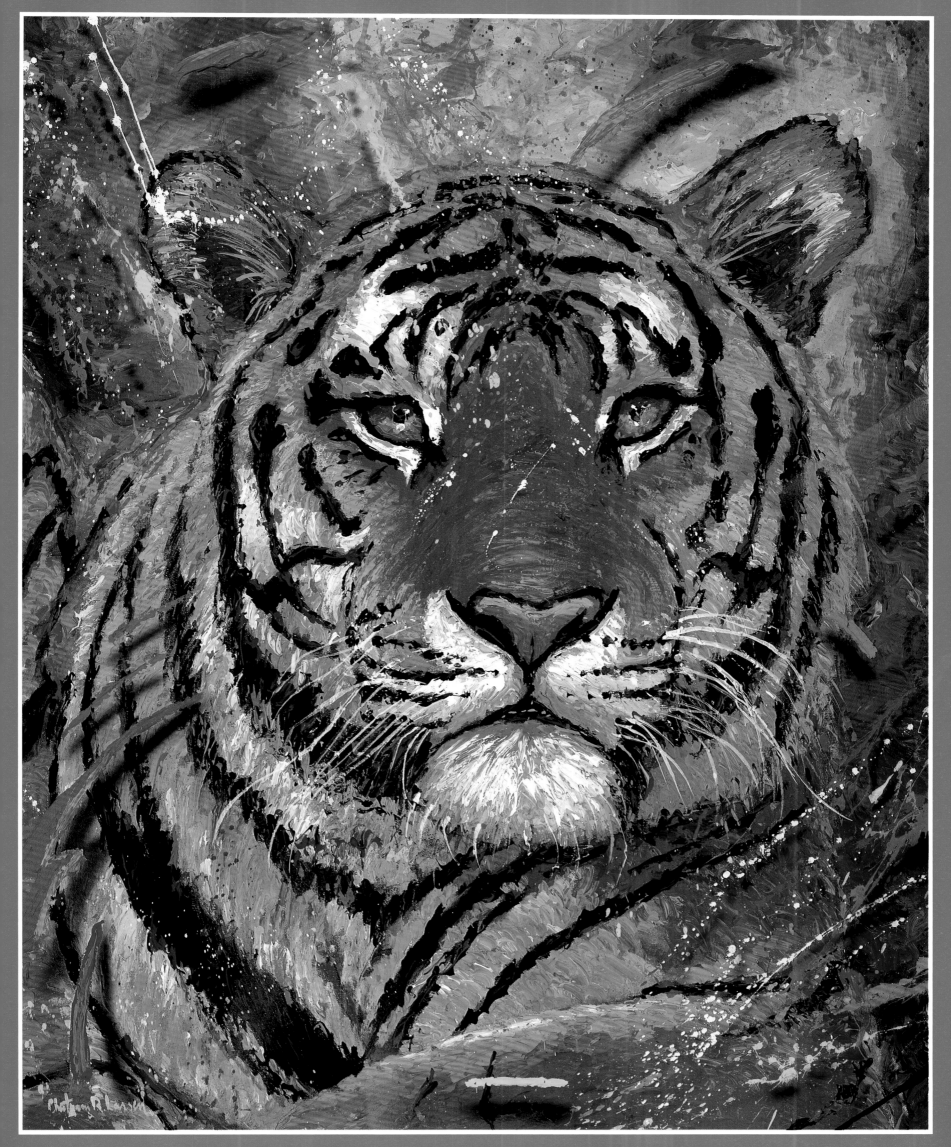

PLATE 90 • **TIGER**

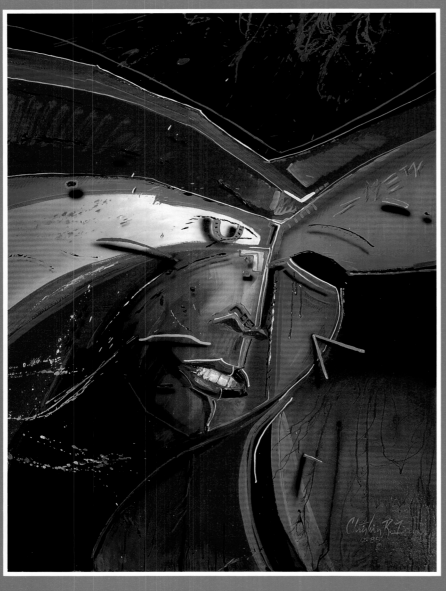

PLATE 91 ◆ **SAY YES**

PLATE 92 ◆ **EXIT**

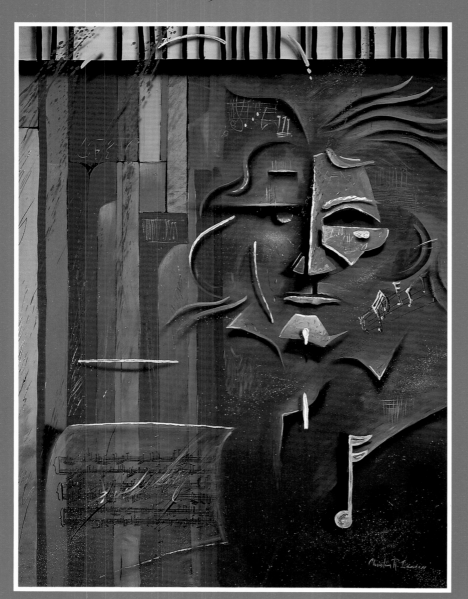

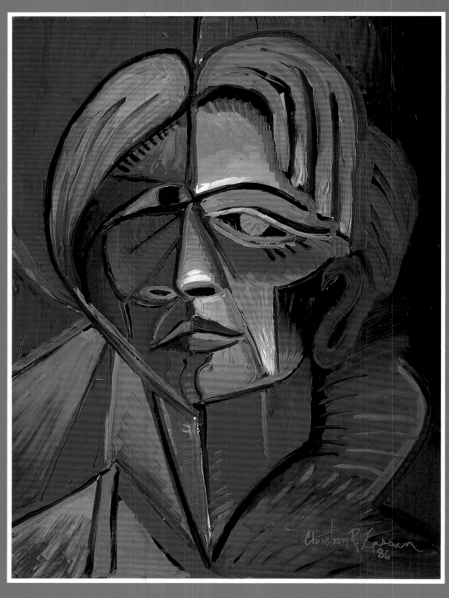

PLATE 93 ◆ **BEETHOVEN**

PLATE 94 ◆ **CUBIST SELF-PORTRAIT**

PLATE 95 • **GOLD LEAF MASK**

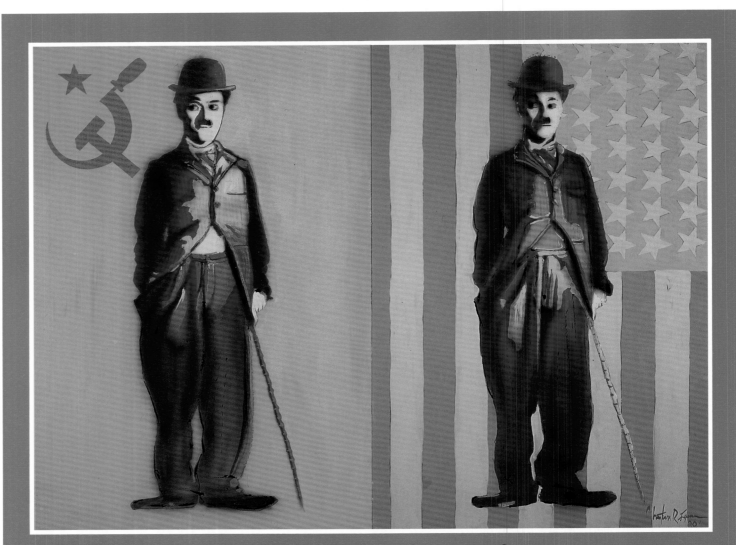

PLATE 96 • **Charlie Chaplin x 2**

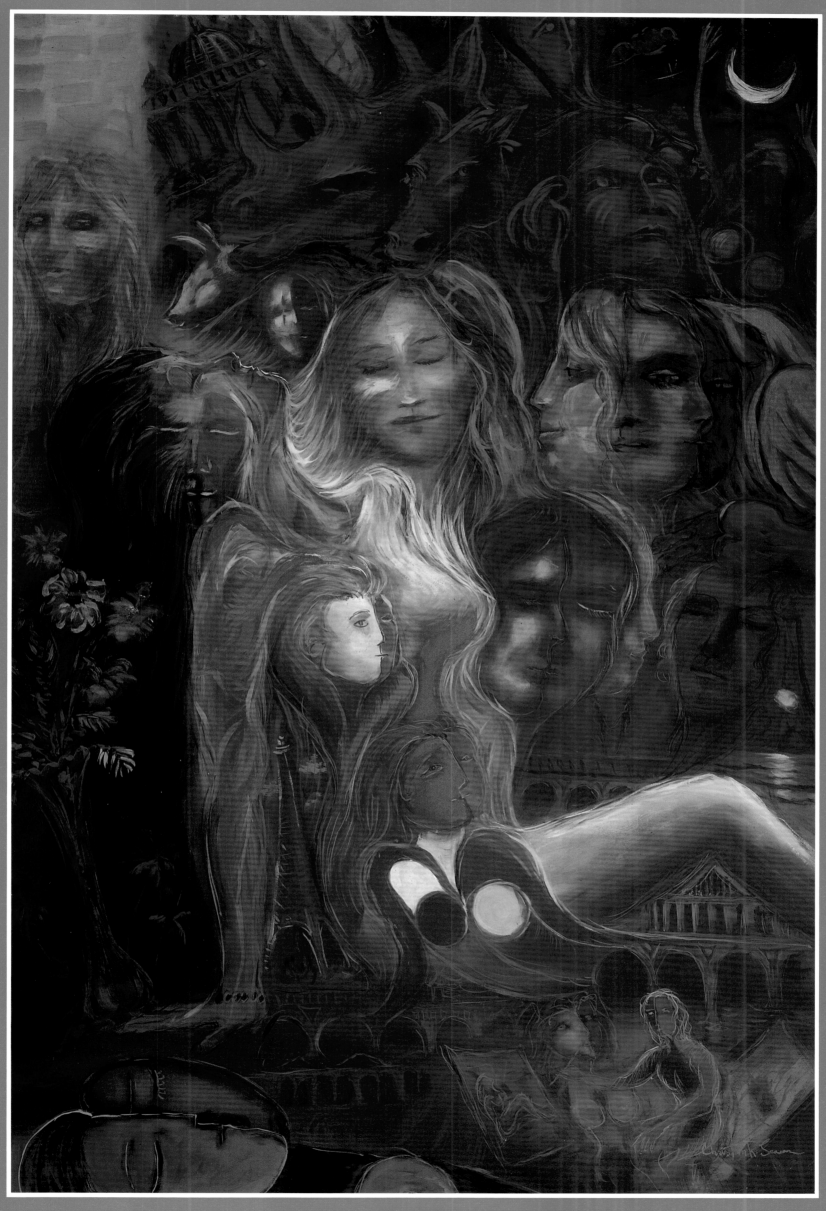

PLATE 97 • **DREAM**

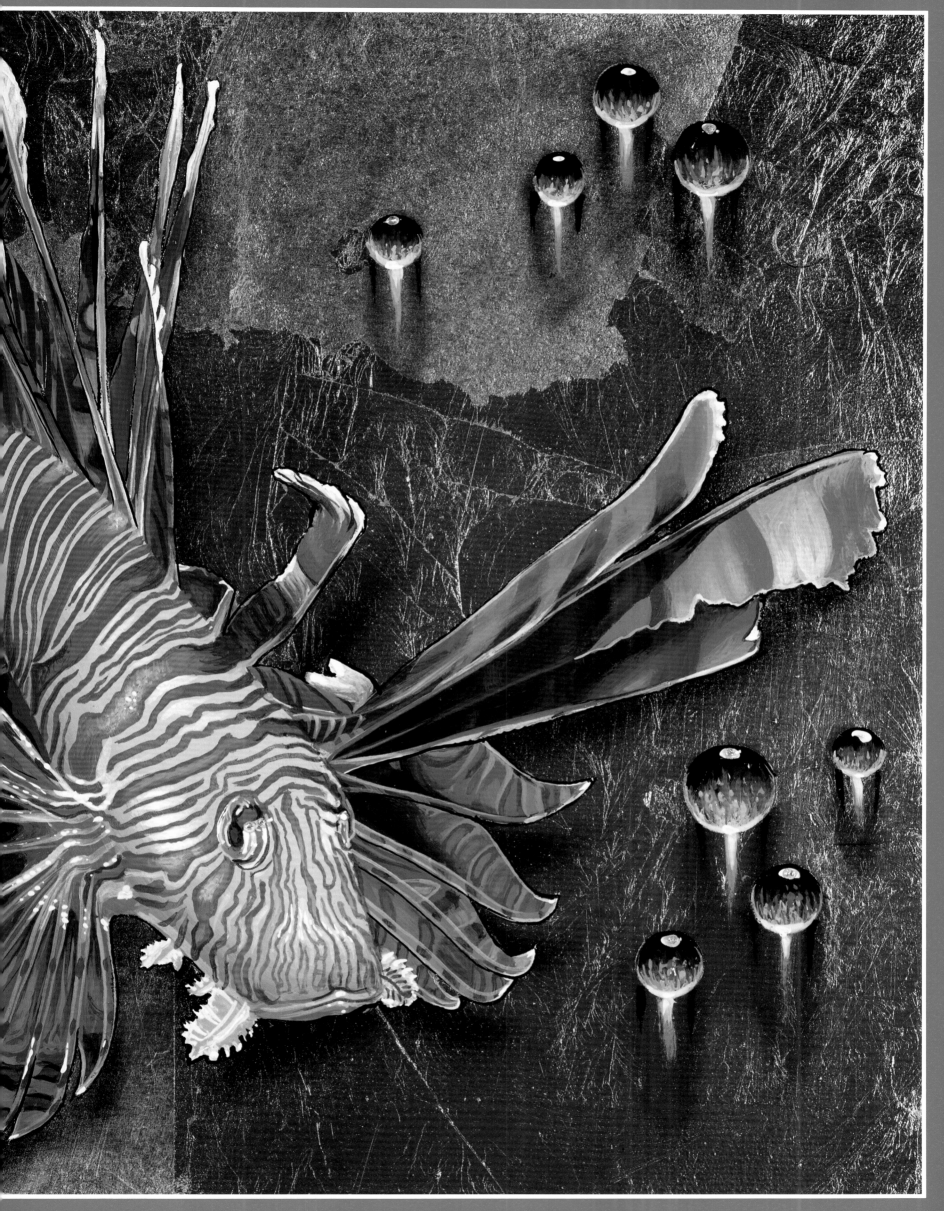

PLATE 98 ◆ **LION OF THE SEA**

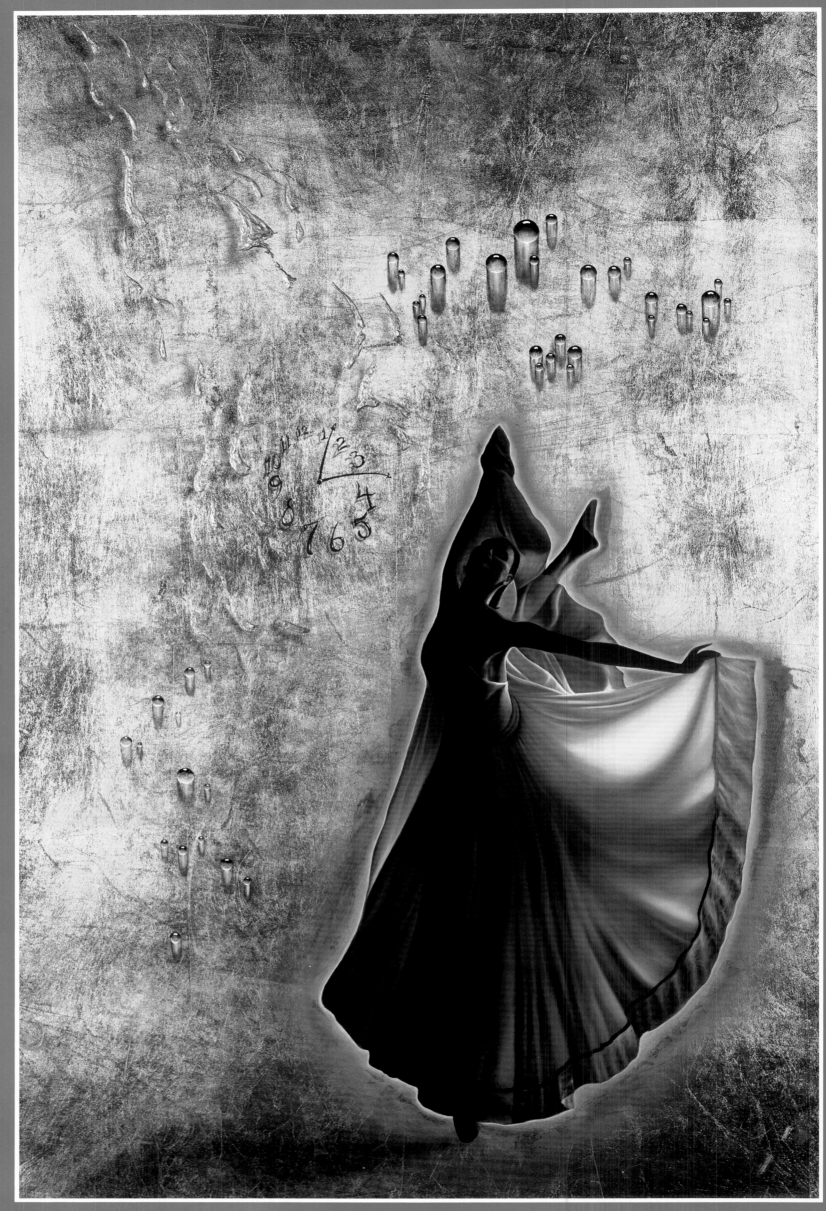

PLATE 99 ◆ **TIMELESS DANCE**

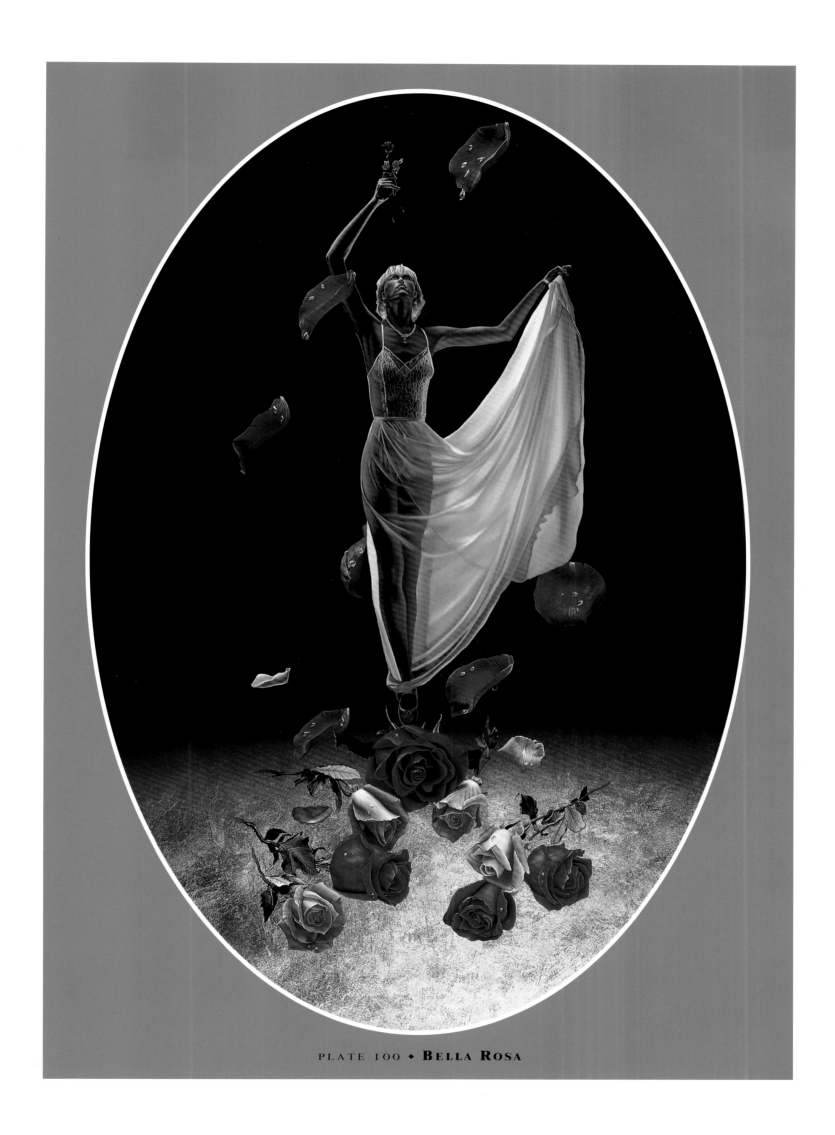

PLATE 100 • **BELLA ROSA**

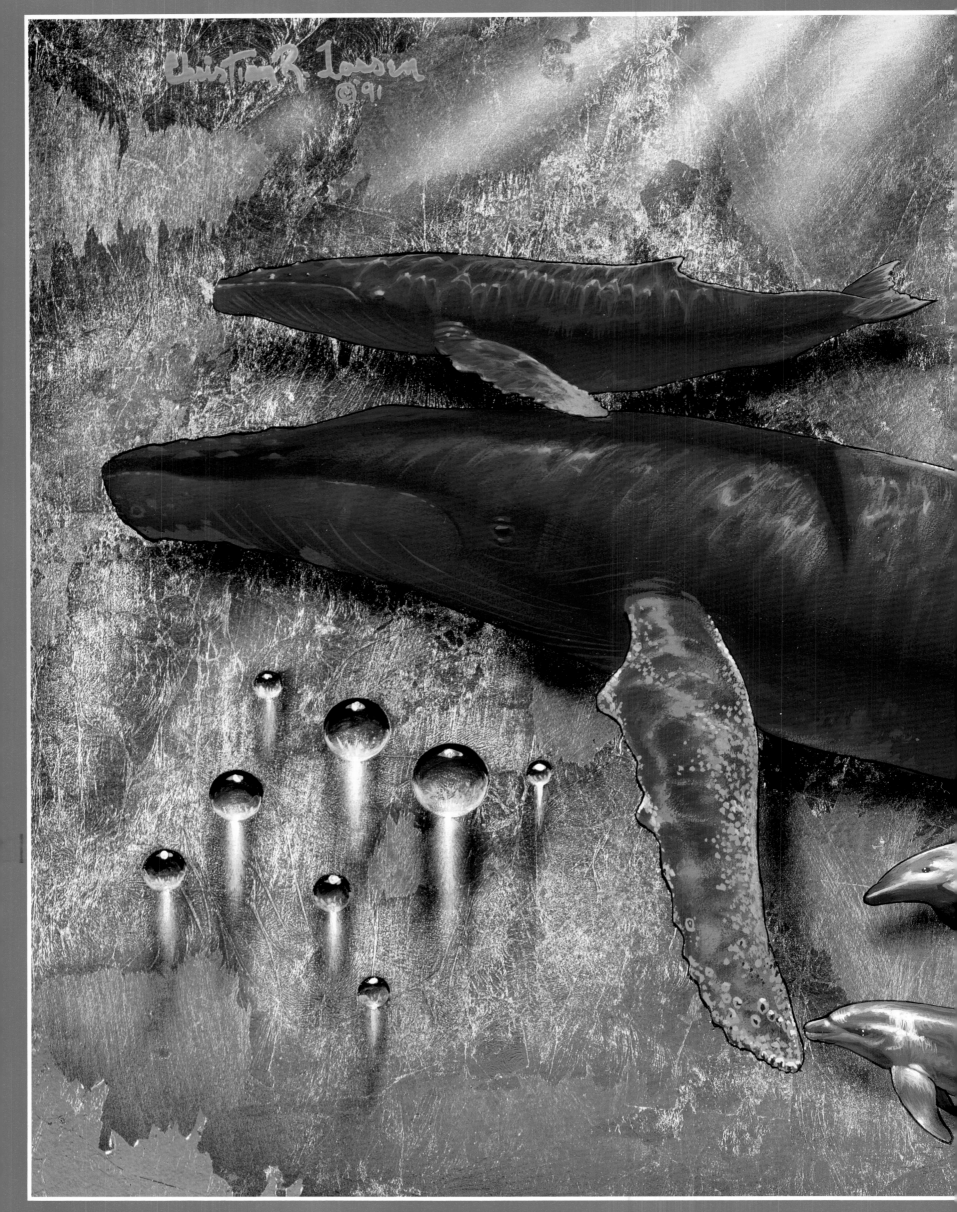

PLATE 101 • **MYSTIC ETERNITY**

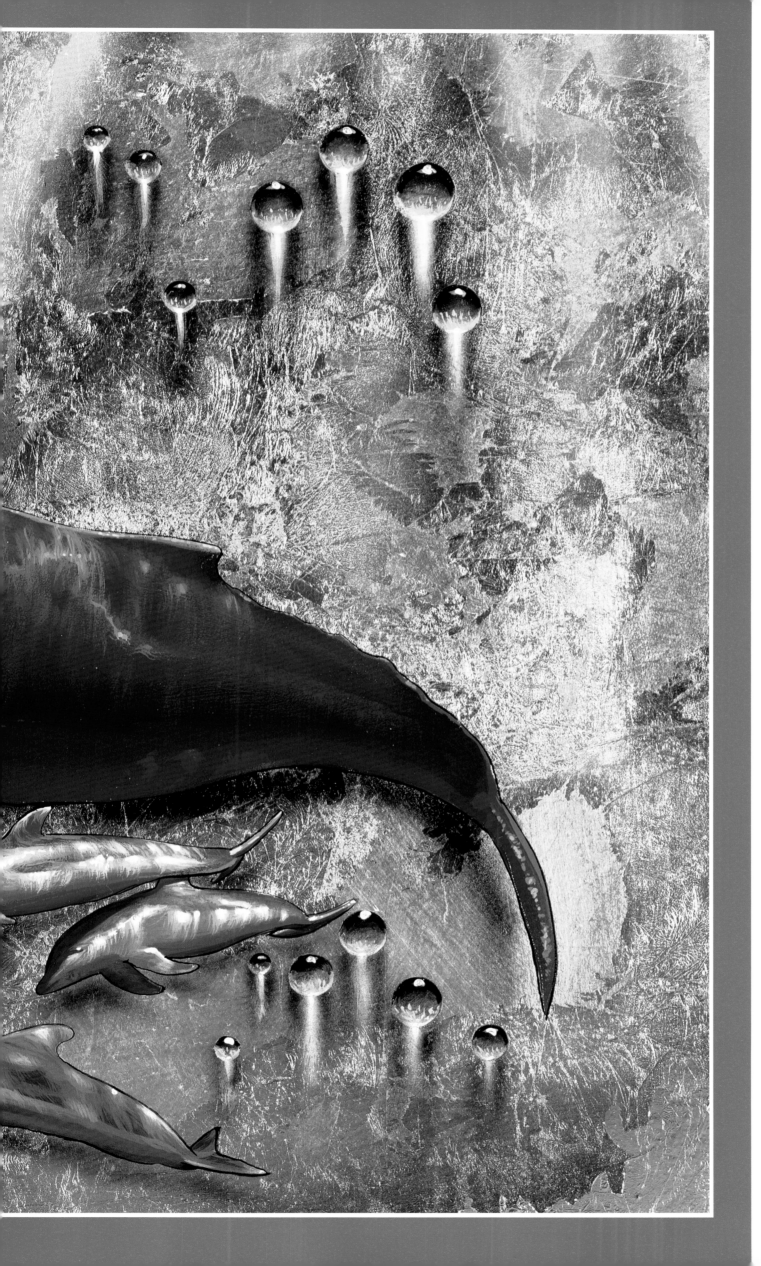

INDEX TO THE PLATES

Commentary by
Christian Riese Lassen

Technical and anecdotal

information from the artist

on the works featured in

the Galleries

PLATE I
SELF-PORTRAIT
1993. Acrylic/enamel on trovicel. 20" x 30" (51cm x 76cm)
This painting is a celebration of my oneness with the ocean environment and my pledge to do my part to conserve its pristine expanses.

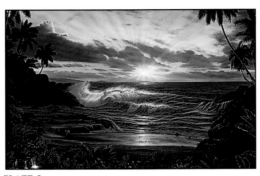

PLATE 2
MAUI DAYBREAK
1988. Oil on panel. 24" x 36" (61cm x 91cm)
One of the most intricate seascapes that I've painted, it depicts a little cove typical of the beaches on Maui. There is an incredible amount of brushwork in the foam traces on the waves and in the lush foliage. I consider *Maui Daybreak*, *Romance of the Sea* [PLATE I 5], and *Blue Hana Moon* [PLATE I I] to be the most successful seascapes I've painted.

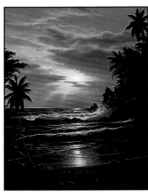

PLATE 3
PURPLE SUNSET
1987. Oil on panel. 18" x 24" (46cm x 61cm)
Painted during the same period as *Crimson Glow* [PLATE 6], this work captures another of those passionate moods that typify evenings on the west side of Maui.

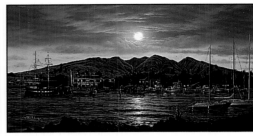

PLATE 4
HOME PORT II
1985. Oil on panel. 15" x 30" (38cm x 76cm)
My first painting of Lahaina Harbor, *Home Port II* depicts an unusual lighting reality. It's dusk, and the moon is rising over the West Maui Mountains in the east, while the sun is setting behind the observer (who stands on the breakwall) in the west. This balance of forces holds the harbor in a special kind of tranquility.

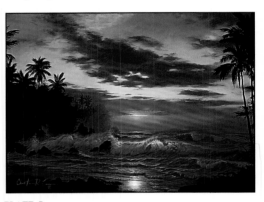

PLATE 5
AFTER THE STORM
1986. Oil on panel. 20" x 30" (51cm x 76cm)
This tropical fantasy depicts a timeless moment of gilded evening calm. An immense contrast is provided by a powerful, driven sea that continues to echo the rage of the storm just passed.

PLATE 6
CRIMSON GLOW
1985. Oil & enamel on canvas. 18" x 24" (46cm x 61cm)
I was experimenting with enamels when I painted this canvas. I applied enamels with an airbrush to create the sky, and in doing so I was able to obtain some truly brilliant colorations. This is fantasy painting that combines elements of several tropical settings and doesn't depict a single specific location.

PLATE 7
SPRECKELSVILLE
1984. Oil on panel. 20" x 30" (51cm x 76cm)
This oil was created during a time when I was very active in windsurfing. I was also experimenting with ways of better capturing a diffused mid-afternoon lighting in my paintings. I've done relatively few daylight scenes, so this was a totally different palette for me. Generally, my subjects include more dramatic lighting effects with the light source within the painting. In broad daylight, objects become flatter and subjects tend to be more monochromatic. To create more drama in the painting, I used the long shadows on the beach, created a lot of detail in the foliage, and involved the transparency of the water, through which the reef is visible in the foreground.

PLATE 8
TROPICAL EVE
1985. Oil on panel. 18" x 24" (46cm x 61cm)
This is a highly atmospheric painting; you can almost smell the warm, salty spray from the agitated surf. All forces radiate out from the central focus of the setting sun.

PLATE 9
IMPERIAL GLOW
1987. Oil on panel. 30" x 40" (76cm x 102cm)
This painting depicts the area of Ho'okipa Beach where the windsurfers launch their boards out into the waves. I did a lot of sketching and took many photographs to formulate this work. Over the years, I've done a number of moonlight scenes and sunset scenes set here. I painted this sunset at the time I was living at Spreckelsville on the north shore of Maui.

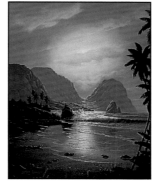

PLATE 10
MOLOKAI ENCHANTMENT
1983. Oil on panel. 18" x 24" (46cm x 61cm)
This was one of the first paintings that I did of Molokai, the neighbor island that's across the Pailolo Channel to the northwest of Maui. This primordial view of the island's north shore depicts a dreamlike vision of a misty morning.

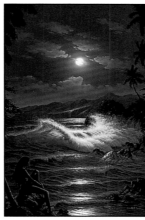

PLATE 11
BLUE HANA MOON
1987. Oil on panel. 24" x 36" (61cm x 91cm)
This is one of the most romantic pieces I've painted, with the classic Hawaiian woman sitting at the shore watching the setting moon and the cresting waves. *Blue Hana Moon* epitomizes the scenes that I was attempting at the time, especially experiments I did to improve my techniques for creating water. For instance, I put paint onto the masonite then splattered turpentine onto it, and it would separate and cause a nice textural feeling in the white water. It gave it an "organic" look. In fact, there are actually no brush strokes visible in this painting. It's very finely painted.

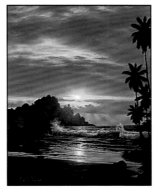

PLATE 12
TROPICAL DUSK
1985. Enamel & oil on panel. 18" x 24" (46cm x 61cm)
Painted at the same time as *Crimson Glow* [PLATE 6] and *Purple Sunset* [PLATE 3], the mix of oil and acrylic media helped to created a highly atmospheric image in which the timeless essence of a rugged tropical coastline is elementally preserved.

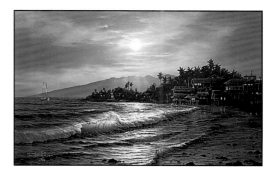

PLATE 13
PEACEFUL LAHAINA EVE
1984. Oil on panel. 20" x 30" (51cm x 76cm)
This was the first painting I sold for a significant amount of money ($10,000). Depicting the diffused hues of a low-tide evening, the sun is setting behind the island of Molokai in the background, and the lights of Lahaina Town are beginning to glow in the gathering stillness.

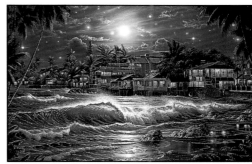

PLATE 14
LAHAINA STARLIGHT II
1993. Acrylic on trovicel. 24" x 36" (61cm x 91cm)
This painting is a complement to my earlier work, *Lahaina Starlight* [PLATE 22]. I wanted to recreate the ethereal nighttime beauty of Lahaina. The detailed brushwork captures the many-hued intensity of the waves against the contrasting backdrop of a magical, moonlit evening. I will forever feel exhilaration and awe during this time of day.

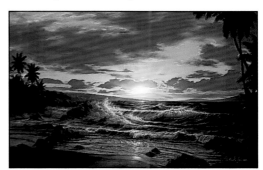

PLATE 15
ROMANCE OF THE SEA
1985. Oil on panel. 20 x 30" (51cm x 76cm)
Depicting the north shore of Maui at Kapalua, I put more work into *Romance of the Sea* than into any other seascape up to that time. The deep richness of this wonderful Maui sunset is the result of a very patient use of the Old Masters' glazing techniques.

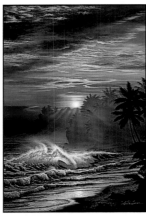

PLATE 16
GOLDEN MOMENT
1992. Acrylic on trovicel. 20" x 30" (51cm x 76cm)
I painted this seascape after a long time away from such basic, elemental subjects. It was a wonderful experience to work on one again. The area depicted is on the north shore of Maui where the qualities of light and texture are frequently reminiscent of liquid gold—as if there was actually gold dust in the air.

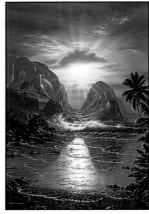

PLATE 17
HEAVEN
1992. Acrylic on trovicel. 22" x 34" (56cm x 86cm)
A companion piece for *Kahana Falls* [PLATE 68], this is a utopian scene of extraordinary natural beauty and harmony in nature. I find it a very serene painting with a special resonance that gives the *Wailani Suite* a very soothing yet evocative energy.

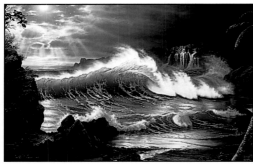

PLATE 18
CLIFFS OF KAPALUA
1992. Acrylic/enamel on trovicel. 20" x 30" (51cm x 76cm)
I love the way the waves surge and crash up against the lava cliffs of Kapalua. This view is from the balcony of my condo on the western end of Maui. The exciting meeting of light and dark, of water and lava rock, fills my ears with the imagined sounds of this dramatic meeting place.

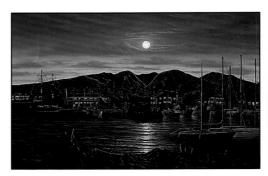

PLATE 19
HOME FROM THE SEA
1985. Oil on panel. 20" x 30" (51cm x 76cm)
This lush, nostalgic portrait of the whaling village of Lahaina at a completely serene moment captures my deep feelings for the rich qualities of darkness and light and quiet movement that are so often a part of the town where I live.

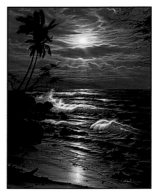

PLATE 20
NAPILI COVE
1984. Oil on panel. 20" x 30" (51cm x 76cm)
When I was a boy, I enjoyed spending long hours at Napili Bay, snorkeling and surfing. This painting is like a nostalgic dream for me, frozen deliciously in time.

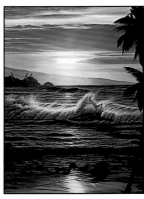

PLATE 21
HO'OKIPA SOLITUDE
1984. Oil on panel. 36" x 48" (91cm x 122cm)
Idealized to set it free in time, this is an interpretation of the rocky point at Ho'okipa Beach where I used to spend a lot of time windsurfing. This painting depicts the small sand beach where most windsurfers launch their boards. The waves peeling around the point are some of the best waves for windsurfing in the world. This was one of the first paintings in which I used an airbrush (to paint the sky).

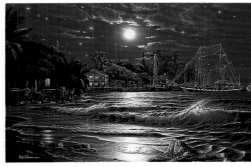

PLATE 22
LAHAINA STARLIGHT
1993. Acrylic on trovicel. 24" x 36" (61cm x 91cm)
I wanted to capture the very essence of my Lahaina hometown at nightfall through dramatic intensities of light and dark. The stars, moon, and surf will always invoke in me a sense of serenity—and spirituality—at day's end.

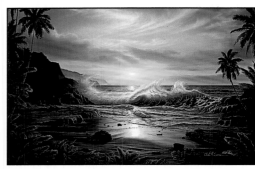

PLATE 23
MAUI GOLD
1992. Acrylic on trovicel. 20" x 30" (51cm x 76cm)
Maui Gold was begun in Tahiti and completed on Maui. The combination of detailed brushwork with a new technique in airbrushing yielded the incredibly rich and evocative hues. This painting is representative of the wonderfully vibrant colors so often found on Maui.

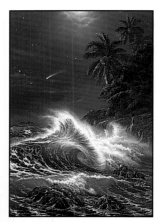

PLATE 24
NIGHT DANCER
1992. Acrylic on panel. 20" x 30" (51cm x 76cm)
This classic Hawaiian seascape depicts the elemental meeting of great natural forces seen along the north coast of Maui. In painting it, I've combined intricate handwork with a new airbrush technique that allows me to create some wonderful lighting effects. I painted *Night Dancer* as a companion piece to *Maui Gold* [PLATE 23].

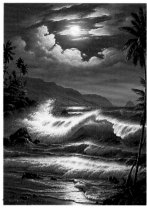

PLATE 25
ENCHANTED EVE
1985/6. Oil on canvas. 20" x 30" (51cm x 76cm)
A fantasy vision of Maui's north shore beneath the fullness of the tropical moon.

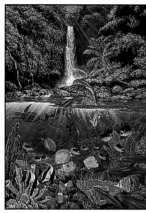

PLATE 26
ETERNAL RAINBOW SEA
1989. Acrylic on canvas. 24" x 36" (61cm x 91cm)
Waterfalls and dolphins, the lush forested shore and the living reef, the rainbow arcing above and the sea turtle below, this painting is a microcosm of life in the Hawaiian tropics. It was painted on the island of Kauai and was subsequently used on the cover of the Honolulu telephone directory.

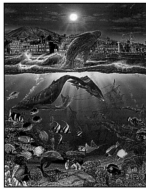

PLATE 27
ISLAND TREASURES
1990. Acrylic on panel. 24" x 30" (51cm x 76cm)
Lahaina is the backdrop for the whales diving near a sunken whaling ship and an open treasure chest on the bottom of the sea. The contrast between the tranquility below, the lunging energy of the breaching whale above, and the celestial bodies in the sky evokes a real sense of different worlds and different lifetimes.

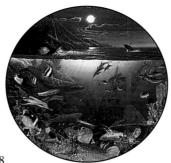

PLATE 28
MAUI WHALE SONG
1988. Oil on panel. 26" (66cm)
Painted during the same period as *Our World* [PLATE 35], when I was experimenting with oils, glazing techniques, and photorealism, *Maui Whale Song* took me about seven months to paint. There is a great amount of detail work and a lot of layering. The unusual perspectives on some of the whales and fish give it a real three-dimensional quality. Its circular motif, too, helps make this a surrealistic, dreamlike fantasy.

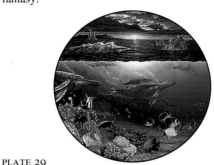

PLATE 29
DIAMOND HEAD DAWN
1987. Oil on panel. 28" (71cm)
This is the fourth or fifth painting I did in the above-and-below-water motif. The setting is near an off-shore reef off Honolulu, with Diamond Head in the background illuminated by the rising sun. Whales, dolphins, and reef fish populate the undersea world as the ancient vessel *Ho'okulea* [*see* PLATE 33] sails by.

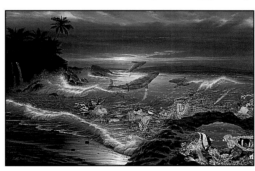

PLATE 30
SEA VISION
1989. Acrylic on canvas. 36" x 60" (91cm x 152cm)
A very surrealistic vision and a kind of two-world superimposition, *Sea Vision* simultaneously depicts several different microcosms: the whales, the reef and its teeming fish; a tidepool (lower right), the surf, the beach, and the tropical headland. This is a very unusual perspective; I've never painted anything like it, nor have I seen anything like it. I think it's a very unique piece.
Note: Prints of this painting are among Lassen Publishing's most successful, and perhaps the most successful art print ever released in Japan.

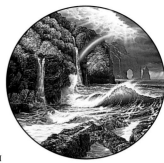

PLATE 31
THE FALLS OF HANA
1992. Acrylic / enamel on trovicel. 26" (66cm)
Hana is one of the most beautiful places in the world. This dramatic painting depicts the essential qualities that make it a unique Garden of Eden where the rich life of land and sea merge together in a glorious and harmonious symphony.

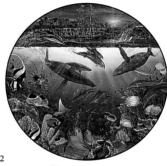

PLATE 32
STARLIGHT LAHAINA
1991. Acrylic on plexi. 30" (76cm)
Whales and dolphins and tropical fish frolic off the coast of Lahaina. To me, this is a festive and happy painting with a lot of color and a lot of movement.

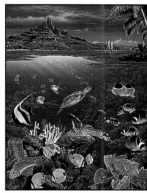

PLATE 33
VOYAGE OF THE HO'OKULEA
1990. Acrylic on panel. 24" x 36" (61cm x 91cm)
Ho'okulea is a replica of the ancient vessels once used to travel between Hawaii and Tahiti. This beautiful boat was created to retrace the paths of the original navigators. The painting depicts vessel in its ancient home waters off the island of Bora Bora in Tahiti. There the boat and crew have rejoined some old friends: the tropical fish and turtles. In Hawaiian lore, these turtles represent friendship and welcoming—the spirit of Aloha.

PLATE 34
HUMUHUMU
1991. Acrylic on plexi. 11" x 14" (28cm x 36cm)
A study of the one variety of triggerfish found on the reefs off the coast of Maui.

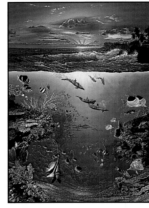

PLATE 35
OUR WORLD
1986. Oil on panel. 24" x 36" (61cm x 91cm)
An extravagant sunset seems to set the mood for dolphins to play in the waves. This is one of perhaps three or four paintings into which I put an exceptional amount of detail work. The third above-and-below scene that I painted, I feel this is a landmark piece for its depiction of marine life around a submarine canyon through the reefs.

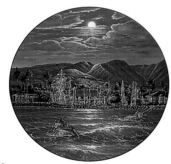

PLATE 36
JEWELS OF MAUI I
1987. Oil on panel. 16" (41cm)
The above scene of a circular diptych, this painting depicts a luminous, living Lahaina town under an auspicious moonrise. In fact, I painted the bottom section [PLATE 37] first.

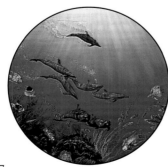

PLATE 37
JEWELS OF MAUI II
1987. Oil on panel. 16" (41cm)
Moonlight illuminates the undersea world off Lahaina.

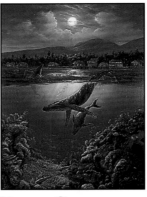

PLATE 38
MAUI WHALE SYMPHONY
1987. Oil on panel. 18" x 24" (46cm x 61cm)
A purple-hued portrait of old Lahaina and the annual migration of the humpback whales under the light of a full-moon night.

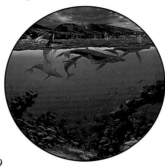

PLATE 39
BORN IN PARADISE
1986. Oil on panel. 40" (102cm)
The second above-and-below-the-water scene that I painted, *Born in Paradise* looks back on West Maui from the Molokai Channel. In this work, I paid special attention to the West Maui mountains which I feel are some of the most dramatic in the world.

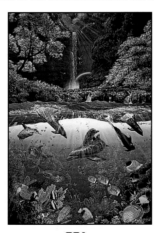

PLATE 40
THE INFINITE WAY
1991. Acrylic on trovicel. 24" x 36" (61cm x 91cm)
I began this painting on one of my surfing trips and later completed it on Maui. The whole upper portion—above the water—was done in Tahiti. There were long intervals between surf sessions when the waves were flat, so I was able to devote large amounts of time to painting the foliage and the falls in great detail.

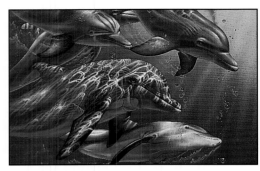

PLATE 41
DOLPHIN QUEST II
1991. Acrylic on trovicel. 16" x 20" (41cm x 51cm)
This is a study of five of the seven dolphins at the Hyatt Waikoloa on the Big Island (see *Dolphin Quest I* [PLATE 49]). In the center is Lono, a friendly, intelligent dolphin, and a bit mischievous in a way; I think I've managed to capture that in his look.

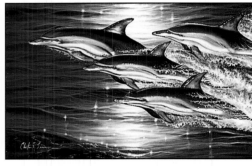

PLATE 42
SEA FLIGHT
1992. Acrylic on trovicel. 18" x 24" (46cm x 61cm)
Dolphins cavorting high above the surface of the water—a celebration of these extraordinary acrobats. The purposefulness of their unified movement speaks to their underlying, spirited unity.

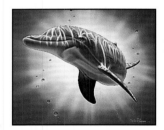

PLATE 43
KOLOHE
1992. Acrylic on trovicel. 15" x 18" (38cm x 46cm)
The lone dolphin, Kolohe, symbolizes and exemplifies all dolphins. You can feel this being's considerable innate intelligence.

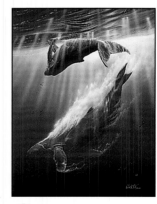

PLATE 44
WHALE SONG
1992. Acrylic on trovicel. 14" x 18" (36cm x 46cm)
Humpback whales are the great musicians of the seas. Before the coming of ships with engines, they could communicate the length of the Pacific. Now man's noise interrupts the whales' song. This painting alludes to another time—past or future—where whale song laced the oceans in a web of music.

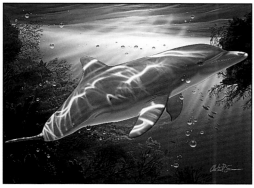

PLATE 45
DOLPHIN VISION
1992. Acrylic on trovicel. 14" x 18" (36cm x 46cm)
This is a more intimate study of one of the dolphins that plays off the beaches of West Maui. The presence of the sunlight from above seems to accentuate the extraordinary awareness that these creatures possess.

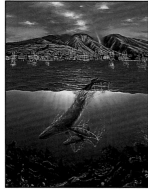

PLATE 46
HUMPBACKS OFF LAHAINA
1983. Oil on panel. 24" x 36" (61cm x 91cm)
This was the first above-and-below-the-water painting that I created. I still enjoy the contrasting realities that it portrays: the relaxed afternoon ambiance of Lahaina and the intimate submarine journey of a mother whale and her calf.

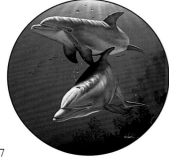

PLATE 47
FRIENDS
1992. Acrylic/enamel on trovicel. 26" (66cm)
This painting of two dolphins shows the special bonding that occurs between these extraordinary animals. It's one of the most amazing aspects of their behavior.

PLATE 48
DOLPHIN QUEST
1991. Acrylic on trovicel. 12" x 16" (30cm x 41cm)
I've spent some enjoyable and enlightening hours with the dolphins at the Waikoloa Hyatt on the Big Island. The people there allow me to swim with these wily creatures and take pictures. Jeff Smith has also allowed me to use his photographs as references for my paintings, and I've done that with this work.

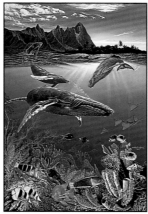

PLATE 49
HAWAII SEA PASSAGE
1988. Acrylic on canvas. 24" x 36" (61cm x 91cm)
This painting depicts the rugged Napali coastline on the north shore of Kauai—a tropical playground where the whales and other creatures can swim freely amidst the coral and lava reefs. I started this painting on Kauai and finished it on Maui.

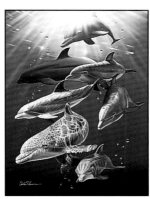

PLATE 50
FAMILY
1992. Acrylic on trovicel. 40" x 29" (102cm x 74cm)
This portrait of a dolphin family clearly reveals their special interconnectedness—how they relate to one another and the brotherly bond between them.

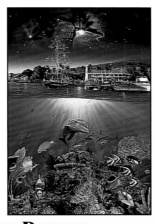

PLATE 51
LAHAINA DREAMS
1990. Acrylic on panel. 24" x 36" (61cm x 91cm)
Lahaina Town is caught between two vastly different but related cosmoses in this painting. Above are nebulae and the stars; below, the many creatures of the offshore reefs. A dolphin, apparently smiling, welcomes you into these vast, interconnected worlds.

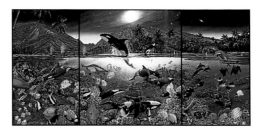

PLATE 52
HARMONY
1990. Acrylic on panel. 25" x 50" (64cm x 127cm)
An idyllic, remote tropical bay plays host to an incredible legion of frolicking Orca whales. Here— at least in this triptych—all these creatures can exist in true harmony. The spiral galaxy whirling over the West Maui Mountains reminds us of the force behind all life, while the play of the Orca is accompanied and complemented by tropical fish, porpoises, and even Hawaiian monk seals.

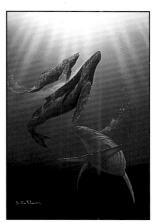

PLATE 53
LORDS OF THE SEA
1990. Acrylic on panel. 24" x 36" (61cm x 91cm)
A monochromatic, almost decorative approach to these great blue whales. They are immersed in their medium, completely relaxed and at home, and yet they are drawn upwards towards the light that bathes the seas.

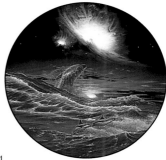

PLATE 54
GENESIS
1990. Oil on panel. 28" (71cm)
An unusual painting, it depicts an open ocean scene—I think it's actually the only one I've ever painted—and the waves, instead of coming at you, are moving away so that you're seeing the backs of the waves. A humpback whale is breaching beneath the Orion nebula as two porpoises fly freely from wave crest to wave crest.

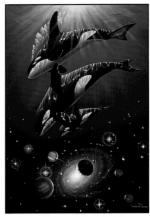

PLATE 55
CHILDREN OF THE STARS

1992. Acrylic on canvas. 29" x 19" (74cm x 48cm)

The killer whales—Orcas—are suspended above a spiral galaxy much like our own Milky Way. This dramatizes an eternal relationship, evoking the ultimate origins of these magnificent creatures, and thus their sacred role in the evolving ladder of life.

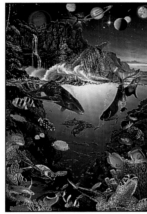

PLATE 56
THE COSMOS

1991. Acrylic on trovicel. 24" x 36" (61cm x 91cm)

One of my most successful above-and-below scenes, *The Cosmos* incorporates the planets and stars at a level of closeness and proximity that connects this astral world with the rich colors and forms of submarine life. The painting ties all of life together, from its creative origins in the universe (the cosmos) of original elements and space, to its most specific and outlandish creatures.

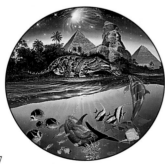

PLATE 57
MAJESTIC ENCOUNTERS

1990. Acrylic on plexi. 48" (122cm)

A very symbolic, East-meets-West painting, *Majestic Encounters* is also a different cross-section of life on this planet. The painting brings a range of worlds and elements together in one circular image: the Orion nebula (a hatchery for stars), the remnants of an ancient civilization, a rare and endangered species of land animal (a clouded leopard), and the fish and dolphins (who want to make contact with the big cat).

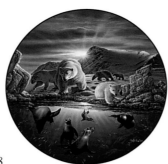

PLATE 58
ARCTIC ODYSSEY

1992. Acrylic on trovicel. 18" (46cm)

The deep, cold light of the far northern latitudes contrasts with the warmth held in the hearty bodies of the creatures that survive there: Polar bear, seals, otters, and birds. To paint this stark landscape is refreshing to my eyes, and to my other senses as well.

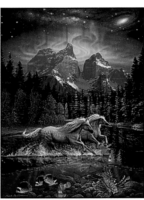

PLATE 59
IN ANOTHER WORLD

1992. Acrylic/enamel on trovicel. 20" x 24" (51cm x 61cm)

This painting rather surrealistically combines two very different environments: a warm undersea world of reefs and tropical fish and a frigid snowscape above. The horses, galloping through the water, depict the basic fire and emotion of life, which is found everywhere on the planet.

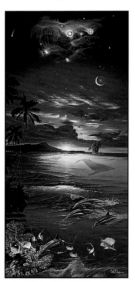

PLATE 60
DAWN OF THE DOLPHIN

1990. Oil on panel. 20" x 45" (51cm x 114cm)

A vertical diptych with an unusual perspective (somewhat similar to *Sea Vision* [PLATE 30]) in which the submarine world is revealed through a transparency of the water, rather than a line separating the world above the surface from the world below the surface. The panels aren't equal in size because the smaller upper panel was actually an afterthought. In carrying the sky up into the cosmic world of stars and nebulae, a surrealistic connection was made to the greater order of things.

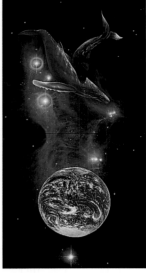

PLATE 61
REVELATIONS

1989. Oil on panel. 15" x 30" (38cm x 76cm)

The planet Earth, suspended in space and backlit by the Veil Nebula, and in the foreground the whales, depicting perhaps one of the more highly-evolved lifeforms to ever exist in the universe. This diptych communicates the naturalness of the whale—perhaps more than man—as a symbol of our watery world.

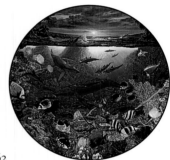

PLATE 62
CIRCLE OF LIFE

1988. Acrylic on panel. 28" (71cm)

I consider this one of my most successful marine life paintings. It depicts a variety of whales, dolphins, sharks, tropical fish, and many different kinds of coral. In a sense this is a tiny cross-section of the immense diversity of sea life in the oceans. The contrast between the light, cool colors below and heavier, warmer colors above adds considerably to the experience of contrast in this work.

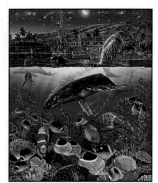

PLATE 63
CRYSTAL WATERS OF MAUI

1991. Acrylic on canvas. 20" x 16" (51cm x 41cm)

A very colorful, almost festive painting, the exuberance of the breaching whale focuses the vibrancy of this work in a way that is very reflective of life on Maui. The scene is reminiscent of *Lahaina Dreams* [PLATE 51], with Lahaina Town framed by the stars of the Milky Way, the moon, planets, and a comet above, with the whales, dolphins and reef fish below. As I recall, I painted this right around the time Halley's comet was last visible.

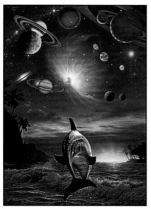

PLATE 64
ETERNITY

1991. Acrylic on plexi. 20" x 30" (51cm x 76cm)

This is a very special painting for me. It includes the Orion nebula, planets, stars and star clusters, a band of the Milky Way, and one of the dolphins leaping right out of the foreground as if he's jumping into the painting. For me this depicts the essential idea of the adventurer as an evolution of the spirit, perhaps as a seeker of enlightenment. Everything here takes place above the surface of the water as I focus more on the worlds of the planets and the stars.

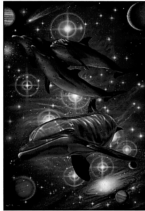

PLATE 65
INFINITY

1991. Acrylic/enamel on trovicel. 24" x 36" (61cm x 91cm)

Dolphins swimming in space somehow transcend themselves and become more the ideal of dolphins, rather than simply dolphins portrayed in their natural element. Thus, it becomes an infinite idea, and so I titled this painting *Infinity*.

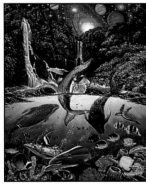

PLATE 66
SANCTUARY

1992. Acrylic on trovicel. 24" x 30" (61cm x 76cm)

Sanctuary was created for the United Nations to be used for its 1992 commemorative First Day Cover calling for the preservation of the world's oceans. The setting is Hawaii, which is most appropriate since the entire state has been set aside as a whale sanctuary. In this work, I have expressed the interconnectedness that I see between Earth's life forms and the very basic creative forces of the universe itself.

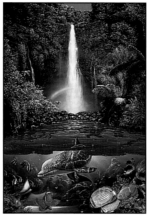

PLATE 67
KAHANA FALLS

1992. Acrylic on trovicel. 20" x 30" (51cm x 76cm)

I painted the top portion of this piece in Japan and the bottom part at home in Hawaii. It was conceived as a companion piece to *Heaven* [PLATE 17], forming what I call the *Wailani Suite*. In the Hawaiian tongue, "wailani" refers to a place where fresh water intermingles with the saltwater of the ocean.

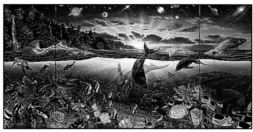

PLATE 68
MYSTIC PLACES

1990. Acrylic on canvas. 24" x 48" (61cm x 122cm)

A timeless fantasy teeming with a glorious range of life and energy, this work brings different worlds closer together so that they can interact. This was my second triptych and the first painting in which I included larger-scale stars and planets in the sky. The dramatic coastline is rendered in a very primordial surrealism.

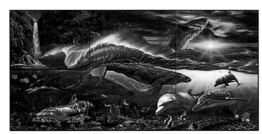

PLATE 69
ANCIENT RHYTHMS

1992. Acrylic on trovicel. 30" x 60" (76cm x 152cm)

A lush fantasy reminiscent of the north shore of Maui at some point long ago or far in the future, this triptych is a celebration of the essential harmony of life. Whale, dolphins, and other sea creatures cavort together under the glorious eye of the setting sun. Commissioned by Michael Anthony of the rock group Van Halen.

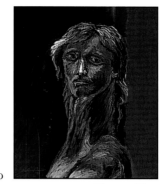

PLATE 70
IMPRESSIONISTIC SELF-PORTRAIT

1985. Oil on panel. 18" x 24" (46cm x 61cm)

At times I'll jump from style to style. For instance, I painted this self-portrait during the period I painted *Purple Sunset* [PLATE 3] and several other stylistically-related pieces. At this time I was experimenting a lot with impressionism, however, this is more of an expressionistic painting. It's highly stylized and the colors have no real adhesion to reality; rather, they create a particular mood. I recall that I was feeling very much challenged by my own painting. I wanted to learn more, and I think this painting captures some of the feelings that I was having then. There was a thirst for more knowledge.

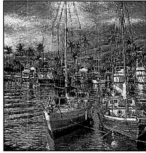

PLATE 71
IMPRESSIONS OF MAUI

1990. Acrylic on canvas. 24" x 30" (51cm x 76cm)

Lahaina Harbor...and one of my more successful impressionist paintings. I took a Monet approach to the subject (as far as application goes)—very rich in color, a woven tapestry of brushstrokes.

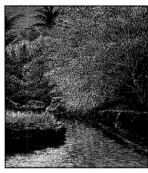

PLATE 72
MAUI GARDENS

1988. Acrylic on canvas. 32" x 27" (81cm x 69cm)

This is a shower tree and a small pond. This particular tree was especially well-formed. It resides at the Hyatt Regency on Maui.

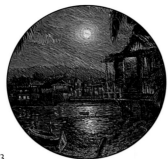

PLATE 73
HOMAGE TO VAN GOGH
1987. Oil on panel. 26" (66cm)

I painted this when I was first studying impression-ism, and I was working through the various styles of the noted impressionist artists. Van Gogh was very much an influence on me, and I wanted to experiment using techniques similar to his. This is a very bold painting; I tried to capture a lot of movement and rhythm in the brushstrokes, as Van Gogh would do.

PLATE 74
KOI IMPRESSIONS
1988. Oil on panel. 16" x 20" (41cm x 51cm)

This was a pond that was right outside the front door where I lived at the time. This painting is loose and fluid, very impressionistic. I like it a lot. I feel that the colors work well and that the approach was correct.

PLATE 75
KANAHA POND
1987. Oil on panel. 18" x 20" (46cm x 51cm)

This is a pond that lies west of Spreckelsville on the north shore of Maui. I did a series of paintings taking advantage of different lighting conditions and using a variety of techniques. Some were experiments with grays and blues. This one is an afternoon scene.

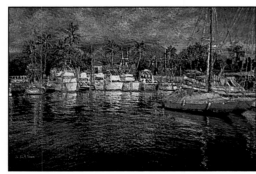

PLATE 76
MAUI COLORS
1988. Oil on canvas. 24" x 36" (61cm x 91cm)

Here I got bold with color, but used a brushstroke inspired by Monet. This very textural painting is per-haps my most successful impressionistic work. The yacht harbor at Lahaina on West Maui's shore has all the natural elements to make this work.

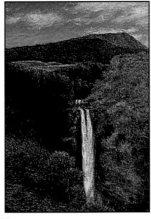

PLATE 77
TWIN FALLS
1987. Oil on panel. 20" x 30" (51cm x 76cm)

This is an interesting painting in that the entire sur-face has one interwoven texture of brushstrokes. I actually built up a texture before I started applying paint—sort of a tapestry of brushstrokes. I used the same technique with *Hana Coast* [PLATE 78]—the same application of paint, trying to weave shapes and colors together so that there are no hard edges and so that everything's interconnected and intertwined.

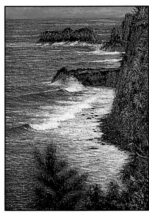

PLATE 78
HANA COAST
1987. Oil on panel. 20" x 30" (51cm x 76cm)
See "Twin Falls" [PLATE 77].

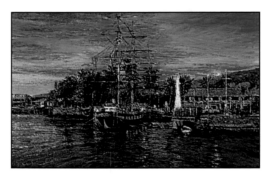

PLATE 79
LAHAINA IMPRESSIONS
1989. Acrylic on panel. 24" x 36" (61cm x 91cm)

As far as subject matter goes, I think Lahaina is an impressionist's dream. The lighting, the buildings, the shapes of the boats in the water, the reflections on the water are very beautiful and very exciting. So, I've done several impressionistic paintings of Lahaina. It's an especially great subject for this approach.

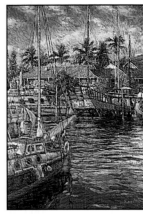

PLATE 80
LIN WA
1986. Oil on panel. 20" x 30" (51cm x 76cm)

The *Lin Wa* is an exquisite glass-bottom boat that has made it possible for thousands of visitors to enjoy the glories of life among the reefs of Maui. I painted this soon after my return from Europe, and it was influenced very much by Monet..

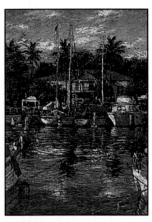

PLATE 81
LAHAINA REFLECTIONS
1986. Oil on panel. 24" x 36" (61cm x 91cm)

This was one of the first impressionistic paintings that I did of Lahaina Harbor. I painted both it and *Lin Wa* [PLATE 64] at a time when I was doing a concen-trated study of light reflections water. The style here (and in *Lin Wa*) is moving towards pointilism.

PLATE 82
TRIPLE CROWN
1990. Acrylic on panel. 20" x 30" (51cm x 76cm)

The surfer is Ronnie Burns, who passed away [in a mountain biking mishap] about six months before I painted this piece. It was used for the poster for the Triple Crown surfing events that take place each year on Oahu's North Shore. Burns was a world-class surfer who had planned to compete. I donated the original to his parents.

PLATE 83
IMPACT II

1988. Acrylic on panel. 24" x 36" (61cm x 91cm)
This is the second "Impact" painting that I did to depict windsurfing. It's a self-portrait, jumping a wave. The two realistic dolphins create a bridge from the kinetic style to a more realistic one. I think the combination conveys the sport of windsurfing quite well: the weightlessness you feel when you're jumping, the colorful sails, and the elements of wind and water coming together. In fact, I feel that this is the most successful of my kinetic paintings. It was used as a poster in *Wind Surf Magazine* and also [greatly enlarged] as a backdrop for the Doobie Brothers' Honolulu fundraising concert for the Vietnam Veterans' Administration.

PLATE 84
WIND SURF FANTASY

1988. Oil on panel. 18" x 24" (46cm x 61cm)
This self-portrait of sailing a perfect wave at Ho'okipa was commissioned by *Wind Surf Magazine* and used on the cover of their 1988 Maui issue.

PLATE 85
POWER DRIVE

1989. Acrylic on panel. 24" x 36" (61cm x 91cm)
Power Drive was the first work I painted in what I've come to call my "kinetic style." The abstract three-dimensional elements are not so much compositional statements as they are vectors that expand on the essential movement of the golfer's drive.

PLATE 86
WINDWARD PASSAGE

1990. Enamel on canvas. 24" x 36" (61cm x 91cm)
I used a palette knife and a tongue depressor and spray paint out of a can to accentuate the effects of movement through the elements of wind and water. The subject depicts sailing off the coast of Oahu near Diamond Head.

PLATE 87
FREESTYLE

1990. Acrylic on panel. 20" x 30" (51cm x 76cm)
With the ski paintings, I really went for it as far as the coloration of the background. I really got very expressionistic and abstract. I think even if you were to take the element of the skier out of the piece, leaving just the colors and the shapes, you'd still find there was substance to the composition and to the paintings.

PLATE 88
WAIKIKI NIGHTS

1989. Enamel on panel. 20" x 30" (51cm x 76cm)
I think this is probably the most successful of all the enamel paintings I've done.

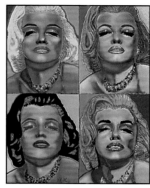

PLATE 89
FOUR MARILYNS

1990. Acrylic on canvas. 12" x 16" (30cm x 41cm)
The duplication of the subject here is a direct Warhol influence, although he rendered it photomechanically and I painted this by hand. I think that when most people think of Pop Art they think of Warhol and his Marilyns. There were a lot of other pop artists that were very popular and famous, like Rauschenberg, Twombly, and Lichtenstein. But the Marilyns are probably most indicative and representative of that period in art, with Warhol being at the forefront of the movement. For me, this was an experiment in color and shape.

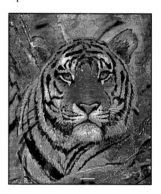

PLATE 90
TIGER

1989. Acrylic on panel. 24" x 36" (61cm x 91cm)
Still using elements of the kinetic style, but leaning more now towards impressionism, this portrait concentrates on the very graphic animal quality of the tiger. There's a lot of heavy brush work and interweaving of colors, but the work still brings forward the illusory elements in the shapes that reinforce the composition and also give the painting an illusion of depth.

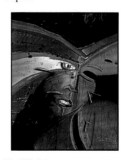

PLATE 91
SAY YES

1985. Acrylic & enamel on panel. 30" x 40" (76cm x 102cm)
This abstract portrait of a woman's face employs cubist elements and symbolisms.

PLATE 92
EXIT

1985. Acrylic & enamel on panel. 18" x 24" (46cm x 61cm)
One of the first abstract paintings of my career, I feel this portrait of a woman is very successful. I think the coloration is good and the shapes are good. It has a lot of dimensional quality about it. The technique is visible. It's one of my favorite paintings. As a first attempt at abstraction, I think it's a landmark piece.

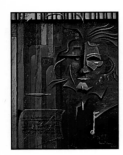

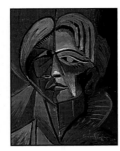

PLATE 93
BEETHOVEN
1985. Acrylic on panel. 30" x 40" (76cm x 102cm)
This painting of Beethoven is a bit of a departure for me. I enjoyed painting it and was very much into experimentation at the time. The image is filled with various symbolisms—piano shapes, piano keys, a sheet of music in the lower left, and the musical notes.

PLATE 94
CUBIST SELF-PORTRAIT
1986. Oil on panel. 12" x 16" (30cm x 41cm)
This cubist self-portrait takes the subject and breaks it into geometric shapes, trying to see it from several different perspectives simultaneously. There's a progression here, from *Exit* [PLATE 92] to *Say Yes* [PLATE 91] to *Cubist Self-Portrait.*

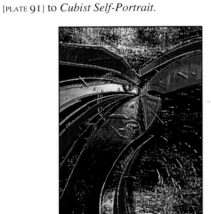

PLATE 95
GOLD LEAF MASK
1986. Gold leaf & acrylic on panel. 20" x 30" (51cm x 76cm)
This was painted in the period between *Timeless Dance* [PLATE 99] and *Bella Rosa* [PLATE 100]. I was experimenting with different subjects using gold as a background, and seeing which was the more successful technique. When I painted *Say Yes* [PLATE 91], I had been experimenting with abstraction and symbolism and cubism and a lot of other "isms." Now I wanted to see what happened when I put them on a gold background because gold has such an extraordinary three-dimensional quality; it has a reflectiveness and a lot of depth and texture. The use of gold continues to be an ongoing thing with me.

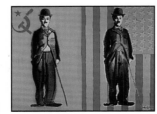

PLATE 96
CHARLIE CHAPLIN X 2
1990. Acrylic on panel. 36" x 48" (91cm x 122cm)
Charlie Chaplin, pop-style. There were rumors that Chaplin was a Communist. The Soviet and American flags here are not their real colors; they're fictitious colors, kind of a parody of the symbolism of countries and alliance to different countries. Ideologies and governments don't mean much to me; I think it's all kind of a joke.

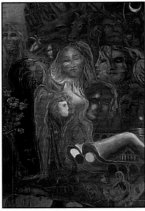

PLATE 97
DREAM
1986. Oil on panel. 20" x 30" (51cm x 76cm)
This painting brings together the influence of the great Marc Chagall with a bit of Picasso. It's a very dreamlike scene. The central figure is a woman surrounded by a variety of images, including self-portraits representing various symbolisms; this dream has many different personalities and players. It was a very experimental stage in my artistic career, and many of the images are captured from my own dreams.

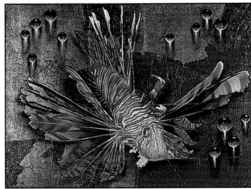

PLATE 98
LION OF THE SEA
1991. Gold leaf & acrylic on panel. 8" x 10" (20cm x 25cm)
The super-realistic droplets have been a recurring theme through a lot of my surrealistic work, beginning with *Timeless Dance* [PLATE 99], the first painting in which I used gold leaf as a background. I suppose that, for some reason, I wanted to bring my connection with water and the ocean into everything I did. I painted the lionfish while I was in Tahiti.

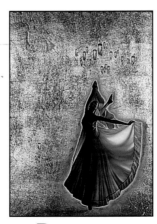

PLATE 99
TIMELESS DANCE
1986. Gold leaf & oil on panel. 20" x 30" (51cm x 76cm)
Timeless Dance was the first of the series of gold-leafed work. I like the reflective quality of the gold; I like the color of gold against the other colors that I use. This was the first paining in which I placed fully-cut diamonds into the highlights.

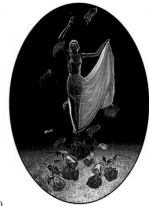

PLATE 100
BELLA ROSA
1987. Enamel & oil on panel. 20" x 30" (51cm x 76cm)
Bella Rosa was probably my most successful painting in this direction, using gold and enamel in a highly-technical type of painting where the subject is very graphically illustrated, yet set into a very surrealistic atmosphere. The figures—both for *Timeless Dance* [PLATE 99] and *Bella Rosa*—were done in the Old Masters' technique. This was very time-consuming and tedious work, but very educational. I was pushing the medium to an extreme with my technique; it involved hundreds of layers of paint. In the end, I think they are successful..

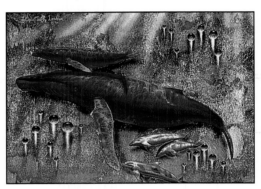

PLATE 101
MYSTIC ETERNITY
1991. Gold leaf & acrylic on plexi. 11" x 14" (28cm x 36cm)
The elements of light and time seem to be combined here in a very successful way—the gold in the water, light rays coming down, a school of dolphins. The whales are epic and archetypal. This work is a confirmation that acrylics are definitely a more direct approach to color; oils are far more subtle. But there is a graphic power here that I love.